WITH TEXTS BY

DIANE ARBUS

ESSAY BY

THOMAS W. SOUTHALL

EDITED BY

DOON ARBUS AND MARVIN ISRAEL

DIANE

ARBUS

MAGAZINE

WORK

APERTURE

FOREWORD

In the twelve years since its publication, the Aperture monograph *Diane Arbus* has remained the foundation for all critical and popular assessments of her life and work. This has not been altogether a good thing. The book was conceived as an homage. At the time it seemed that without some record of her achievements they might as easily be forgotten as remembered. Guided by her own selectivity, the monograph attempted to portray, through her words and pictures, how she saw herself as an artist. As a collection of some of her best work and a clue to her intentions it served a purpose. But as a depiction of her career, for which it has since been held accountable, it is misleading.

A photographer is prolific by nature. Diane Arbus started taking pictures in the early 1940s—landscapes, still lifes, nudes, anything considered at the time an appropriate subject for a photograph. In 1956 she began numbering her negatives in sequence and, during the next fifteen years, contacted more than 7500 rolls of film and made finished prints of more than a thousand different pictures. That material included early 35mm projects on Coney Island, movie audiences, the female impersonators of the Club 82, and also commercial work for magazines, commissioned portraits, and a few late, extensive projects. Scarcely any of these photographs appeared in the monograph.

Like most photographers of her time, Diane Arbus looked to magazines as the sole means of earning a living taking pictures, which was not merely gratifying but essential. They offered her an opportunity to work and have her work seen, gave her access to people and events she might not have been able to photograph otherwise, and, perhaps most important of all, encouraged her to think of herself as a professional. If the nature of the assignments she was given sometimes compelled her to publish pictures that failed to measure up to her standards, they also helped extend her range by forcing her to adopt or invent new techniques to fulfill the task. From the start, and throughout her career, she attempted, with varying degrees of success, to devise ways of making her own interests as a photographer coincide with those of a magazine, to conceive of ideas that promised to satisfy them both. Many of these pictures are certainly of interest in themselves, perhaps now more than ever. They also constitute an experience that contributed a great deal to the development of her style, her technique, and the way she thought about photographs and subject matter. A number of photographs now regarded as her personal work were originally planned, but never published, as magazine projects.

This book is a roughly chronological record of what she did for magazines. It is about work as a process rather than a series of isolated achievements and about the evolution of a distinctive photographic style that grew out of ingenuity, eclecticism, and the simple necessity of getting the job done.

Doon Arbus and Marvin Israel

THE GREATEST SHOWMAN ON EARTH, AND HE'S THE FIRST TO ADMIT IT

by TEX MAULE

PHOTOGRAPH BY DIANE ARBUS

If Roy Mark Hofheinz operated anywhere but in the state of Texas, he would stick out like a sore thumb. In Texas he sticks out like a sore pinkie. Even so, he is without doubt the most inventive, imaginative and successful entrepreneur in the world, and he is the first to admit it.

Hofheinz is best known as the owner of the Astrodome, which he isn't. He has the use of it for a lot less than it would cost him to own it. When he was a kid he didn't have enough money to go to the circus. He now owns a half interest in Ringling Bros. and Barnum & Bailey. He always wanted to be a baseball player, but he was handicapped by three shortcomings. "I couldn't run, hit or throw," he says. He now owns the Houston Astros, which don't do much better.

Hofheinz also owns four hotels and Astroworld, which is modeled after Disneyland and features an artificial mountain named Der Hofheinzberg. In the near future he will own five more hotels, a bigger and better Astroworld and, hopefully, an NHL club. Hofheinz's empire, or Astrodomain, is built on a swamp on the outskirts of Houston, which, not many years ago, was graced only by a straggling mesquite tree. This grew on what is now the 50-yard line of the Astrodome, which rises out of the south Texas prairie much as Hofheinz's belly swells from his body.

It is not true, as some Houstonians would have you believe, that Hofheinz asked the architects of the Astrodome to model it on the general outline of his majestic abdomen, although it has been estimated that the costs of building the Dome and Hofheinz's belly are not too far apart. It is a fact, however, that Hofheinz's waistline matches his age, which is 57. Hofheinz says he eats "anything that won't bite me back," and his poison is diet Dr Pepper and Jack Daniel's,

continued

THE GREATEST SHOWMAN ON EARTH,
AND HE'S THE FIRST TO ADMIT IT
Text by Tex Maule
Sports Illustrated, April 1969

CONTENTS

THE VERTICAL JOURNEY
SIX MOVEMENTS OF A MOMENT WITHIN THE HEART OF THE CITY
Captions by Diane Arbus *Esquire*, July 1960

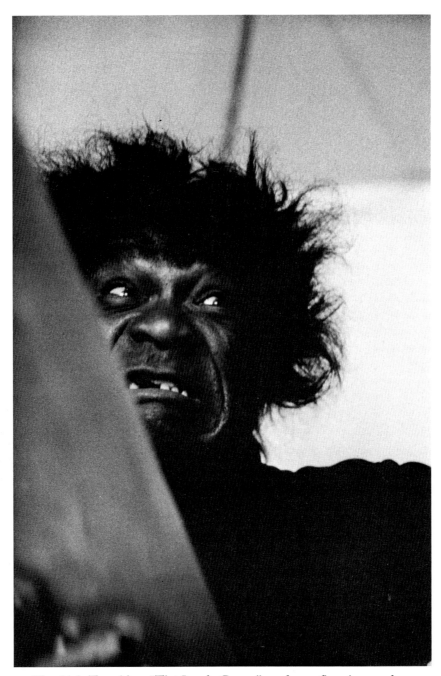

Hezekiah Trambles, "The Jungle Creep," performs five times a day
at Hubert's Museum, 42nd & Broadway, Times Square

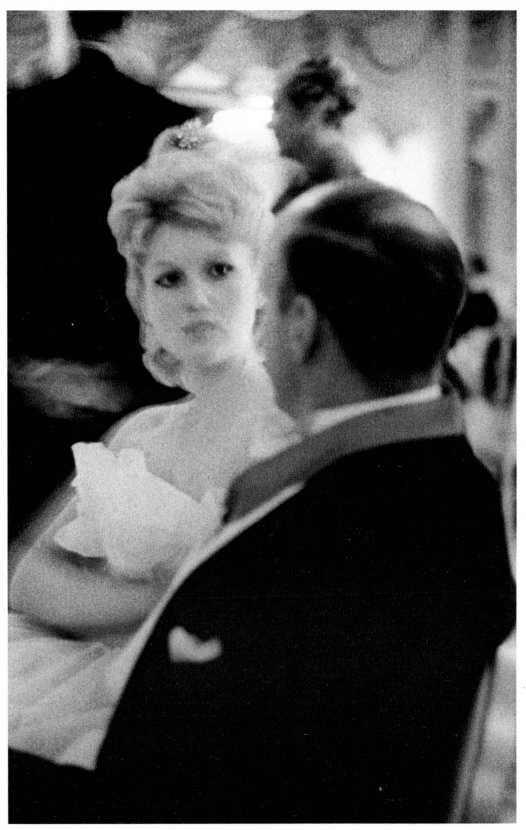

Mrs. Dagmar Patino, photographed at the Grand Opera Ball
benefiting Boystown of Italy, Sheraton-East Hotel

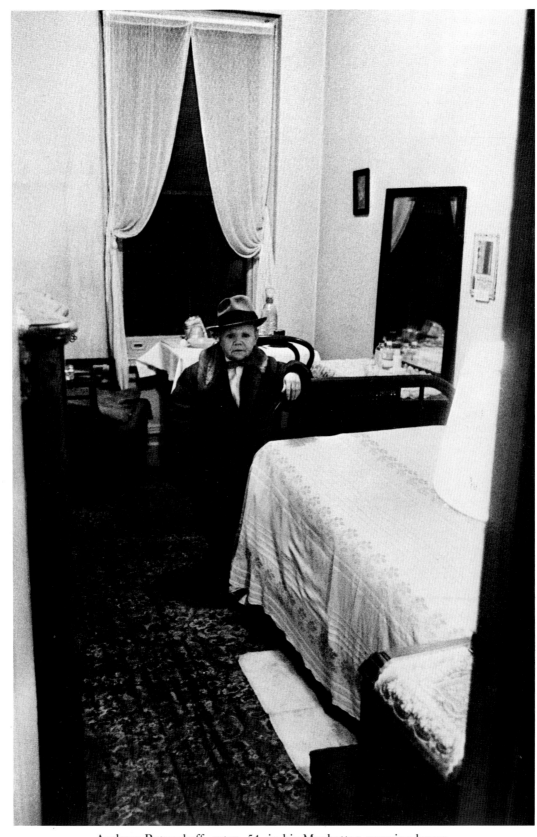

Andrew Ratoucheff, actor, 54, in his Manhattan rooming house
following a late-show performance of his specialty: imitations of Marilyn Monroe
and of Maurice Chevalier singing "Valentina"

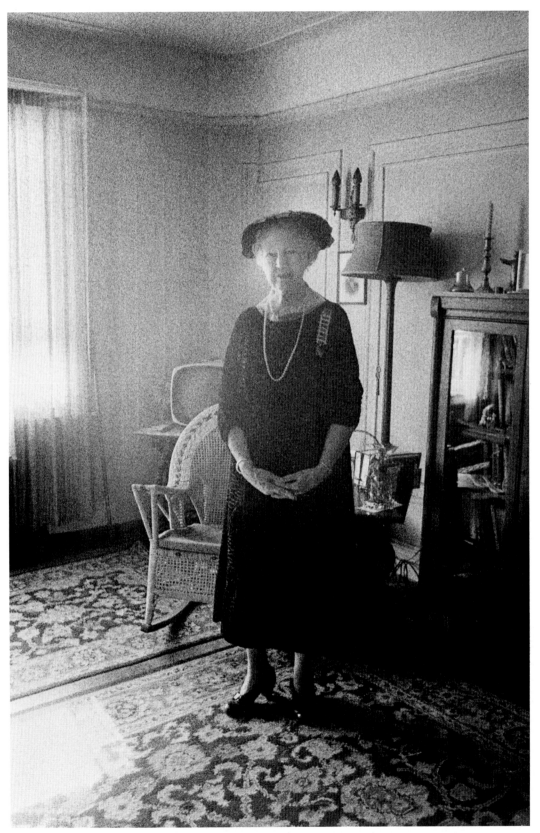

Flora Knapp Dickinson, Honorary Regent of the Washington Heights
Chapter of the Daughters of the American Revolution

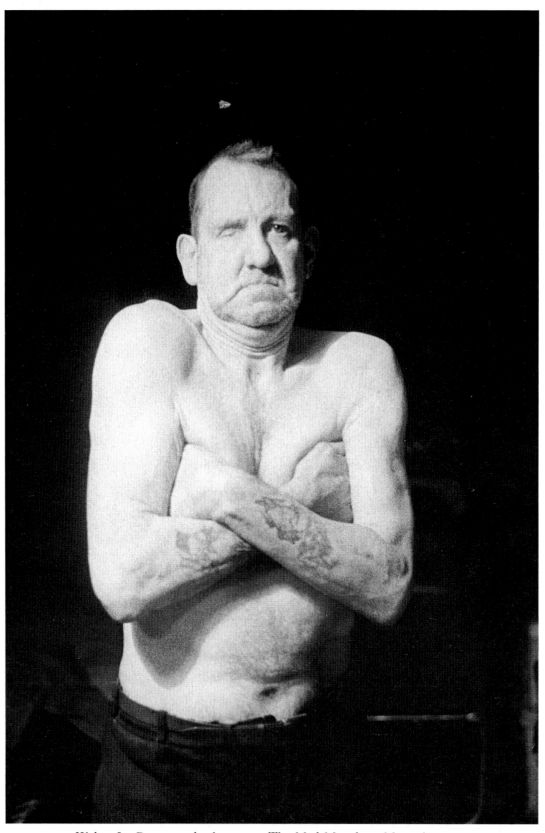

Walter L. Gregory, also known as The Mad Man from Massachusetts,
photographed in the city room of *The Bowery News*

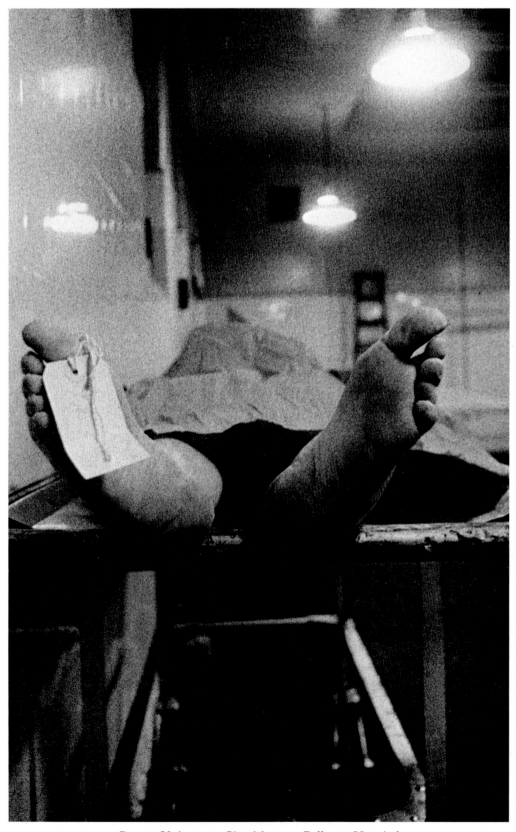

Person Unknown, City Morgue, Bellevue Hospital

THE FULL CIRCLE

Text by Diane Arbus *Harper's Bazaar*, November 1961

These are five singular people who appear like metaphors somewhere
further out than we do, beckoned, not driven, invented by belief, author and
hero of a real dream by which our own courage and cunning are tested
and tried; so that we may wonder all over again what is veritable and
inevitable and possible and what it is to become whoever we may be.

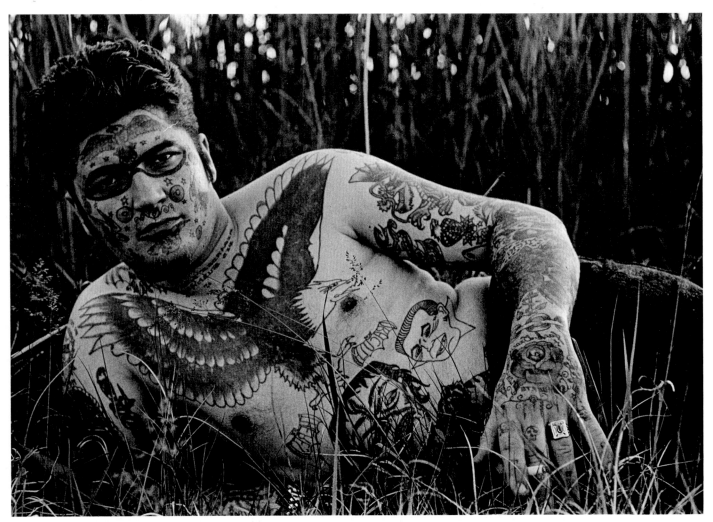

Jack Dracula, the Marked Man

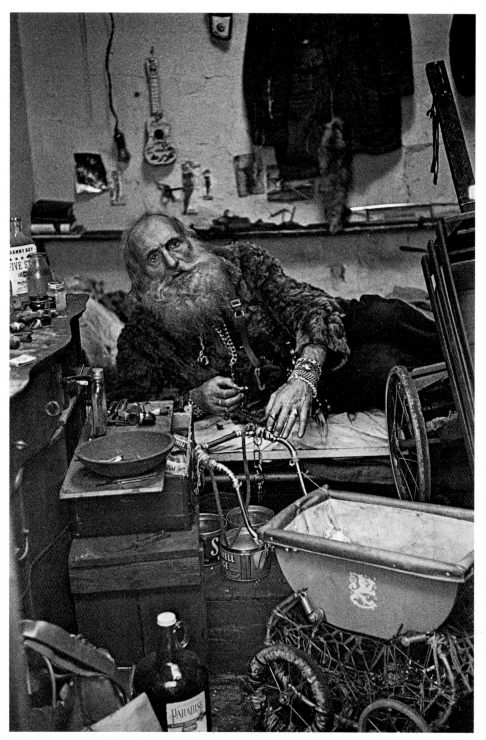

William Mack, Sage of the Wilderness

JACK DRACULA, The Marked Man, is embellished with 306 tattoos (estimated value: $6000) and although this work-in-progress conspicuously distinguishes him, he is living in seclusion and I have solemnly sworn not to reveal his whereabouts. There are 28 stars on his face as well as 4 eagles in varying postures, 6 greenish symbols shaped like doughnuts, a Maori moustache, and a pair of trompe-l'oeil goggles. Under his hair is the winged cap of Mercury with a rose cluster across his crown. His first tattoo, about four years ago, was a hinge in the crook of his right arm and now a bat nestles near his left collarbone, a 2 ft. wide eagle flies downward across his chest, a tiger and snake wrestle below his navel, a scorpion grasps a dollar sign on his right forearm, a werewolf stares from his kneecap, and on the inside of his underlip is inscribed the name DRACULA. He is also adorned with winged dragons, a peacock, a geisha girl, a cigar-smoking skull in top hat, macabre butterflies, a hypodermic entitled DEATH NEEDLE, a head of Christ, boats, birds, fish, devils, swords, flowers, ghouls, chains, hearts, anchors, parrots, satyrs, cupids, horses, penguins, The Horrible Three (Frankenstein, Dracula, The Phantom of the Opera) and one afternoon while I sat with him he put a small new rose on his thigh. There is also quite a lot of reading matter like I LOVE MONEY, DEATH BEFORE MARRIAGE, DRINK AT CHARLIE'S, MERRY CHRISTMAS, IN MEMORY OF MOTHER, AMOR, DOLORES, BARCELONA JACK, HAPPY NEW YEAR, MUERTE, SUE, SYLVIA, REGARDEZ LES COURS DES SUBMARINES, THERESA, SANDY, MICKI, JUDIE, the names of his three heroes: BORIS KARLOFF, BELA LUGOSI, LON CHANEY, and on his fingers the initials of some obscenity which his girl friends were so good at deciphering that he finally converted the ones on his left hand into flowers. Jack is tattooed simply because he wants to be. He could remove them by a secret process but he doesn't choose to. The needle penetrates $1/32$ of an inch and each little puncture bleeds slightly but heals in a week or two. He must stay in the shade because the designs on his back contain a dye which turns poisonous on prolonged exposure to the sun. He can outstare any stranger and causes a sensation on the subway, looking large, proud, aloof, predominantly bluegreen, like a privileged exile.

Women think he must be a hero to have borne so much pain but he says it didn't hurt. He has so much more than enough of women that he treats them with a devastating coolness which makes for a pleasurably vicious circle. They often promise to marry him if he will erase his tattoos so whenever he wants to break off with a girl he gets another. Jack is a writer and devotee of horror stories and has introduced me to the literary netherworld while I in return gave him a volume of Kafka whom he used to think was a fictitious character on a Shelley Berman record. IN THE PENAL COLONY made him chuckle. Here is a fragment from his writings entitled A VISIT FROM COUNT DRACULA:

'Twas the night before Christmas
When all through the house
Not a creature was stirring
Except a dead mouse.

He has read DRACULA nine times and tells some people that he is a vampire or a direct descendant of the Count or a native of Transylvania, although he was born in Brooklyn. He is an authority on Necromancy and he thinks some vampires may still exist. When I asked him if he believes in the devil he said, "Let's put it this way: I wish he'd come up just long enough for me to sell my soul to him in exchange for a few powers, like being able to fly and to blast some people out of existence." He keeps some knickknacks around to intimidate people, like a set of pseudo eyeballs in formaldehyde. His pet bird is called MURDERER because of what it did to his other bird. Children stand enraptured before him or often to Jack's delight they play fine monster games together. He is rich and shrewd and industrious. Friends and enemies respect him equally but there is no one he cannot do without. Jack is fond of skindiving but he cannot swim. He told me he is not afraid of anything and I believe him.

WILLIAM MACK, known as The Sage Of The Wilderness, The (Abominable) Snowman, Santa Claus, El Dorado, Rasputin, Daniel Boone, Garibaldi. Mr. Mack lives on Third Ave. in a room which measures about 7 by 8 ft., with 9 umbrellas, a cowbell, 20 rings, 5 hammers, 38 cigar butts in a bowl, 11 bracelets, 4 watches, 3 earrings, 6 necklaces, 35 empty bottles, a Hopalong Cassidy gun and holster, a wagon, 46 rolled up pieces of string, 19 brushes for hair, shoe, paint or floor, 5 segments of broken mirror, a pink doll carriage with a sort of underslung hammock he has devised out of more string, a toy ukulele, a jar full of plastic umbrella tips, 5 canes, some Blue Seal Pomade, 7 pairs of scissors, a jar of Maraschino Cocktail Cherries, 6 saws, a medicine dropper, a squashed coffee pot, 2 pinup pictures of Sophia Loren and 1 each of Brigitte Bardot and Julie Newmar, 9 belts, a pair of brown child's shoes hanging by the laces, a bogus detective badge, 8 augers, a plastic carnation, a fox tail, a copy of The Koran and a Holy Bible, a 1959 Horoscope, a ladder, a Guide To Sexual Harmony In Marriage (Mr. Mack was never married), 9 pliers, 10 screwdrivers, an English-Arabic Dictionary, 18 shopping

bags, a pair of white lady nurse's shoes, a Guidebook of U.S. Coins, 7 paint scrapers and some Breath O' Pine All Purpose Cleanser. ("Three months living here and I'm still straightening up.") When people ask him why he collects so many things his favorite answer is to say that it's good for his rheumatism and when people ask him where he was born he likes to say he was born in the kitchen. He could tell because he heard the water running.

He is 72 years old, German, an ex-merchant seaman living on his pension. Once I accompanied him on his daily ritual round which begins at 5:30 A.M., walking down Third Ave. in the freezing dawn picking empty bottles out of garbage cans, loading them into his baby carriage, stopping off at select bars which are very like private clubs, for parts of breakfast and the early morning special extra free drink, then south and east to the Bottle Collectors. Mr. Mack says he doesn't do it for the money, and indeed it is precious little money: the rate is something like 8 cents for 12 bottles and the day I was there he had 48 bottles and 3 gallon ones, which yielded a total of 35 cents. Picking up bottles is what he calls his diversion and he is humorously indulgent when people give him money which they must seldom dare to do because he is such an awesome, noble, enormous, possessed and legendary figure. I think he is most awfully strong. Often he carries a great sack on his shoulders. He appears to be the bearer of an undecipherable message. Nevertheless he is very fond of polite, aristocratic conversation and he sometimes goes to Union Square for a good etymological argument. He is a Muslim convert and a student of language and philosophy. He has had experiences on the lower Astral Plane and I think I have seen him in a sort of trance state. He says that the average person not only eats too much but breathes too much. And he says that Life isn't supposed to make sense ("If you take it literal, if you try to figure it out it is a mass of confusion, a pack of lies signifying nothing . . . The mutable cannot perceive the Immutable"). And the last time I saw him he said to me: "It's a great life if you don't weaken but you are bound to weaken one day."

PRINCE ROBERT de ROHAN COURTENAY, His Serene Highness, surnamed The Magnificent, the rightful Hereditary claimant to the Throne of the Byzantine Eastern Roman Empire, styling himself His Imperial Majesty, the Magnificent Emperor of the Byzantines and of the faithful Romans, Semper Augustus, was born in Oklahoma in 1886, having lost his Empire, along with a treasure valued at $90,000,000, when the Turks overran it in the year 1453. He is The Titular Sovereign of Constantinople, The Imperial and Serene Chief of the Armorican Dynasty, The Grand Duke Sebastocrator, The Hereditary Porfirogenitor and Serene Dynast, The Byzantine Patriarch of Trebizond and of Alexandria, The Autocratic Sovereign of Nicea and Bithynia, and he wears the decorations of Hereditary Royal Grand Master of the Sacred Order of Military Chevaliers of the Star, Hereditary Commander and Supreme Royal Knight of the Sacred Order of the Five Mystic Stars of the Orient, Exalted Commander of the Transcendental Order of the Esoteric Treasure of the Three Emeralds, Hereditary Commander and Supreme Royal Knight of the Grand Order of Constantinople and of The Regal Order of the Imperial Crown and The Grand Order of Michael Imperator and of the Imperial Order of The Golden Tassel, Hereditary Exalted and Supreme Royal Commander of The Grand Order of Teresa Sophia and Hereditary Supreme Royal Knight of the Imperial Order of the Inner Council. He has in his possession an illuminated genealogy tracing the unbroken royal-male lineal descent, primogeniture, from the year 820 to the present.

He lives in a bejeweled, encrusted, embellished and bedizened 6 by 9 ft. room on 48th St., called The Jade Tower, with a ceiling of orchids and painted butterflies, a legendary lantern, tasseled silken hangings, golden ornaments, a vermilion floor, an American flag and two padlocks on the door. On his left hand he wears a genuine 43 karat pigeonblood ruby ring, in his bureau drawer he keeps the ingredients for his breakfast of three raw eggs and a pat of butter in hot coffee, on his walls are his own thousand splendid fantastical paintings of nymphs in Oriental sunsets and under his bed his 9000 poems and writings entitled THE HYPNOTIZED MANDARIN and O LALLA PALLOO. A fragment of his composition follows:

O Inoy Ouno
O Heehus urche sfort rash
S O S urli findson litrash

which, by reading phonetically and unscrambling the spaces between words, translates:

O, I know, you know
He who searches for trash
So surely finds only trash.

The Prince is considered to be a very forceful man with the heart of a lion and a lovable and understanding nature. At least one woman is reputed to have killed herself (in 1934) for love of him. He is well known as a philanthropist and friend of the underdog (sponsor of the Skid Row Legion) and I accompanied him one evening on the Bowery where he dispensed cigarettes and monies to the delighted derelicts.

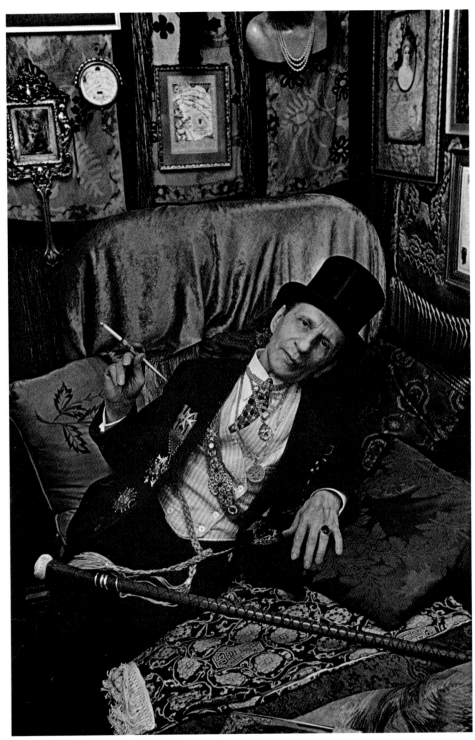

His Serene Highness, Prince Robert de Rohan Courtenay

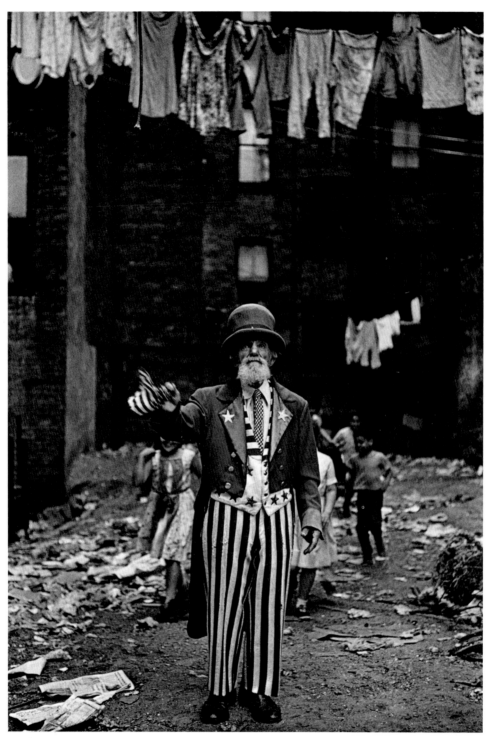

Max Maxwell Landar, Uncle Sam

If his Empire were restored to him, he would model its Constitution after that of the United States with the additional proviso of Absolute Power for the Emperor, but he does not seek this destiny, preferring to live quietly as he does, enjoying the nightly society of his friends in the 57th St. Automat. He has prudently avoided venturing near Constantinople, the hereditary Capital of the Empire, where several of his ancestors were assassinated, but some years ago five friends, under the leadership of a certain beautiful Circassian woman known as The Lady X, formed an expedition to search for the Prince's lost treasure which lies buried in four underground vaults. Before leaving, The Lady X suffered a change of heart, saying, "Prince, let me stay with you." But he persuaded her it was best that she go, conferring upon her the title of Countess. Some months later the Prince was taking the air of a warm summer evening on the Staten Island ferry when a swarthy stranger approached him from behind saying he had a message for the Prince, handing him a small package and vanishing as suddenly as he had appeared. In the package was a silver box and in the box a shrivelled human finger on which he recognized the ring of The Lady X. The shock was immense, and he experienced the "striated regret" of realizing that none of his friends were ever to return.

The Prince signs his work with a symbol, thus: representing the sun (above), the earth (below) and himself as a splinter, descending. And here is something I found among his writings:

> So with growth, changing environment and the vagaries of fortune, the facets of a man's life so vary, in a seeming and rapid inconsistency, that he appears to live his life as a succession of characters—in different dramas— sometimes high, sometimes low—and his innermost secrets are hidden in Time; and Time knows nothing! To outsiders, the personal history of anyone is merely a legend, imperfectly understood—and a fable believed and agreed upon!
>
> Most Fondly
> Au Revoir

MAX MAXWELL LANDAR has become UNCLE SAM. It happened that about a year ago a patriotically named tax advisory service conceived the notion of advertising itself by means of a sandwichman in an Uncle Sam costume, so they had a red, white and blue satin suit made at a cost of $175 and hired a tall Negro man to appear in it, but a week had hardly passed before some goons drove up and threatened to beat him up if he didn't quit, so he did. Somehow Max

inherited the job and the suit, which so well becomes him, although it is too large, that his dreams inhabit it too. He has worn it professionally as sandwichman to a barber shop, a pen company and an exterminating service, but mostly he wears it to advertise himself.

Says Max, "Last year this time I was Nobody, now I'm Somebody . . . I am what I call a Personality . . . without a doubt the youngest 80-year-old man in the world: no hair even on my private parts . . . my beard is now like Bernard Shaw's; even if it doesn't grow, it's out of this world, and my face is interesting . . . when I'm ready I'll be Buffalo Bill from the back . . . I have a suggestion for you: I could be other people . . . No? . . . Good! . . . I am greater than ever before . . . I've got the greatest laugh in the Country and the World . . . I am writing my life story which will be similar to MISSION TO MOSCOW which Dwight D. Eisenhower wrote . . . you will be in it . . . I am a soprano contralto, the Greatest Singer in the world today and I have the voice of a man, woman and child . . . I'm going to Hollywood . . . you won't be sorry . . . there's no question about it: I'm going to be rich and famous . . .

I can prolong the life of the Leukemia victims of the world and Eleanor Roosevelt and Bob Hope will take care of Cancer . . . I am ordering Congress what to do and I'm sure I'll have a meeting with Kennedy . . . I am a Phenomenon . . . M . . . E . . . ME!"

Max lives on the lower East Side with his faithful servant Georgia, trudges the streets, tireless as the seven dwarfs, stopping traffic with his imperious upraised hand and repeating his name to anyone who will listen or even to anyone who won't. He says he is the first person authorized to be UNCLE SAM since 1812 and he plans to bring the Liberty Bell to New York. He took me to Washington for the Inauguration, walking the entire way, from one end of the train to the other, proclaiming his mission. The plan was for me to photograph him being The First Man To Shake The Hand Of Dwight D. Eisenhower When He Was No Longer President but we couldn't get close enough. Instead we slept on benches in Union Station, he sold leftover Campaign souvenirs inscribed KENNEDY WILL WIN to finance the trip home, and he climbed the Washington Monument in a blizzard, all 898 steps of it, in 43 minutes, solemnly delivering his oration to George Washington at the bottom, for an audience of the five guards and me. He sometimes suddenly imitates Shirley Temple or dances the Cha Cha Cha shaking invisible maracas, and he can simultaneously eat a doughnut and sing without moving his

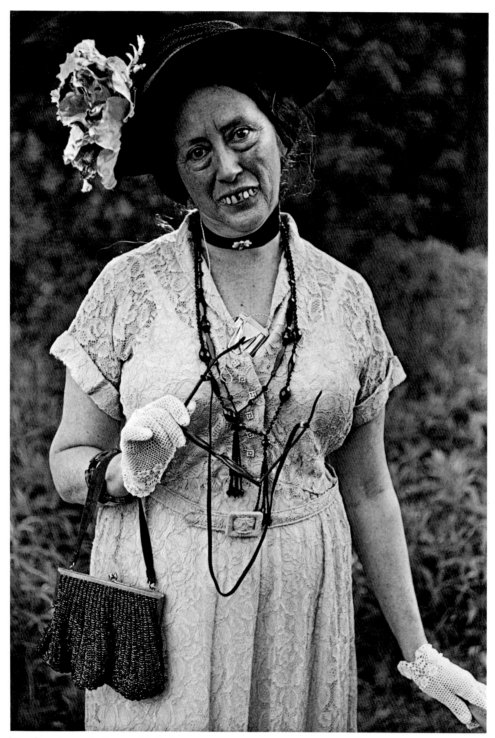

Miss Cora Pratt, the Counterfeit Lady

Polly Bushong

lips. At Christmas time I helped him buy several editions of a plastic Nativity Scene at Liggett's for 99 cents, which he sent to the Kennedys for their newborn son and to Clark Gable's widow for the forthcoming child. He is planning to send something to the Pope and to Cardinal Spellman too. Max is a master optimist. "God is good to me," he said once. "Unless I die I can make a lot of money and of course," he added shrewdly, "if I die, you've got something."

MISS CORA PRATT, The Counterfeit Lady, is fashioned of a set of teeth, an old wig, beads, brooches, feathers and laces out of the attic, pencil, padding, and the whimsical inclinations of Polly Bushong who has been practicing this little hoax for nearly twelve years. It really began longer ago than that, for when she was just a child, Polly's father, a socially prominent New England gentleman, introduced the parlor game of shocking people by wearing a crenelated slice of raw potato under the upper lip as buck teeth. But it remained for Polly, years later, to purchase a fine and monstrous extra row of real false teeth and to pursue the game to the logical conclusion of occasionally becoming someone else, which she has done with such inspiration and cunning that she has never once been found out. If Polly is a delightful, witty and talented Dr. Jekyll, Cora is a guileless, rapturous and preposterous Mr. Hyde, who commits the most unerring blunders and cheerfully treads where angels fear to. Once Cora appeared, by prearrangement with the host, as the maid at an elegant New York cocktail party, attended by a dazzling array of steel tycoons, shipping magnates and theatrical luminaries, wearing a permanently crumpled uniform and a pair of saddle shoes, announcing sweetly that she was just helping out for her friend the real maid who had come down with a frightful case of impetigo. She surreptitiously sipped the drinks as she served them, blew the ashes out of the ashtrays in full view of the aghast guests, solicitously offered pieces of cheese on her outstretched bare hand to gentlemen who looked hungry, and fell asleep in a corner of the living room.

Sometimes Polly is informed by her hostess of the foibles and fancies of particular guests so that Cora may say even more precisely the wrong thing to them; like the shy and quiet retired financier, an enthusiastic stamp collector who had been hoping for years to happen on the famous single sheet of 1918 24-cent airmail stamps on which the airplanes were accidentally printed upside down, thus multiplying their value to about $7000 per stamp. Cora waylaid him in the library to tell him of her rich uncle and how he had died, God-rest-his-soul, leaving her a little property and an attic full of junk including a whole bunch of good-for-nothing stamps, every one of which had already been used. Her friends had tried to trick her by calling up pretending to be some stranger from London or Paris wanting to buy all the silly stamps, but she had always hung up because she wasn't one to be taken in so easily. Finally she had made use of them for decorating the sweetest little matchboxes to give away to her friends at Christmas, even a whole sheet which had pictures of upside down airplanes on them so she had carefully to cut out each little airplane with her manicure scissors and paste them back right side up the way they belonged.

Often Cora is reputed to be extremely wealthy, and an eager stockbroker once spent an entire evening hopelessly wooing her fortune while she blithely conversed about doughnut recipes and butterflies and Five Day Deodorant Pads. No one has ever dared to enlighten him and he is hardly likely to imagine that Cora does not exist.

Cora has tweaked the moustaches of an uneasy diplomat, mentioned unmentionables in the Chase National Bank and sipped coffee from a saucer at the Plaza. Once she took the train to Boston with a terrible rubber scorpion perched on her bosom.

If the ruse is revealed people are sometimes permanently outraged but more often utterly enchanted, and indeed there was a time when Cora was receiving so many more invitations than Polly that Polly became quite put out and pretended for a while to have misplaced the teeth altogether.

But recently Polly went on a ten-day cruise to the West Indies during which Cora appeared mysteriously, just once, in curlers and shower cap and sunburn cream and ruffled bathing suit, like an apparition which the other passengers were never able to explain or forget.

Polly says that Cora lives in Peabody, Mass., where she chases butterflies and bakes gingerbread in a cottage overlooking the garbage dump.

Cora speaks of Polly with utmost admiration and Polly is devoted to Cora, while Polly's mother cannot bear her and Polly's brother thinks she is divine.

Polly says, "She is so *dear* and *happy* and *pathetic;* you'd be surprised how much you can tell about people by whether or not they take to Cora."

Even her best friend couldn't tell that Polly is Cora and although Polly knows what Cora doesn't only Cora can say anything that comes into Polly's head.

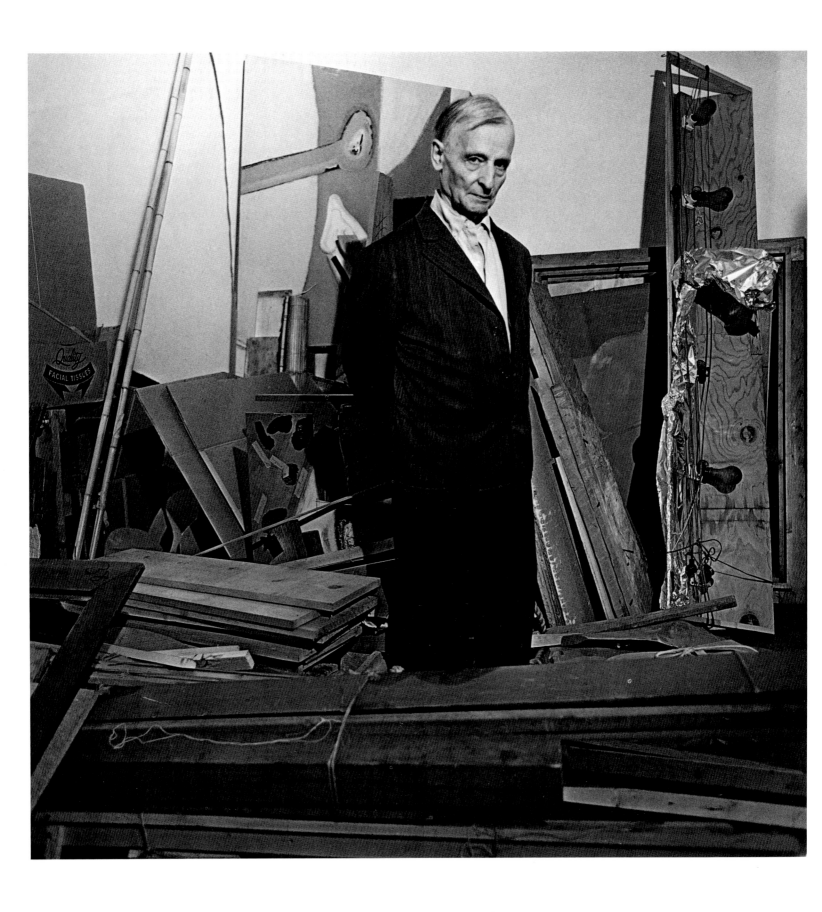

CHRISTOPHER ISHERWOOD
Unpublished, 1962

British author of *A Meeting by the River* and
The Berlin Stories, near his California home

< FREDERICK KEISLER
Unpublished, *Harper's Bazaar*, 1962

The eminent architect, sculptor, and painter, in his
studio on 14th Street in New York City

JAMES T. FARRELL: ANOTHER TIME, ANOTHER PLACE
Text by Richard Schickel *Esquire*, November 1962

Author of the *Studs Lonigan* trilogy, in the
bed-sitting room of his Manhattan hotel

EUROPE'S UNCOMMON MARKET >
Text by Frank Gibney *Show*, March 1963

Marcello Mastroianni, international film star of
La Dolce Vita, in his New York City hotel

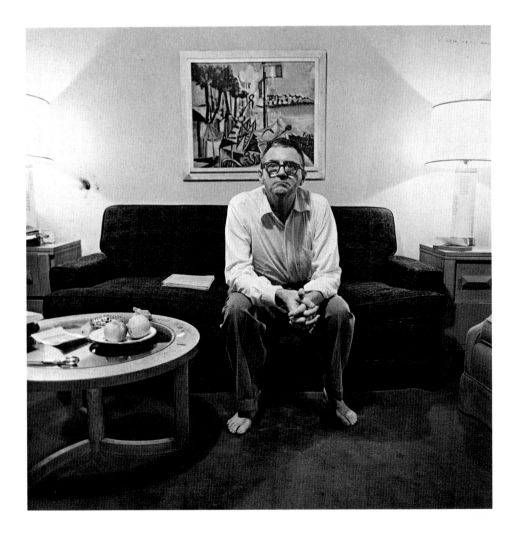

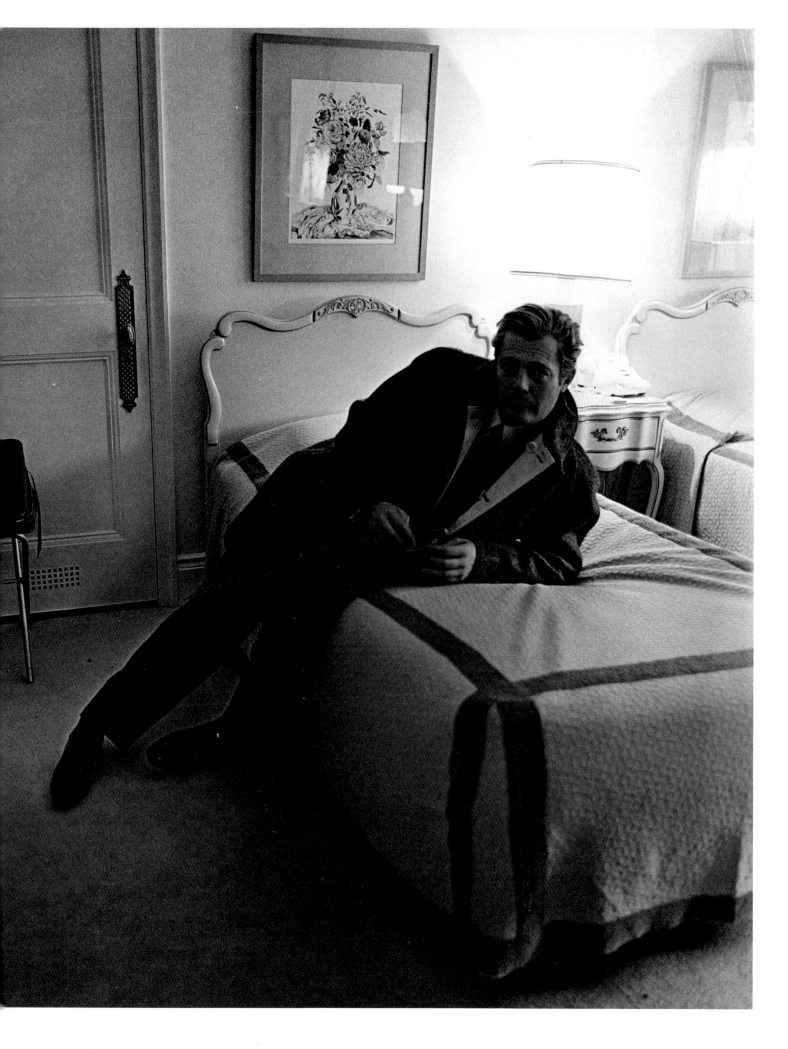

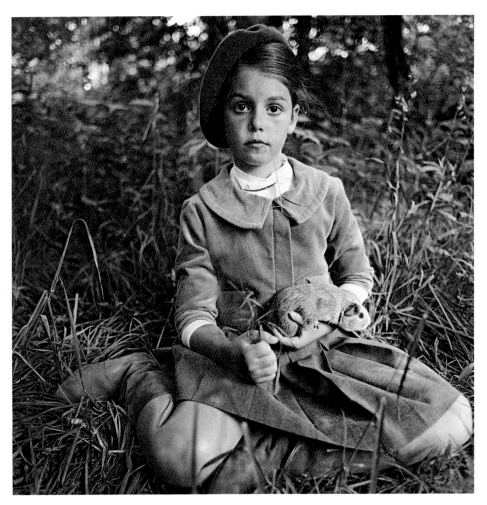

BILL BLASS DESIGNS FOR LITTLE ONES
Harper's Bazaar, September 1962

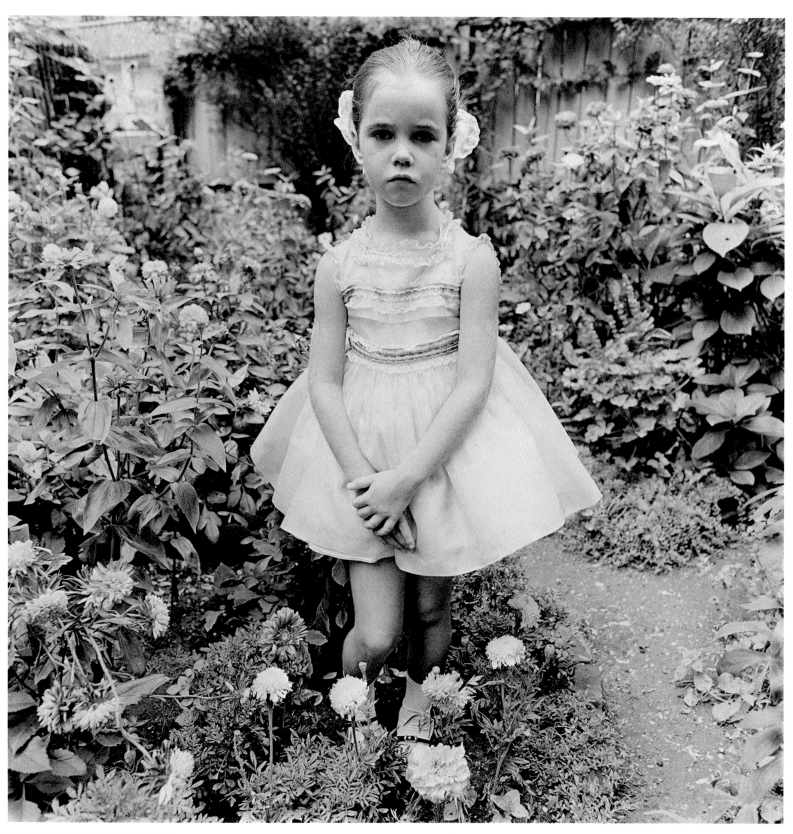

PETAL PINK FOR LITTLE PARTIES,
WHITE-OVER-PALE FOR PARTIES
Harper's Bazaar, November 1962

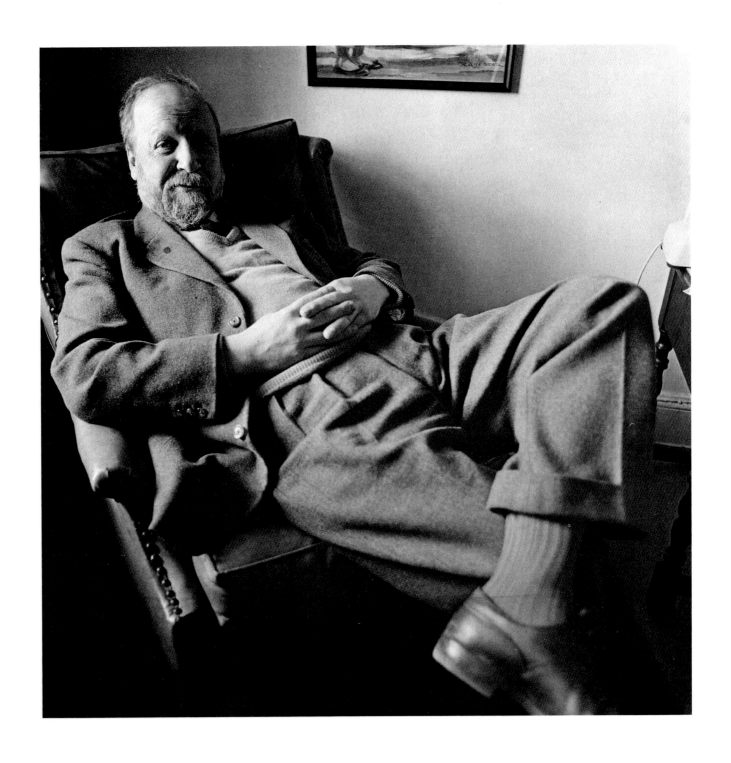

WILLIAM GOLDING
Text by Geri Trotta *Harper's Bazaar*, August 1963
British author of *Lord of the Flies*

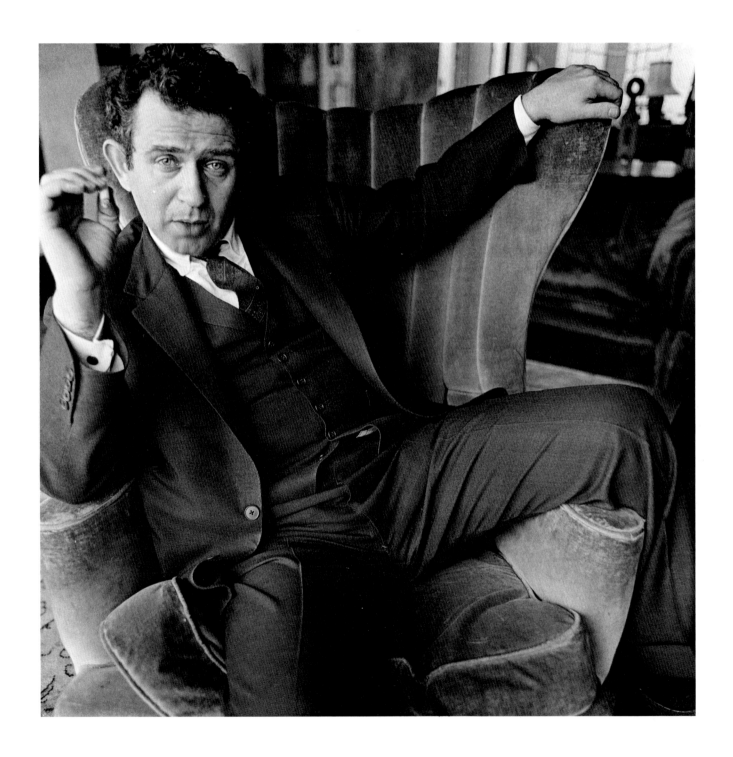

THE KENNEDYS DIDN'T REPLY
Review of *The Presidential Papers* by John Kenneth Galbraith
New York Times Book Review, November 17, 1963

Author Norman Mailer in his Brooklyn home

*AUGURIES
OF
INNOCENCE*

*If the Sun or Moon should doubt,
They'd immediately go out.*
WILLIAM BLAKE

*The man in the wilderness said to me,
How many strawberries grow in the sea?
I answered him as I thought good,
As many red herrings as grow in the wood.*
ANONYMOUS

AUGURIES OF INNOCENCE
Text excerpts from William Blake,
Lewis Carroll, and Phila Henrietta Case
Harper's Bazaar, December 1963

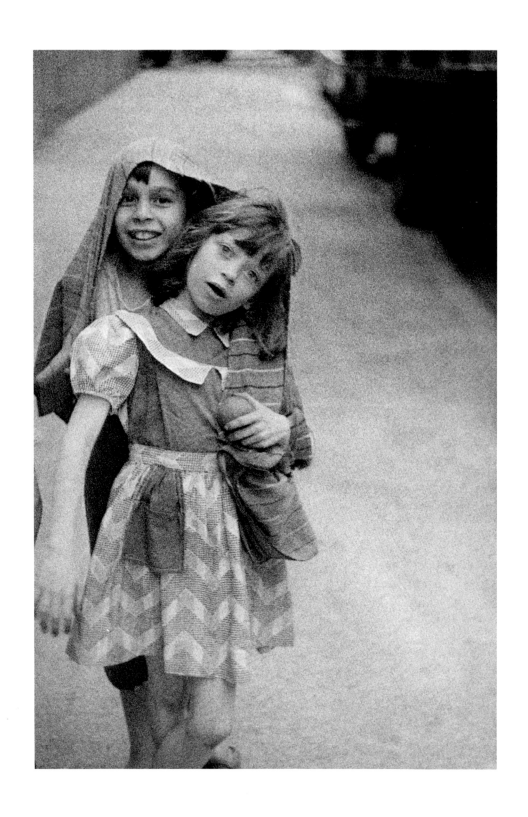

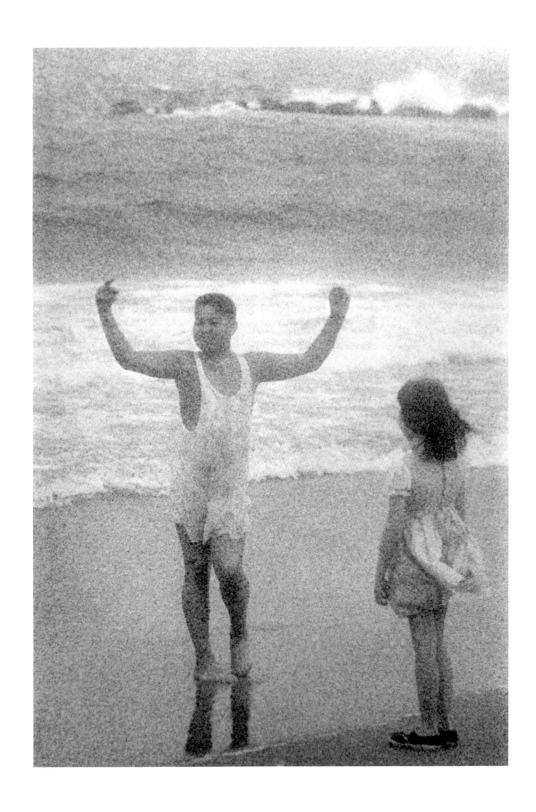

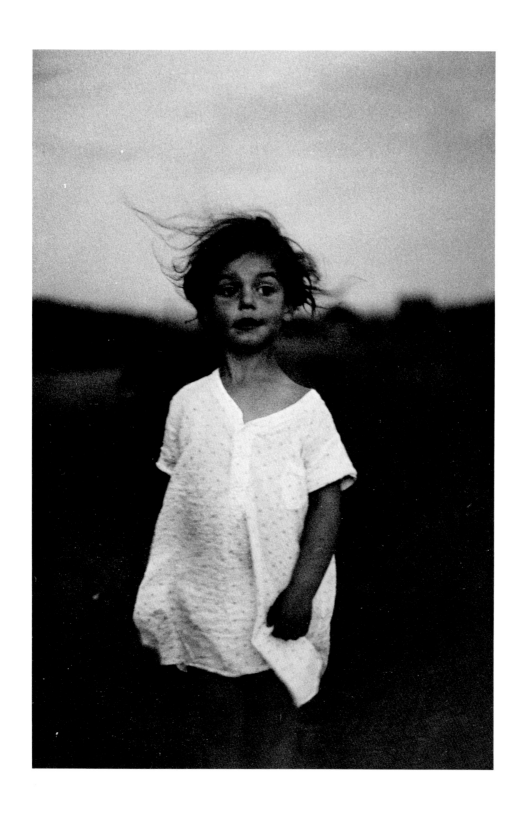

THE SOOTHSAYERS

WHAT'S NEW: THE WITCH PREDICTS

Text by Diane Arbus; edited by Marguerite Lamkin

Glamour, January and October 1964

sooth′say′er n. 1. one who claims to have supernatural insight or foresight; a diviner. 2. a truthful person.

DORIS FULTON is eighty-three and last August the doctors (but they are not fortune tellers) had given her two months to live and she had not figured to be here for Christmas. But she has led a charmed life and never been afraid. When she was five she dreamed the Johnstown Flood which happened two days later. The Navajo Indians taught her to read fortunes from cards they gave her which are small and pink with sort of comic book pictures drawn on them in ink. While she is reading the cards it's like she hears it in her ear—it's an awareness—and she writes a little letter to the Lord asking how she can help this person and in three days they call her back to tell her the wonderful thing that happened. Your todays, she says, are making your tomorrows.

DR. GEORGE DAREOS of Venice, California, says that Elizabeth Taylor was Cleopatra in another incarnation and she is destined to go down in history as the greatest actress in the world. He says we all undergo twelve incarnations and he can tell by a person's stride how old a soul they are and old souls generally die young and in a very beautiful way. Life is like a flower and he himself will die under strange circumstances but he is not afraid and once two men broke into his house and tried to strangle him with the bed sheets but he cried out and they fled. He looks forward to great unrest in the stock market in 1964, but those who have stock should hold onto it. He told Jayne Mansfield not to marry Mickey Hargitay. He says the first incarnation is the hardest and destiny is fixed at the moment of birth. He said he was very fond of Cary Grant but it turned out he meant Gary Cooper. He says that all the Hearsts love him. He has a century plant in his garden which bloomed last year.

LESLIE ELLIOT is an astrologer as wilted and radiant as a wraith. He has teeth which are almost as blue as his eyes and fingernails as long as a lady's and he almost never leaves the house and he rarely eats. Once he didn't eat from the 24th of September to the 2nd of November. He feels suspended above the world, floating and weary, and he will be ready to die on fifteen minutes' notice. He says most people are seeking what they will not find and all he himself wants is quite a lot of peace and quiet. He has no pleasures except the pleasures of making astrological charts (which sometimes affect him so deeply that he vomits or faints). People who are really addicted to him require a chart to ascertain the auspiciousness of every move they make. Every chart has a positive and a negative aspect. Leslie's own chart is negative and once you are over twenty-four years old (which he is) nothing can be done about that.

SANDRA does not like to be called Madame Sandra or indeed anything but plain Sandra although her name is really Isabel. On her door it offers *Numerology, Astrology, Cards, Crystal, Handwriting, Spiritual, Psychic, Clairvoyant, Tarot, Palmistry*, but she says she doesn't know how she does it; it just comes to her. When she was fourteen her parents became aware of her gifts and apprenticed her to a retired reader. Now she is seventy-nine years old and a widow. She says she will live to be a hundred and never share her bed with another man. She does not predict death because people need encouragement. During the war she gave many free readings but she has learned not to trust everyone and now if someone comes in with only a dollar she is likely to tell them to come back when they have two more. People come to her about affairs of the heart or of the stock market. Once a Jewish lady came to ask her if her gentile maid should help her make the gefilte fish. Sensing the lady to be orthodox and nervous, Sandra advised that the maid merely scrub the vegetables.

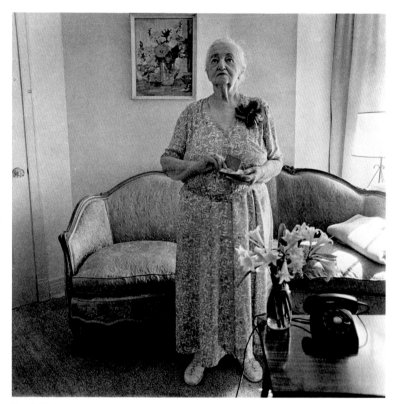

Doris Fulton

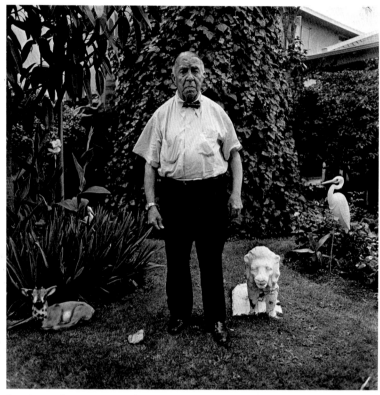

Dr. George Dareos

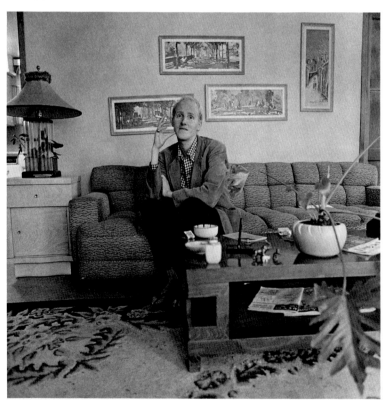

Leslie Elliot

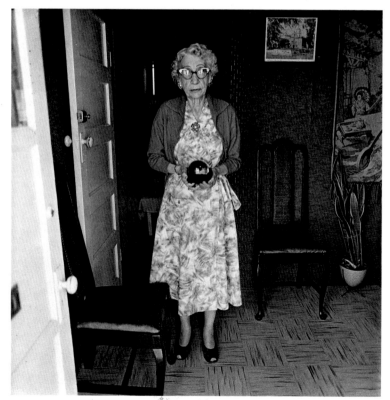

Madame Sandra

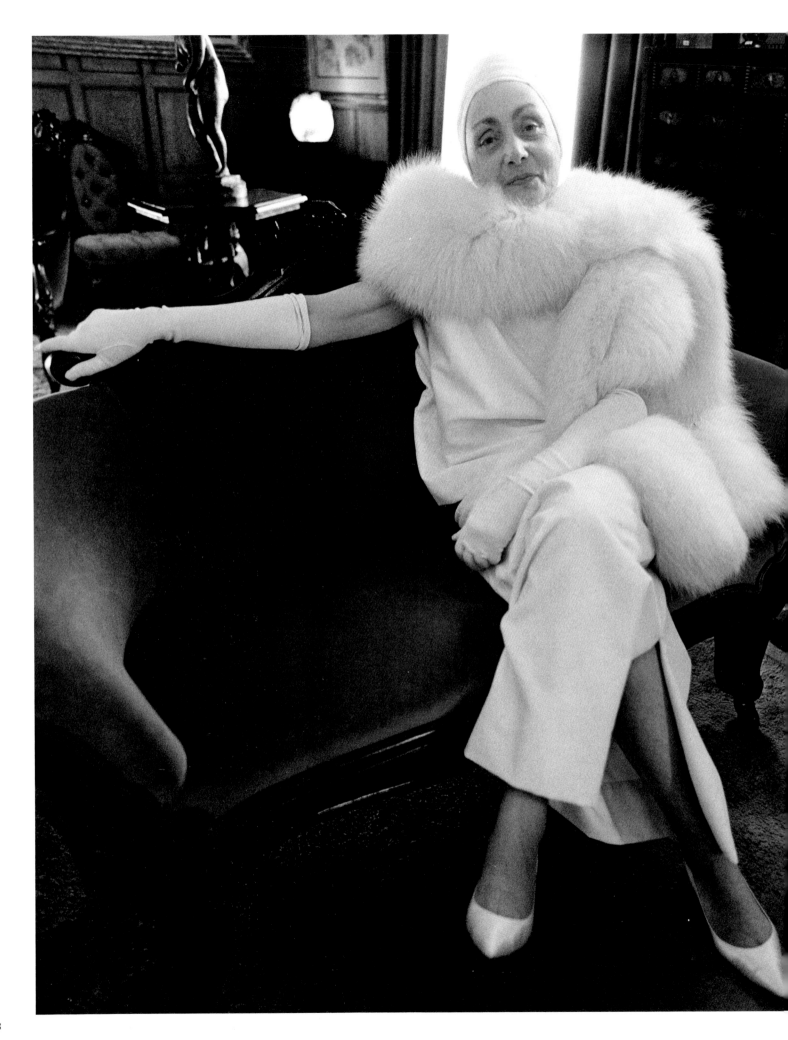

MADAME GRÈS: A UNIQUE TALENT
Harper's Bazaar, February 1964

Alix Grès, one of France's most
distinguished fashion designers

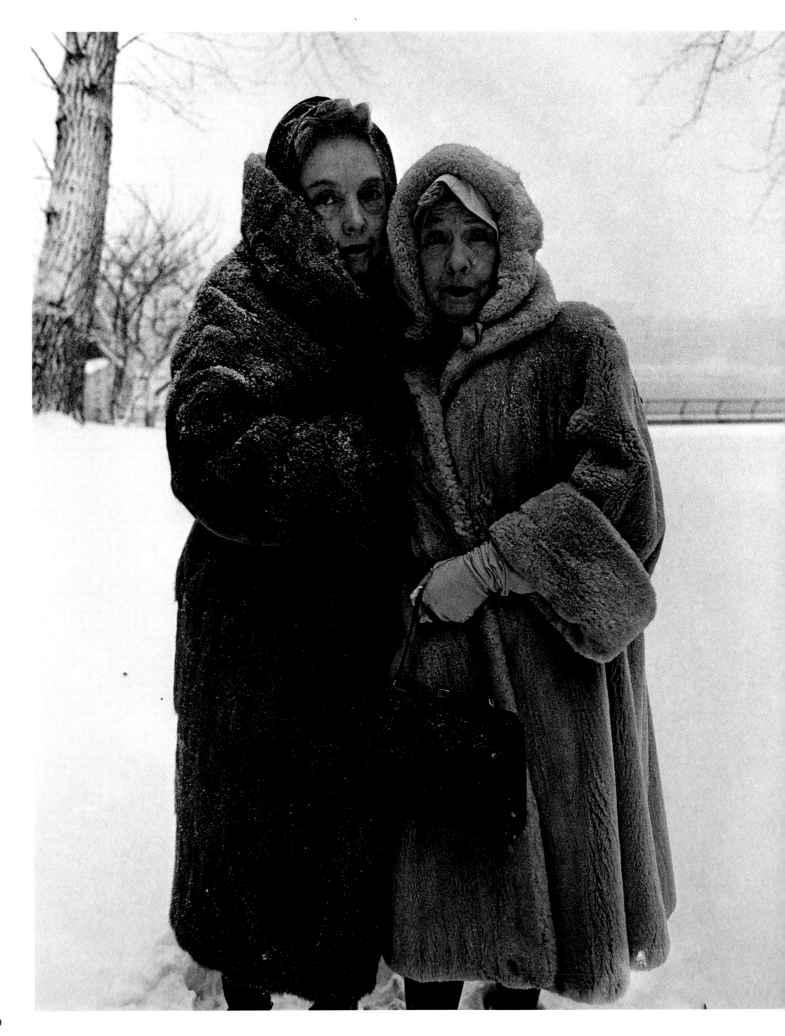

AFFINITIES
Text by Geri Trotta *Harper's Bazaar*, April 1964
A series portraying friendship between creative partners

Lillian and Dorothy Gish,
eleventh-generation Americans
and renowned film stars
of *Orphans of the Storm* and
Way Down East

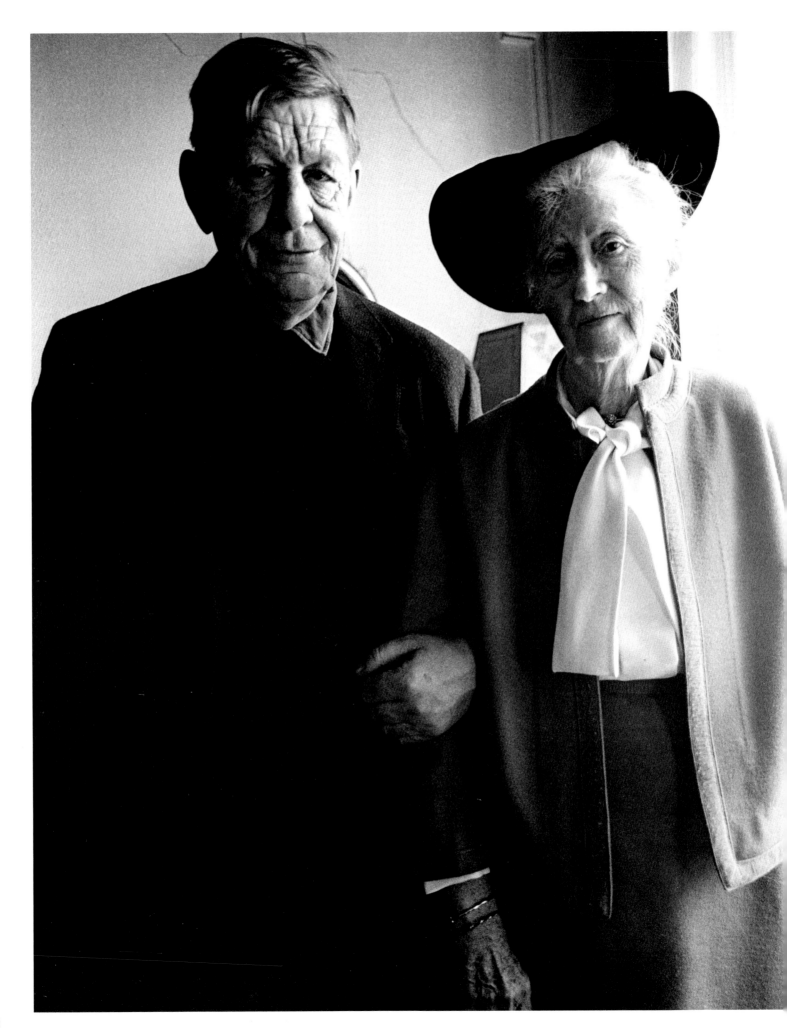

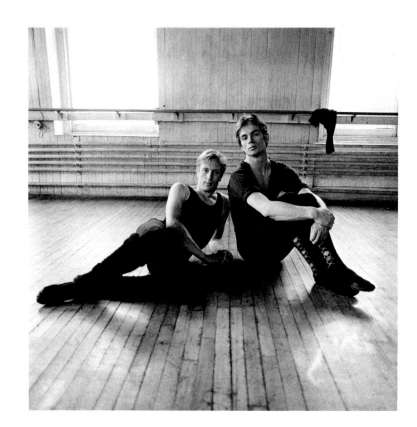

Erik Bruhn and Rudolf Nureyev >
in New York for the presentation
of an evening of their ballet pieces

Poets W. H. Auden and
Marianne Moore, friends for
twenty years, shortly before she
introduced his reading at
the Guggenheim Museum
in New York City

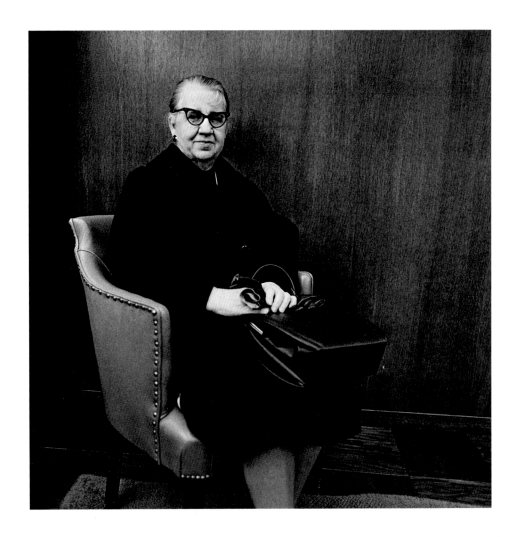

LEE OSWALD'S LETTERS TO HIS MOTHER
(WITH FOOTNOTES BY MRS. OSWALD)
Esquire, May 1964

Mrs. Marguerite Oswald, mother of the alleged assassin
of President John F. Kennedy

MILDRED DUNNOCK >
Unpublished, *Harper's Bazaar*, 1964

American character actress who appeared on Broadway
in *Richard III* and *Cat on a Hot Tin Roof*

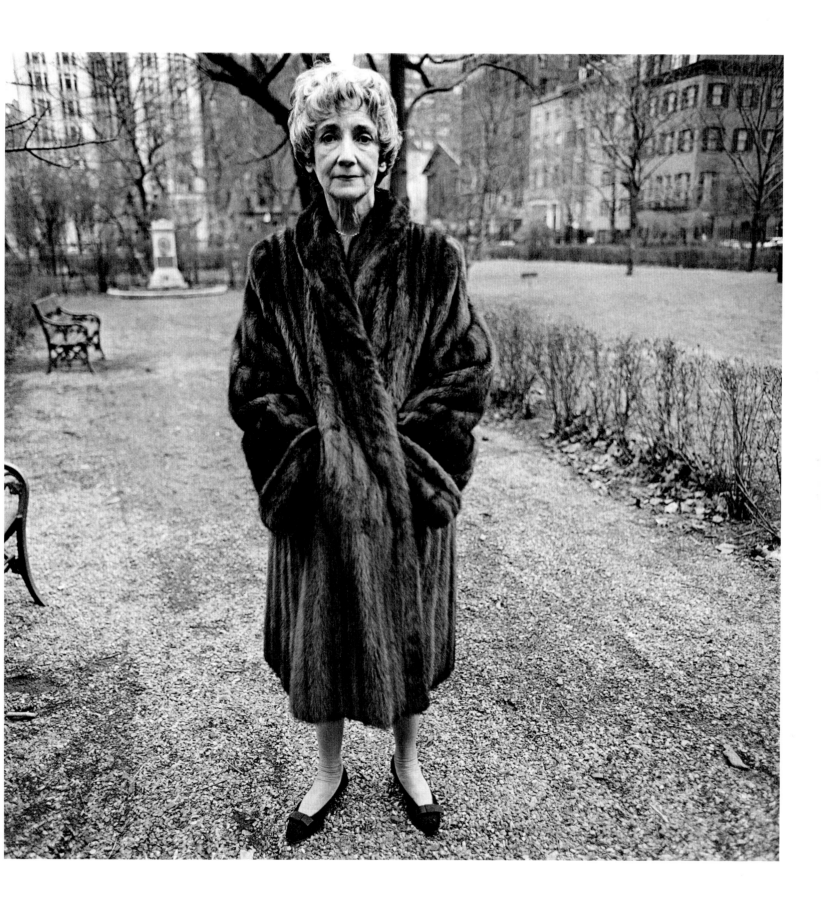

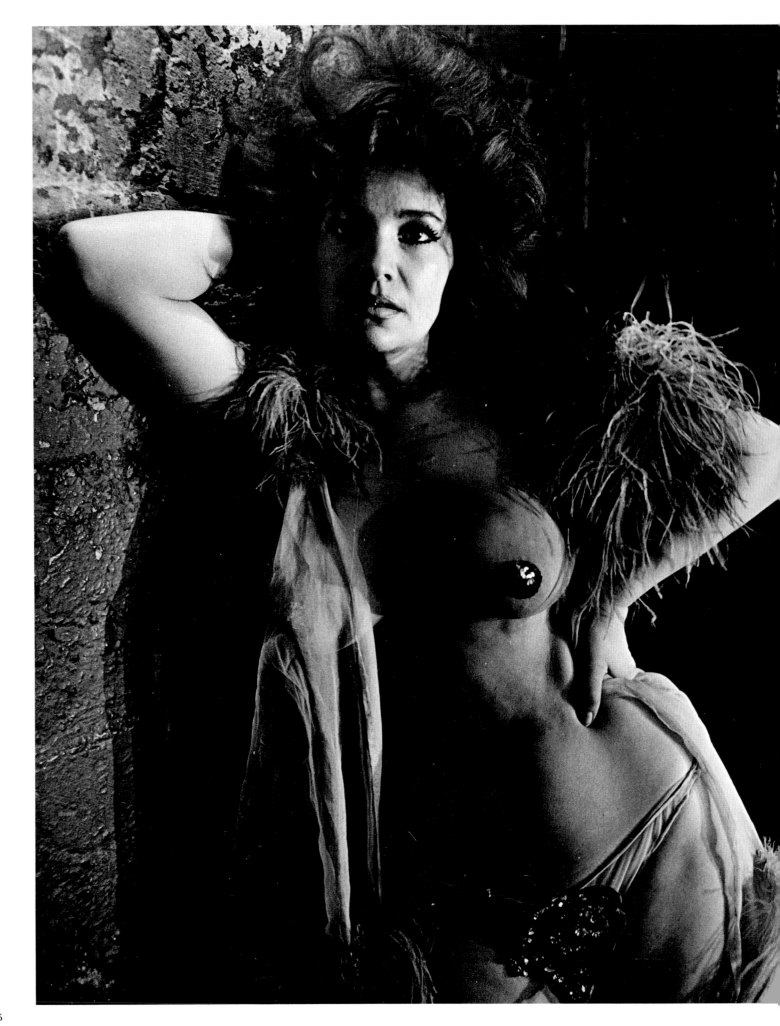

BLAZE STARR IN NIGHTTOWN
Text by Thomas B. Morgan *Esquire*, July 1964
A queen of burlesque and star of the Two O'Clock Club in Baltimore

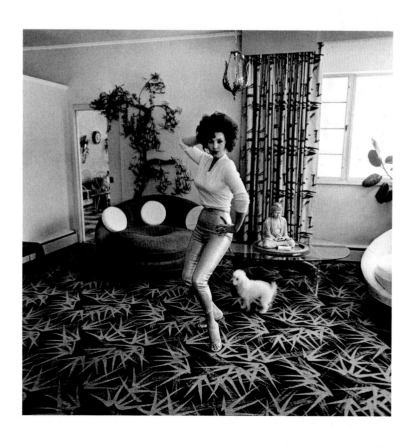

THE BISHOP'S CHARISMA

Text by Diane Arbus
Unpublished, 1964

And there appeared a great wonder in heaven—a woman clothed with the sun, and the moon under her feet, and upon her head a crown of twelve stars.

Revelation: 12

On a cliff overlooking the Pacific, in a cemetery in the sun, a small lady in damask robes with hair of a phosphorescent pink holds aloft a styrofoam cross encrusted with smaller crosses and raises her eyes till they pale at the vision of Jesus Christ. She is called Bishop Ethel Predonzan of The Cathedral Of The Creator, Omnipresence, Inc. Christ, she declares, has summoned her there to Santa Barbara, California, all the way from Astoria, Queens, to await His Second Coming on December 4th of this year.

I followed the Bishop across the country to hear her story and to listen to God's voice on a 45 rpm record, as he says to her: "I appeal to you for the future of this earth to lead the people, my dear. You are their Guiding Star. Do not fail Me now that I stand before you . . ." etc.

The Bishop's history is almost too long to remember. She vaguely recalls that she was a princess in ancient China, the wife of Moses, Bathsheba, and the daughter of Absalom, as well as the wife of King Solomon, who was not so wise as people think, she admits, because she often told him what to do. Later she was the twin sister of Jesus Christ, but died and became Mary Magdalene. She was Joan of Arc and Bernadette, too, but now she is Bishop Predonzan.

"I am the First Child of God," says the Bishop, "I am Firster than Jesus."

"When I was Bathsheba, the Pharoah's wife, Fatima, believed in me and their little boy was born paralyzed. In those days there was no telephones, only camels, but my Heavenly Father told me to go. Oh, what They make you do sometimes. We were millionaires and I was a Queen. We travelled by camel. I went to the boy and whatever I touched was healed, but I had only healed half the boy when they arrested me and put me in the lions' den. They came from all over to see me eaten by the lions who had been starving for several days."

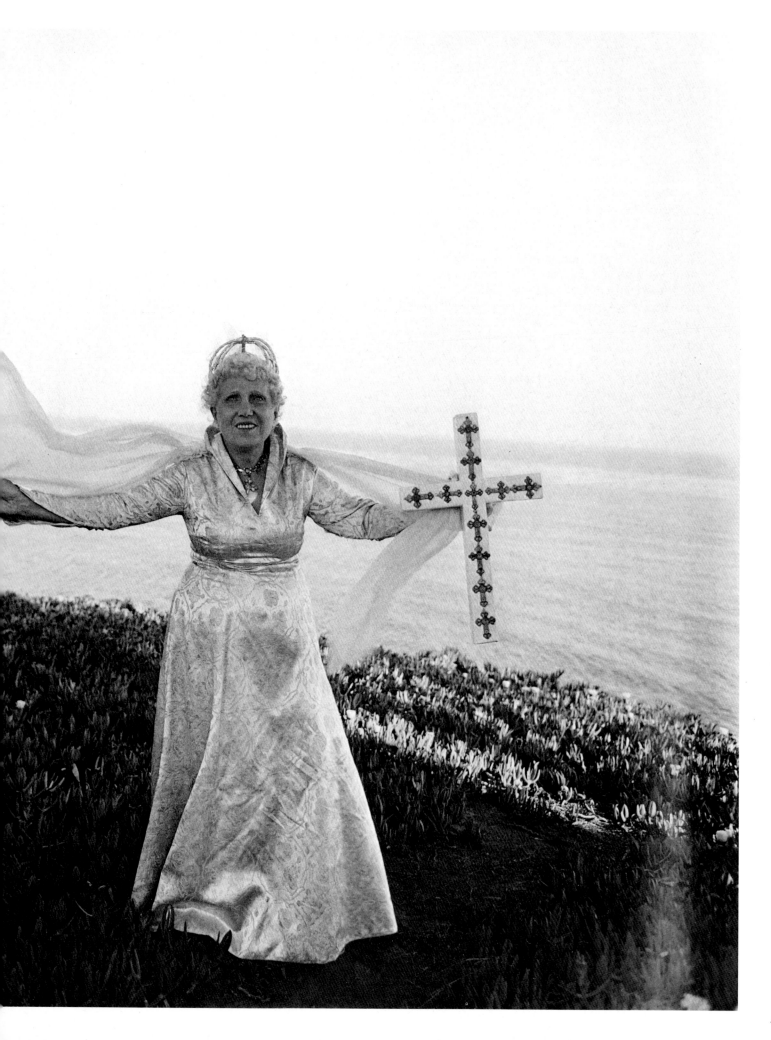

The Pharoah and Fatima appear to her now in Manifestation, says Bishop Predonzan. They kiss her robes and assure her that someday everyone will do likewise. George Washington appears on his birthday and St. Patrick on St. Patrick's day. She tells how Moses visited her one night and said, a bit querulously, "I know you're my wife and I love you and you've done wonders but why can't I come back too, just once?" Then he gave her three extra Commandments.

All her animals speak to her. She even taught her parakeet to say, "I love Jesus. I love The Father. I love the Angel Gabriel. I love The Bishop. I love Johnny. I love Victor." The latter two are her son and husband who have given up profitable jobs as motor vehicle bureau inspector and movie projectionist to follow in the Bishop's footsteps and record her Visitations. People from different planets visit her. The ones from Saturn have no ears, only a hole in the head and very short legs. Sometimes when she is walking on the street she sees people who suddenly disappear.

At nine o'clock every morning and evening the Bishop prays for the whole World.

"The Sun is my Power," says the Bishop, "I am the Pipe of the Sun." And I have seen her stare into it, unblinking, for the longest time, her face all radiant, her eyes pale and uncanny as if they were too full of light; her cup seems indeed to run over. As Caesar is reputed to have said, "This child has got The Light in the eyes."

"I see wonders," she says, "I have seen two moons."

The Bishop says that she can see God's face inside the sun or at night in her room. He looks like His Son, she says, and He is big, covering half the ceiling over her bed. Sometimes she wakes and sees a sort of luminous lava all over the place and lights shining everywhere on the ceiling and the walls. "My God, my God," she says as she remembers, "millions and millions of little cupids all through the rooms. I walk through the lights. They are vibrating . . . all different colors, packed like the sand, all lights." She sees emeralds and diamonds in the air, wonders of gold and jewels, and fluorescent lines crisscrossing everywhere like a great web in the sky. When God comes, the Bishop says, He speaks to her. He takes her inside His robes and holds her in His arms.

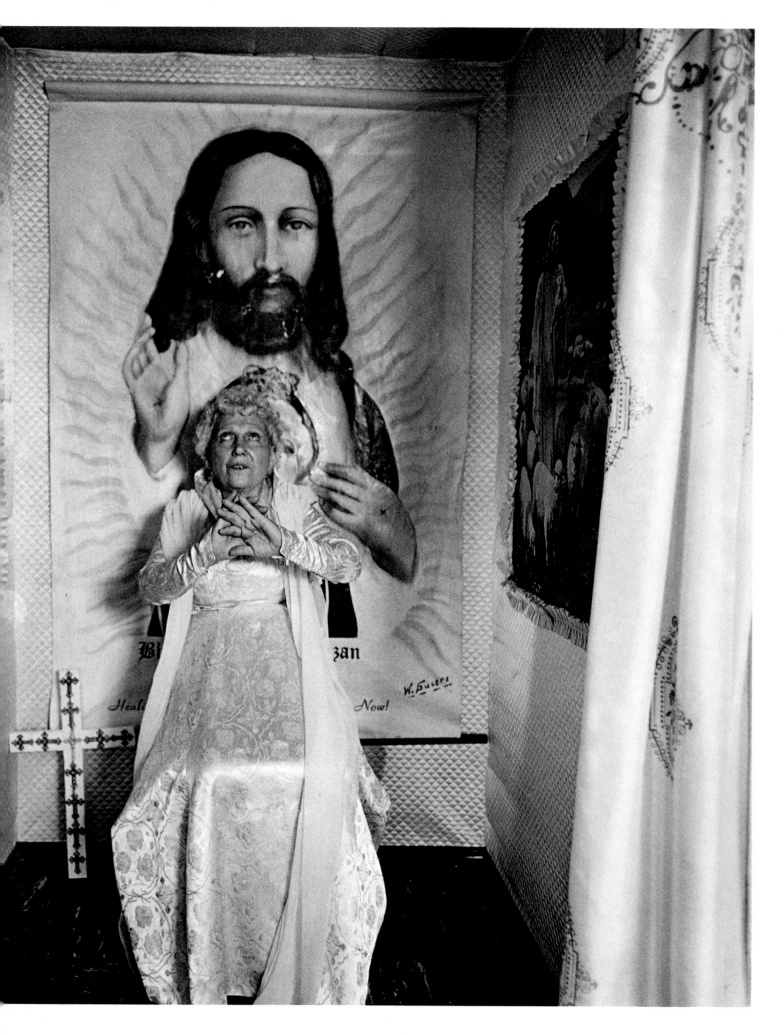

"He has a gorgeous voice," she says. "What a diction. There is no one on this earth that can speak the diction of The Father and Christ."

Sometimes while the Bishop is talking, a strange sound interrupts her speech. This is how Jesus kisses her in the throat, she explains, blissfully, "like a butterfly." Occasionally, she relates, He tells her: "I am going to fly with you tonight. You must be pure like a glass of water." And then He comes, she says, His wings like a hurricane, and takes her to the Heavens ("Ooooooh, what a feeling"), to the different planets. "My Lord, my Lord," she cries out to Him, "I'm going to fall," but He touches something in the back of her neck and she is no longer afraid.

Bishop Predonzan has written 1600 pages of a Bible which comes to her by Divine Dictation.

She says she has cured incurable diseases and healed thousands of people, even over the telephone. Many movie stars depend on her although they prefer to remain anonymous. Her numerous fur pieces of Ermine and White Fox are the gifts of grateful people she has restored to health.

"I'm never going to die," says the Bishop, "I'm going to live forever."

And when Christ comes on December 4th she promises that we will be granted Eternal Life too. The animals will speak and there will be nothing but Peace. The mountains will go into the sea and only the worthy will survive, but they will survive forever. The Bishop will be beautiful and young (about fourteen years old) and she will sing like an Angel.

"People are terrible," she says, "they never believe nothing." Neither the Pope nor the President answered her letters. It is true, she admits, that Christ was going to come once before, in 1957. But everything depends on cadence and vibration, she explains. Conditions were too negative. If He had come the world would have disintegrated, and so He told the Bishop, "I couldn't make it, My Child."

"I'm only crazy for God," the Bishop says, and if Christ does not come this time no doubt she will wait till He does.

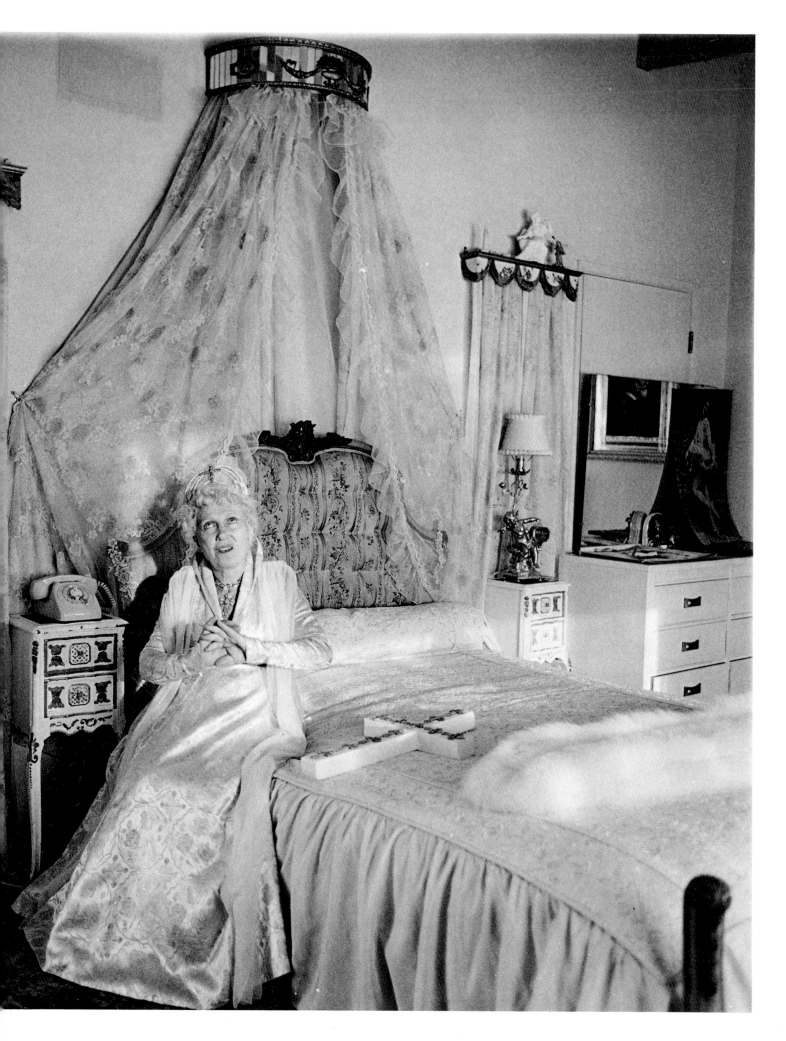

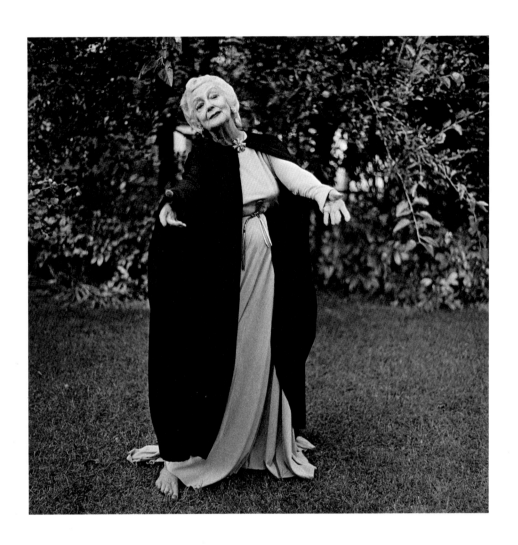

RUTH ST. DENIS
Unpublished, *Harper's Bazaar*, 1964

Pioneer of American dance

NEVERTHELESS, GOD PROBABLY LOVES MRS. MURRAY.
YEAH, BUT IT'S ONE NATION UNDER *NOTHING*, SAYS SHE,
WITH HONESTY, HONEST, HONEST FOR ALL.
MADALYN MURRAY WEARS NO GIRDLE >
Text by Bynum Shaw *Esquire*, October 1964

Madalyn Murray, the atheist who fought against prayer in public schools

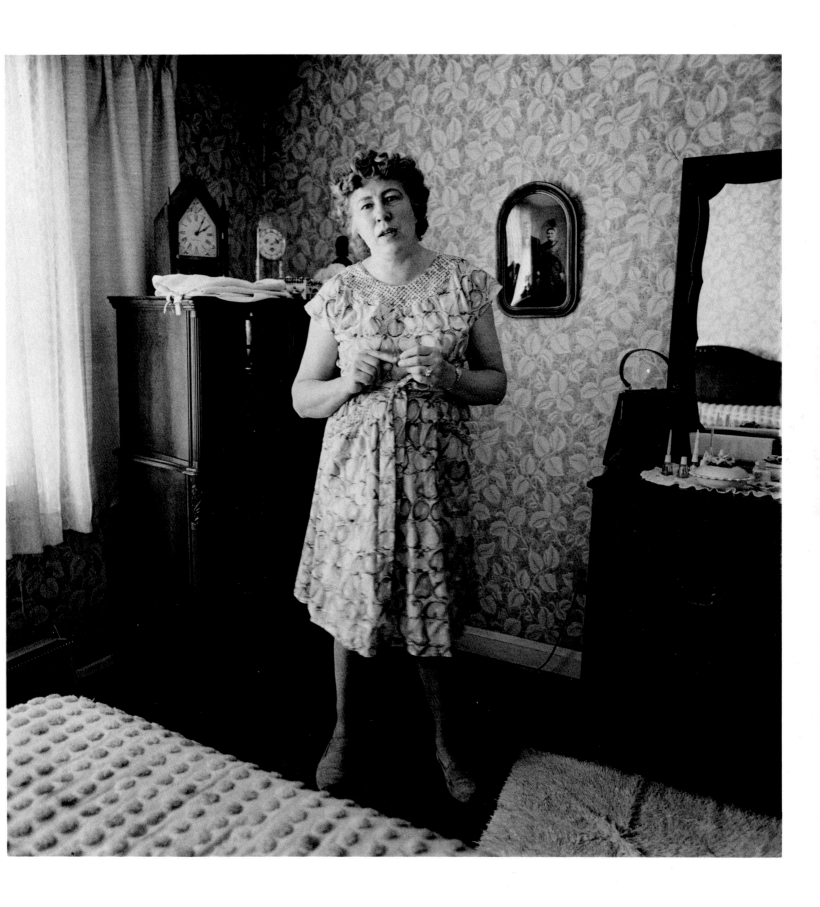

55

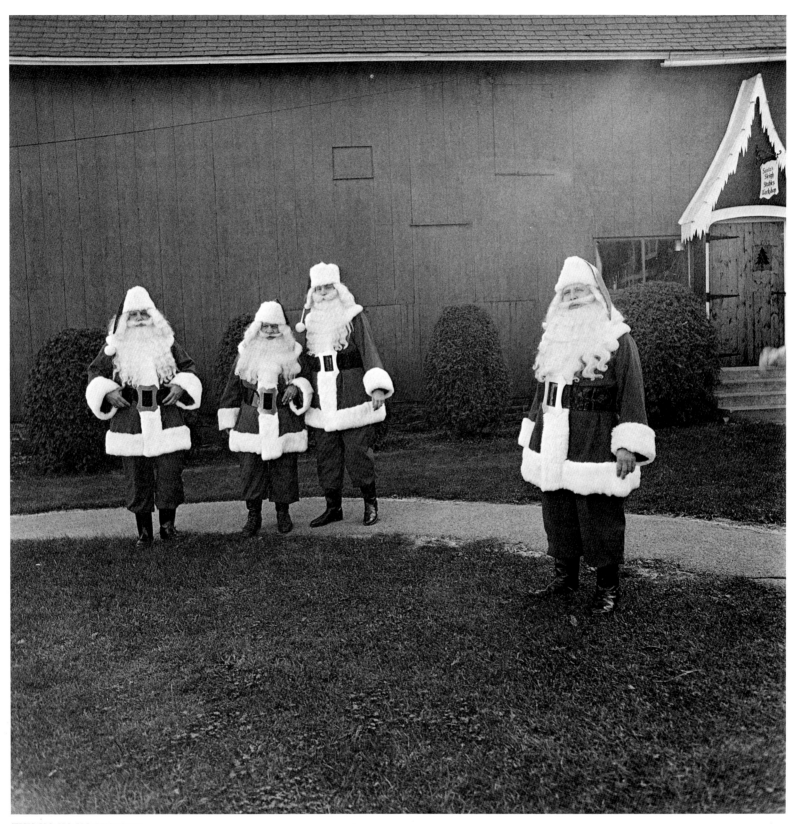

THIS HO-HO-HO BUSINESS
Text by Alan Levy *Saturday Evening Post*, December 12, 1964

Student santas attending the twenty-eighth annual
Santa Claus School in Albion, New York

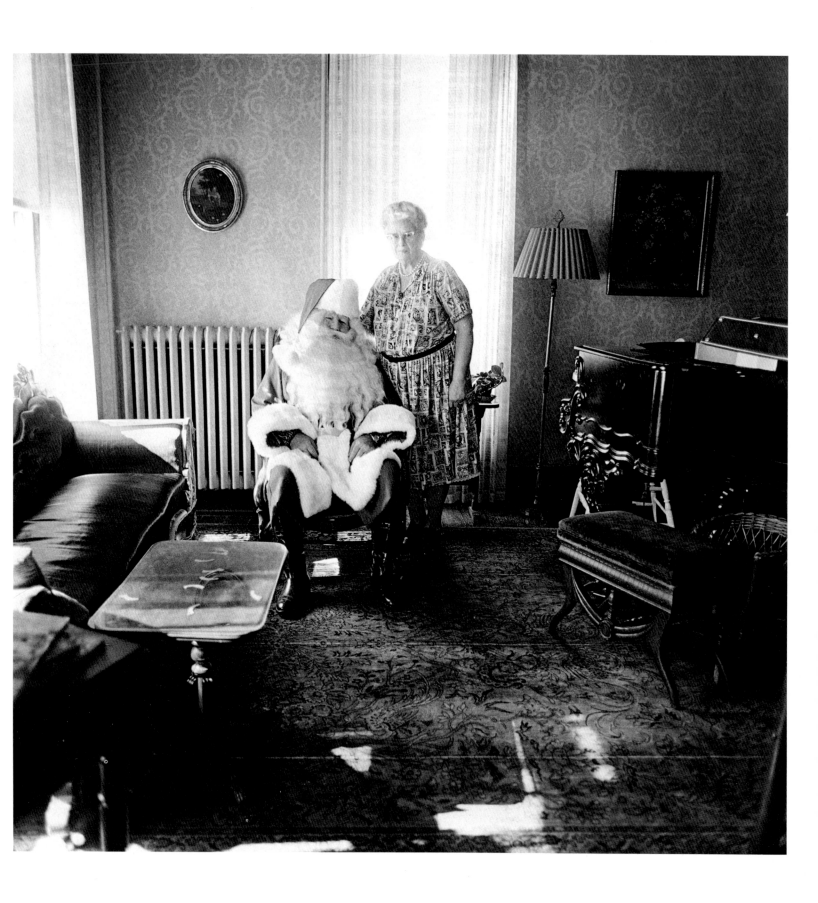

MAE WEST: ONCE UPON OUR TIME

(Published as EMOTION IN MOTION)
Text by Diane Arbus *Show*, January 1965

On her seventy-first birthday Mae West feasted on a rhine-stone-studded birthday cake. She is as Mae West as ever. Nourished by her own legend, she has outlasted every lover and initiated a nation of boys into manhood. A little poem children used to recite in the streets may indeed have foreshadowed the changing mores everyone so deplores and enjoys:

> Mae West
> Half undressed
> Come up and see me sometime
> And I'll show you the rest.

But her fortress is almost as impregnable as Sleeping Beauty's. There is a high fence surrounding her villa by the sea in Santa Monica, a broken telephone at the gate and a sign saying Beware Of The Dog beside the bell although there is no dog to beware of. Beyond the overgrown garden, across the gilded living room, among the nude likenesses of the mistress of the house, a pair of wild Woolly monkeys strain at their chains on a trapeze in the corner. Toughy and Pretty Boy are as restless, importunate, and noisy as cannibals, as unhousebroken as can be all over the carpet. Her secretary, a timid man in his shirtsleeves, says that Miss West is in bed. The butler, a charming Puerto Rican boy called Grayson, solemnly serves a ham sandwich to pass the time. Mr. Paul Novak, her splendidly muscular good friend, reassures the monkeys, who have eaten something which disagreed with them and are annoyed by the presence of a stranger. When you think that for over half a century a legion of young men have stormed this citadel, it is a tribute both to them and to her. She has been called a Queen Bee whose favors leave strong men limp. Some say that she is the greatest female impersonator in the world. It is rumored that she has nine million dollars in the bank and her paternal grandmother is said to have possessed three well-formed breasts.

But when at last you come up and see her you know you are in the presence of a lady. Resplendent and familiar, she smiles between her superb teeth and rolls her eyes heavenward. She might have been describing herself when she wrote of Diamond Lil in her novel of the same name:

> Her eyes were large cool blue ponds, her hair was yellow as maize and she wore it in an astonishingly lovely style of her own. . . . Her waist was like the stem of a wine

glass. . . . A blonde satin dress hugged her corseted hips like a lover. . . . On her fingers and wrists was a profusion of diamonds all calculated to blind the percipient male, who hesitated between sins of commission and omission, into thinking that fornication was a virtue. No masculine eye could travel from the crown of that spun-gold head past those vermilion-tipped peaks of breasts down to those curling rose-petal toes without being conscious of a physical change.

Better yet, she is imperious, adorable, magnanimous, genteel and girlish, almost simultaneously. There is even, forgive me, a kind of innocence about her.

It is as if she had been in that radiant white satin bedroom forever. Like Goldilocks, she has a choice of beds: a square one in the boudoir and a round one in the bedroom. ("Isn't it gorgeous?" a gentleman caller murmurs confidentially. "Just like a wedding cake.") But, as Mae says in her autobiography, "I have never been able to sleep with anyone. I require a full-size bed so that I can lie in the middle of it and extend my arms spread-eagle on both sides without their being obstructed."

"Sex," says Miss West, "is an emotion in motion. . . . Love is what you make it and who you make it with."

She has made it so well that she seems never to have suffered or yearned or pined like most people do, in the tradition of the love song. She is an unmitigated optimist. ("I saw the pattern of my relationship with the male sex that was to recur throughout my life, where the one becomes the many, and without so much as having to lift my voice. This is not ego saying this; just a fact.")

"Men are my kind of people," she says. "I want them absorbed in me. . . . I was once asked what ten men I'd like to have come up and see me sometime. Why ten? Why not a hundred, a thousand? Not all at once of course. The delightful possibilities stagger the imagination. . . . I always remember their faces. Their names aren't too important. . . . The man I don't like doesn't exist. . . . They were all inspirations to me. . . . Each one is different: the way they sigh, the way they moan, the way they move; even the feel of them, their flesh is just a little different. . . . There's a man for every mood. . . . Not all men come to love fully trained or prepared. Just as one important woman in their

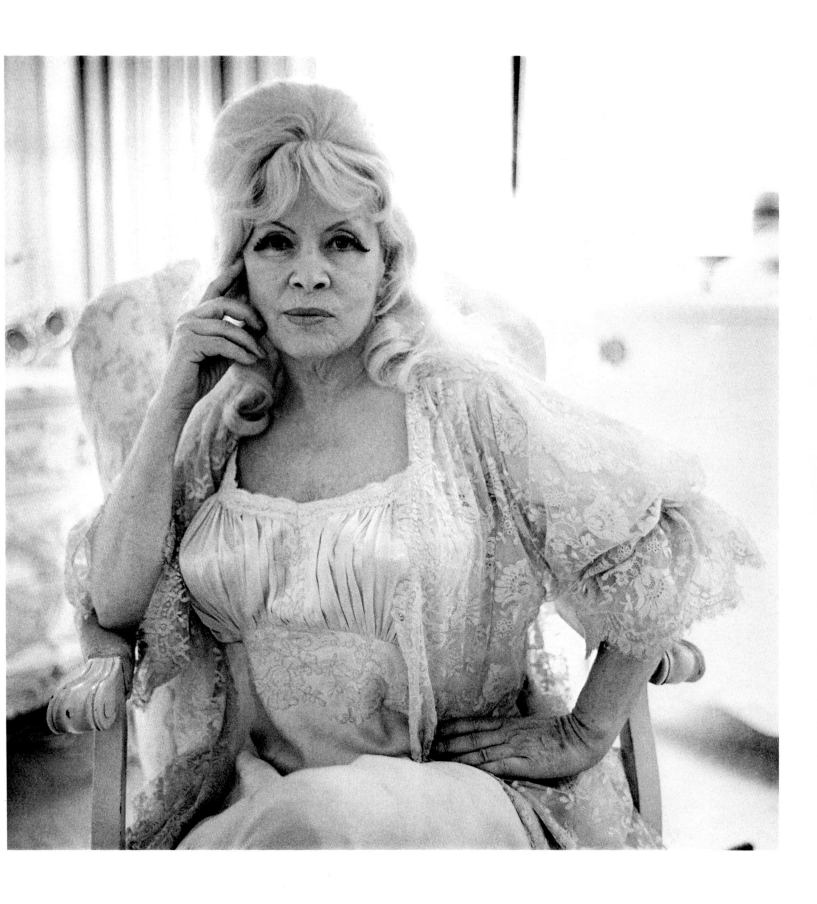

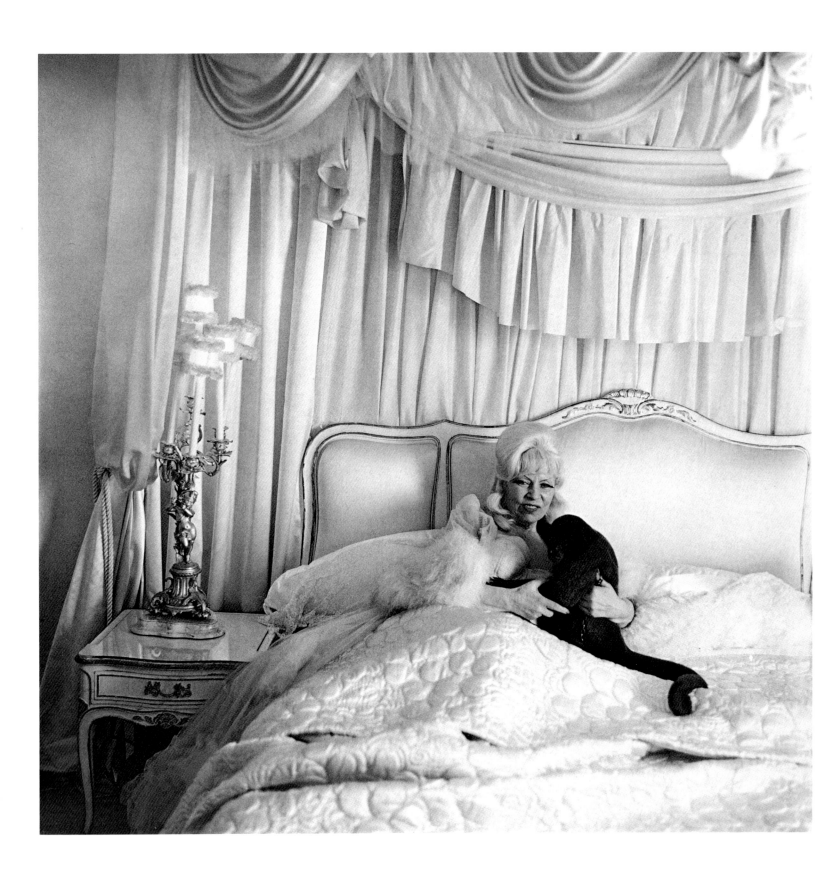

life is their mother, the other can be their teacher. I have found men who didn't know how to kiss. I've always found the time to teach them."

"Sexy Mae," she sometimes calls herself appreciatively, and runs her fingers across her own topography. "I am the first one to use the word in its pure sense in public. I invented the gestures," she says, making them. "I am the original Sex Symbol. The others are counterfeit." When she was sick with a virus infection about a year ago the doctors x-rayed her chest and found this little thing . . . an extra thyroid gland . . . and called in a specialist who said it was remarkable. Perhaps it accounts for everything.

"Too much of a good thing can be wonderful," and Miss West remembers with something like awe the man with whom she spent her most memorable fifteen hours. "He was," she says, "twenty-six men in one night."

Anyone can see that marriage would not become her, although she tried it once, ill-advisedly. "But we must have marital fidelity or we wouldn't have nothing," and she offers a few words of advice: "You've got to guard your sex interest . . . watch over it like a business. . . . The best way to hold a man is in your arms."

"Have you ever had a famous lover, Miss West?" I asked.

"You mean famous men who have been my boy friends? Well," she replied, "there was a famous writer who lived in England. I can't recall his name."

"Dylan Thomas," I suggested, "or Somerset Maugham?"

"No. He was a vegetarian and at a press conference the reporters asked whether his diet hadn't affected his virility. 'I only know,' he answered, 'I've always had a terrific desire to kiss Mae West.' What was his name?" she murmured to herself as she rang for the butler and asked him to ask the secretary who was the famous writer who had always had a terrific desire to kiss Mae West. And after a moment's consultation in the pantry the butler emerged and said, "George Bernard Shaw."

Although Mae's mother could hardly have foreseen her daughter's destiny she seems to have groomed her for it from the start. "Dear," said Mrs. West to little Mae a long time ago, "I want you to know the difference in men." Mrs. West called her "dear." "Open the door, dear," she'd say be-

cause Mae wouldn't open the door unless she was asked in a nice way. Mrs. West prudently avoided teaching her daughter to cook but taught her so well to abhor drunkenness, vulgarity, and cigar smoke that she abhors them to this day.

In her teens Mae began to take special care of her breasts. Someone told her that the painter Degas called breasts "the eyes of the torso," so she regularly massaged hers with cocoa butter every night and sometimes in the morning.

She has always been careful of her health and shown a marked preference for strong men. Whenever possible she likes her boy friends to have a blood test in advance. Once she asked a handsome man she was beginning to fancy if he would go and get a test. He was delighted because he thought she meant a screen test.

Mae has her own way with the language. She might be called the mother of the double entendre. Once she was banned from the radio because of the way that she said to Don Ameche in a play about Adam and Eve, "Would you, honey, like to try this apple sometime?"

Her monkeys adore her and try to mimic everything she does. "You know how it is," she says, "sometimes you're just fooling around and you take a rubber band between your teeth and pull it out with your fingers and strum. . . . Well, the monkeys do that too."

Every night she comes down to dinner on Mr. Novak's enormous arm, looking suddenly fragile by candlelight in a peach or apricot satin nightgown, and takes her seat like the Queen of a mythical kingdom before a place which is set, according to some mysterious protocol, with two paper napkins, one on the left and one on the right.

But the world of Mae West is not entirely physical. Her psychic eye has been opened. She has seen visions: a hundred faces in a circle, the faces of old friends come back from the spirit world. And she has heard voices: once a little angelic voice which sounded in her inner ear, saying, "Good morning, dear," and another time a deep rich masculine voice in her solar plexus uttering phrases from another century, like THEE and THOU. "I don't know what He was talking about," she says, but she knew who He was. "I knew that in some marvelous way I had touched the hem of the unknown. And being me, I wanted to lift that hemline a little bit more."

Mr. and Mrs. Howard Oxenburg

Mr. and Mrs. Armando Orsini

Robert Shaw and Mary Ure

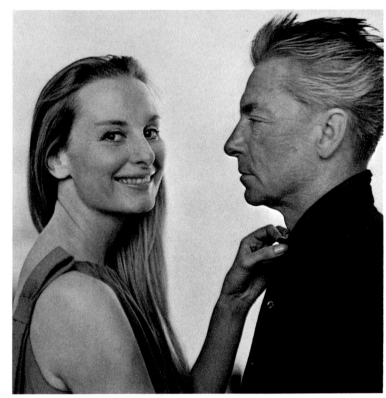

Mr. and Mrs. Herbert Von Karajan

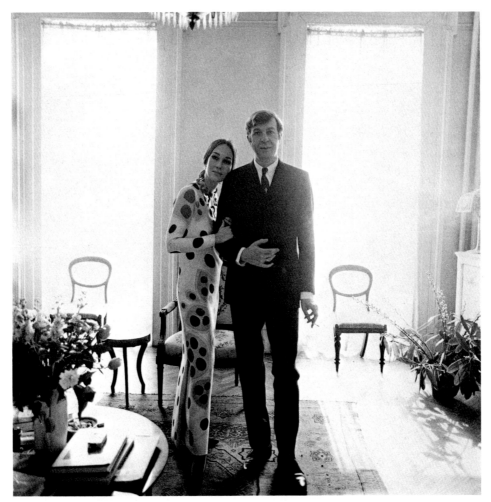

John Gruen and Jane Wilson

FASHION INDEPENDENTS: ON MARRIAGE
Harper's Bazaar, May 1965
Distinguished couples and their personal style

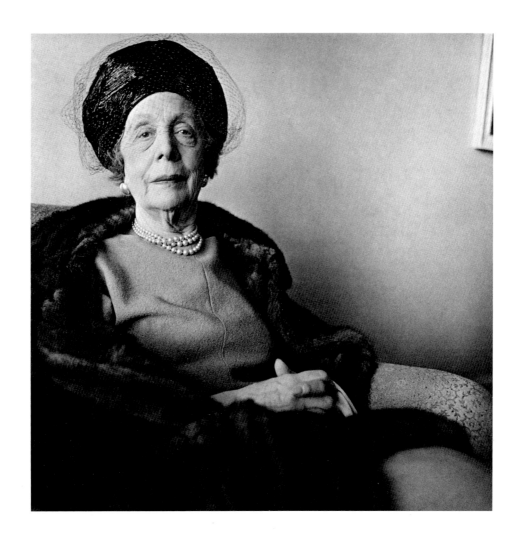

DAME EDITH EVANS
Unpublished, *Harper's Bazaar*, 1965

English film actress

MARCEL DUCHAMP >
Unpublished, *Harper's Bazaar*, 1965

Expatriate French Dadaist and his wife Alexina Sattler,
at home on 14th Street in New York City

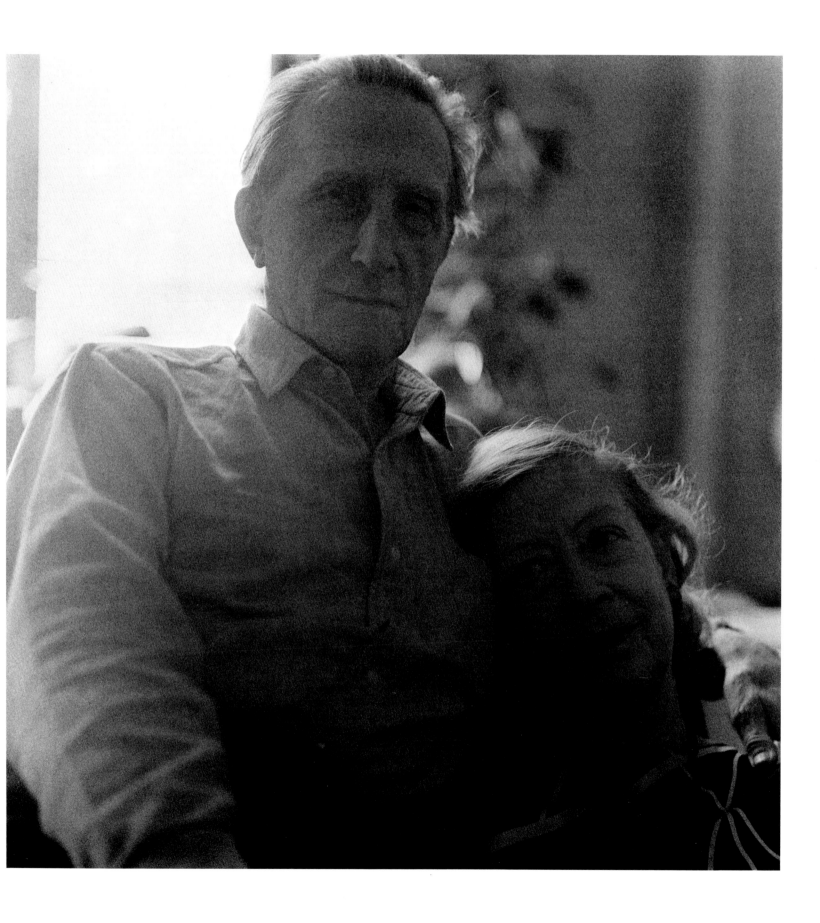

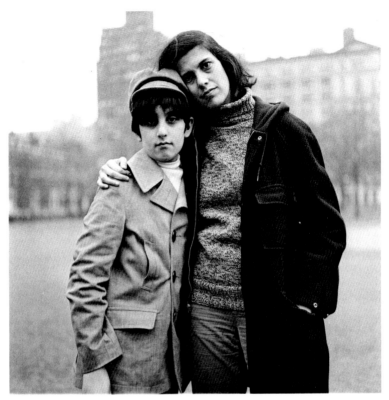

Writer Susan Sontag with her son, David

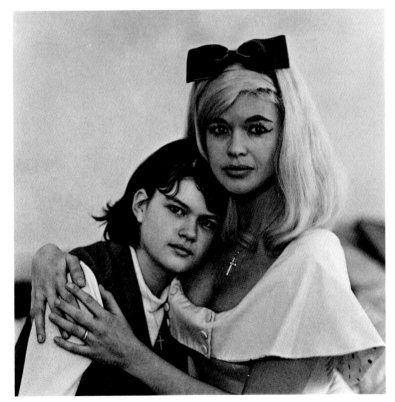

Jayne Mansfield Climber-Ottaviano, actress, with her
daughter, Jayne Marie

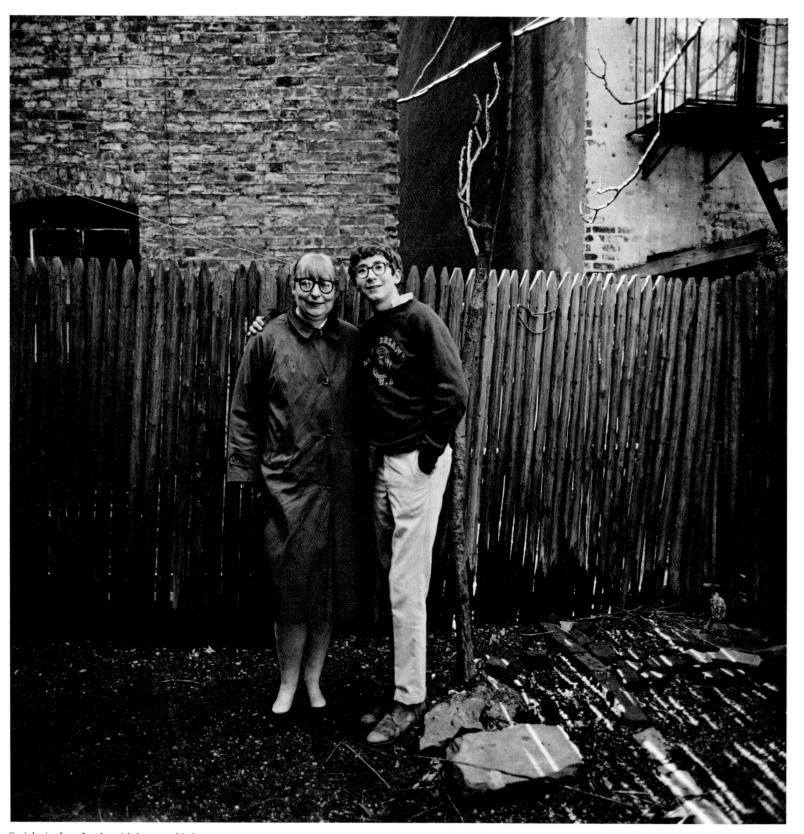

Sociologist Jane Jacobs with her son, Ned

NOTES ON THE NUDIST CAMP

Text by Diane Arbus Unpublished, 1965

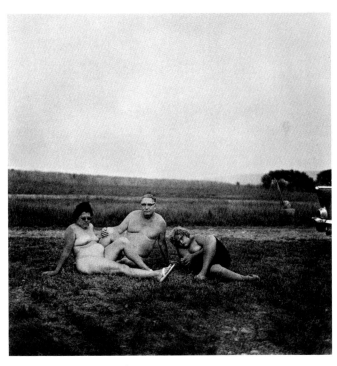

NOTES ON THE NUDIST CAMP
Unpublished, *Esquire*, 1965

The people down there
All run around bare
And they don't care
Who sees their hair
They do expose themselves
To the air
Because they believe
That is only fair . . .
—sung to the melody of "La Donna E Mobile," from a camp operetta

There is not much to it, you might say. It's like walking into an hallucination without being quite sure whose it is.

By prearrangement, the Camp director met me at the bus terminal. We recognized each other by the clothes we wore. "Are you aware," he asked, as he drove the several miles to Sunrise Haven, "that you have come to a nudist camp?" He explained that it was a clean way to live. He wasn't, he assured me, trying to tell me that the human body was necessarily beautiful but that there was something clean about it. And it wasn't a matter of fanaticism: when it got too cold, they got dressed.

There was no gate, just a dusty side road through the woods, marked by the statue of a small nude man and woman, and a sign welcoming guests and warning trespassers. Further on, the road divided and circled around the ragged volley ball clearing, the screened cafeteria, the sandy path to the lake, passing a couple of outhouses, a few tents, clusters of immobilized trailers, rows of rudimentary cabins, several rustic bungalows, lots of cottages with picket fences, and some fine suburban homes. The first man I saw was mowing his lawn.

This is a family sort of camp. Single men are theoretically not allowed, although some seem to have got around this rule by divorce or widowerhood. Some people live here all year round and own their homes and have jobs in nearby towns. Others have retired here or come every weekend or for their summer vacation or visit occasionally or stay overnight or merely spend the day to get away from it all. If

you are a member of one of the two national nudist associations you can travel across the country spending each night in a different nudist camp. For many of these people, their presence here is the darkest secret of their lives, unsuspected by relatives, friends, and employers in the outside world, the disclosure of which might bring disgrace. Everyone is known by their first name. Helen and Bill and Al and Betty and Hank and Gracie and Harold and Dot and Ted and Edna might, like the characters in a soap opera, turn out to be teachers or beauticians, policemen or burlesque strippers, electricians or musicians or ministers. One man said that when he meets someone in camp he plays the game with himself of imagining clothes on them and guessing their walk of life. Everyone is very pleasant and polite. When two naked people encounter each other they don't just pass right by, they smile or shake hands: "hello Joe," they say, and something about the weather and how it feels to be nude. But most people are not entirely nude. Some ladies wear beach hats or sunglasses or wedgies and curlers or earrings and pocketbooks. In the cafeteria the teenage waitresses wear organdy demi-aprons. Some men have on only a wristwatch, or shoes and socks with their cigarettes and money tucked into their socks for safekeeping. Sometimes you see someone wearing nothing but a bandaid or a pencil behind their ear or walking a dog on a leash. Nudists aren't purists. Occasionally they even feel the impulse to slip into something more comfortable. One little boy asked for clothes for his birthday, and once when a lady's house caught on fire, she asked the firemen above all please to save her fur coat.

Everyone is very hospitable. The chairs and sofas in the parlors often have towels spread out over the upholstery for people to sit down on. The pictures on the walls are mostly nudes, the flowers in the vases are mainly plastic, and the magazines on the coffee tables are largely girlie. Often in the evening, friends gather to play cards, drink orange pop, and watch TV together.

It is a good life. You turn one color all over in the sun and the water feels fine. Everyone leaves their cares behind. It's a little like heaven. Oh, sometimes the gas meter man arrives to see how much is owing, or strangers peer through fieldglasses as they putter past in their speedboats on the lake, or the cops have to be summoned to arrest a peeping Tom. But that isn't so bad. Sometimes there are problems about local boys coming to court the teenage girls and look around, or arguments about who is boss, but things usually straighten themselves out. There is always the possibility that negroes will try to get in, but for the most part they seem satisfied with their own nudist camps, and, as some joker is sure to point out, "How can they get a tan, anyway?"

Nudists are fond of saying that when you come right down to it everyone is alike, and, again, that when you come right down to it everyone is different. As one man put it, no one is a hundred percent perfectly formed. You get so you recognize people by their bodies instead of their faces. If a nudist man asks a nudist lady, flirtatiously, "How old would you say I am?" it is even harder to answer than if they both were fully clothed. Everyone says sex is not a problem in a nudist camp. As one man said, "It's what is left to the imagination that is obscene. Here nothing is left to the imagination." As another man put it, "Let's face it . . . most people don't look so good."

The two grounds for expulsion from a nudist camp are staring too hard and getting an erection.

Sometimes you begin to wonder. There is an empty pop bottle or a rusty bobby pin underfoot, the lake bottom oozes mud in a particularly nasty way, the negroes are not there, most people don't look so good, some guy asks, "What kind of bees give milk?" and answers, "boobies," the outhouse smells, the woods look mangy. It is as if way back in the Garden of Eden, after the Fall, Adam and Eve had begged the Lord to forgive them; and God, in his boundless exasperation, had said, "All right, then. *STAY*. Stay in the Garden. Get civilized. Procreate. Muck it up."

And they did.

FASHION INDEPENDENTS: MRS. T. CHARLTON HENRY
Text by Geri Trotta
Harper's Bazaar, July 1965

Mrs. T. Charlton Henry, fashion luminary, in her
Chestnut Hill home in Philadelphia

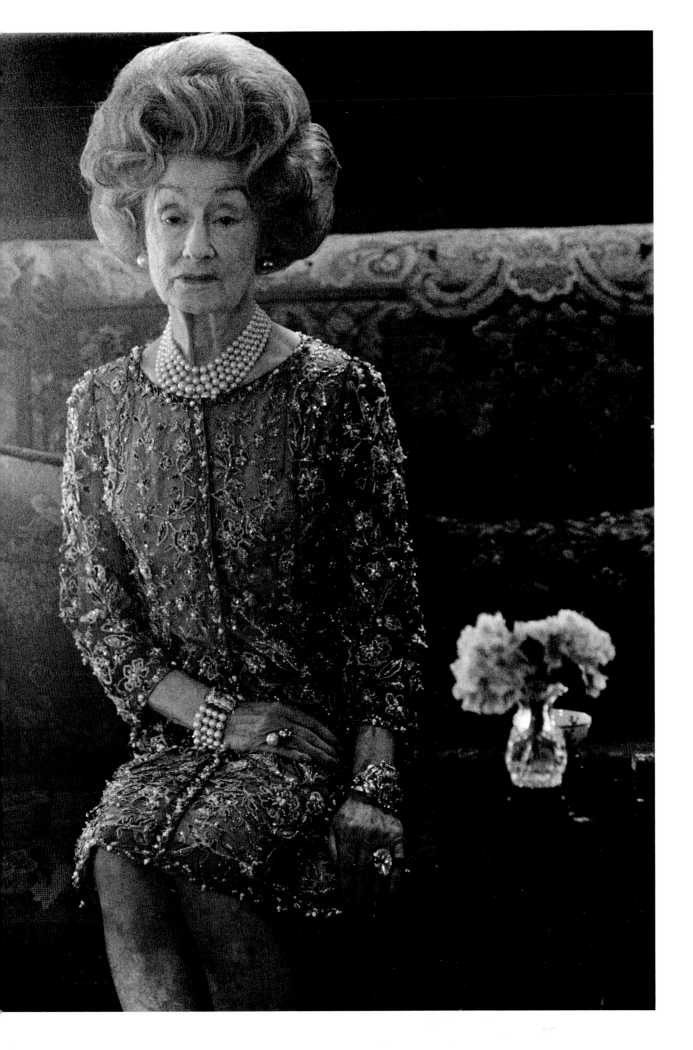

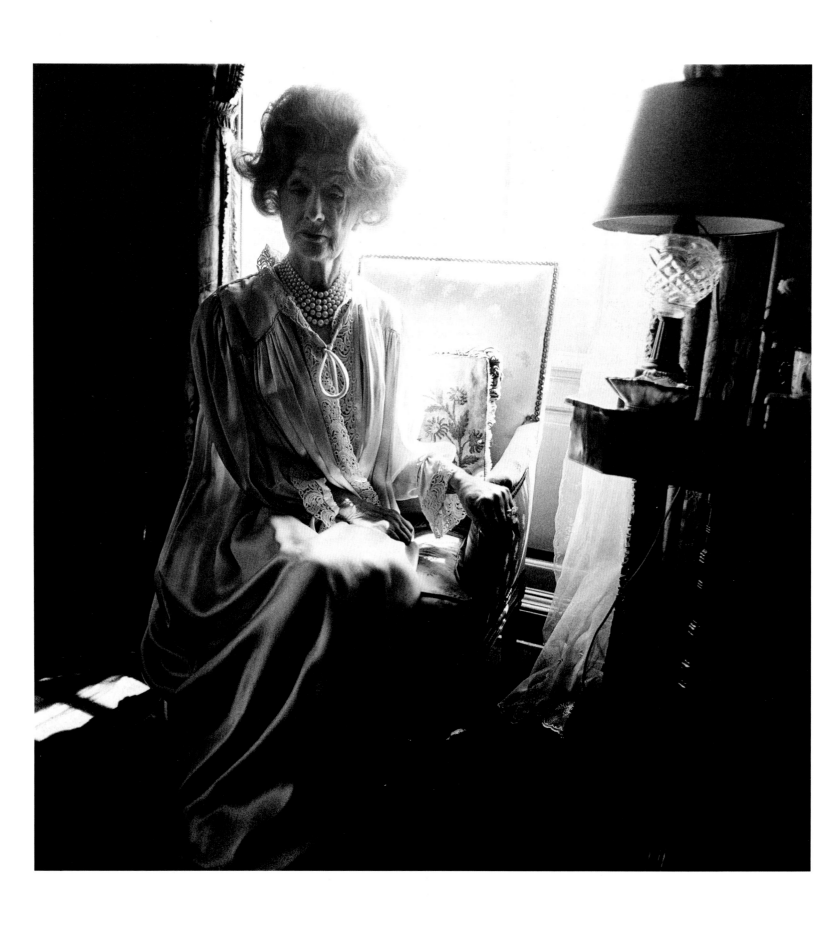

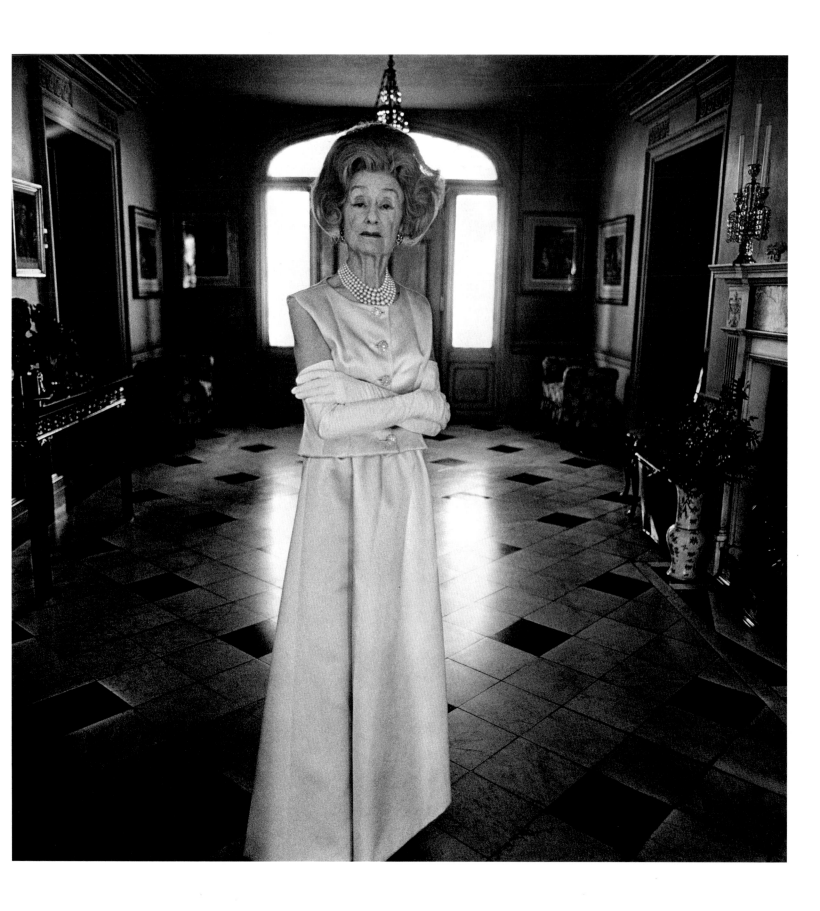

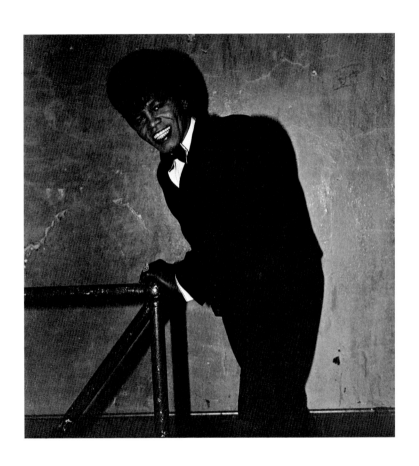

JAMES BROWN IS OUT OF SIGHT
Text by Doon Arbus
New York: The Sunday Herald Tribune Magazine, March 20, 1966

The King of Soul, backstage at the Apollo Theater in Harlem

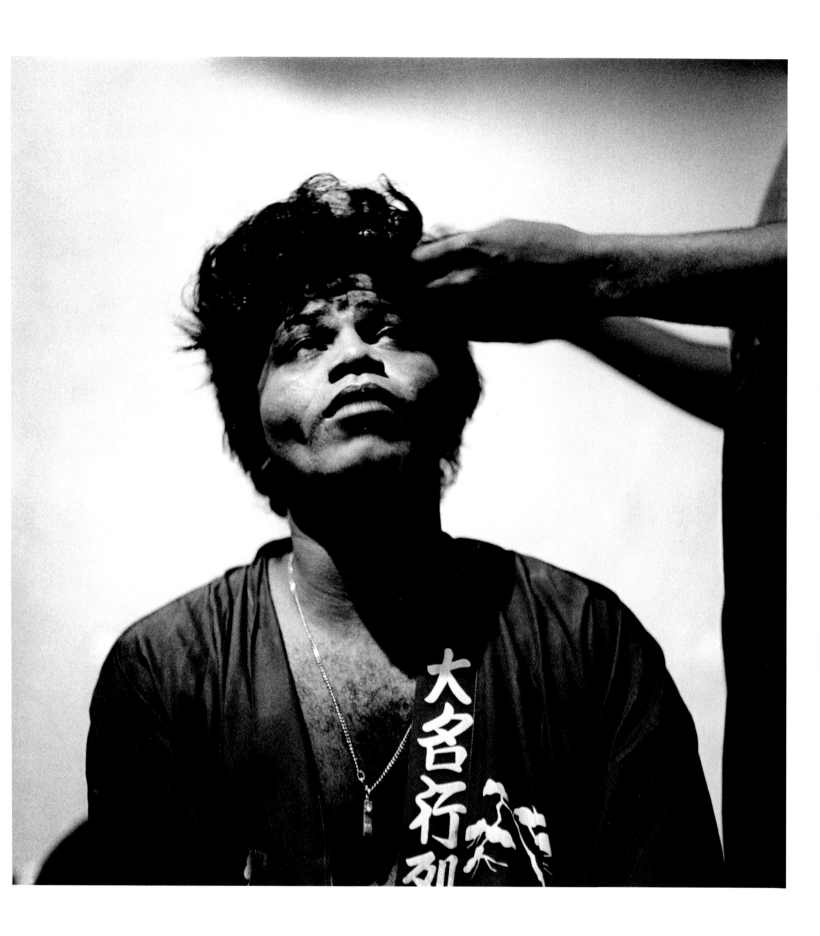

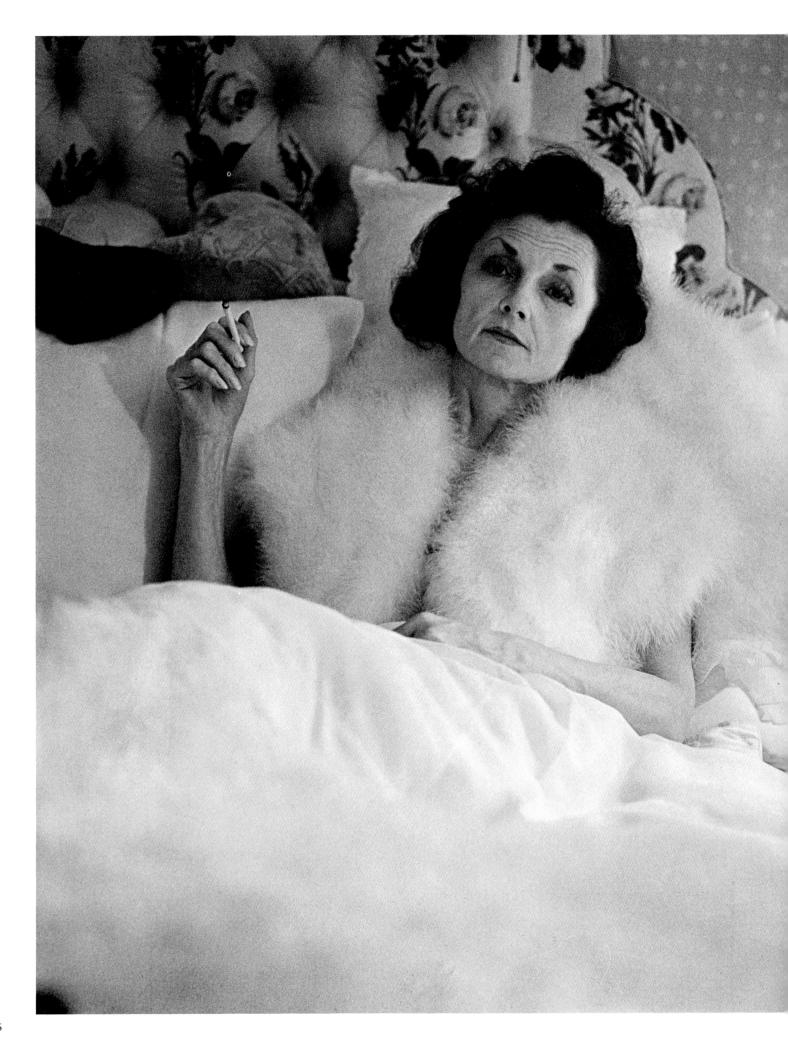

THE GIRL OF THE YEAR, 1938
Text by Bernard Weinraub *Esquire*, July 1966

Brenda Diana Duff Frazier, twenty-eight years after she appeared on the cover of *Life* magazine as the most famous debutante of the year

GERARD MALANGA
Unpublished, 1966

Poet and member of Andy Warhol's Factory

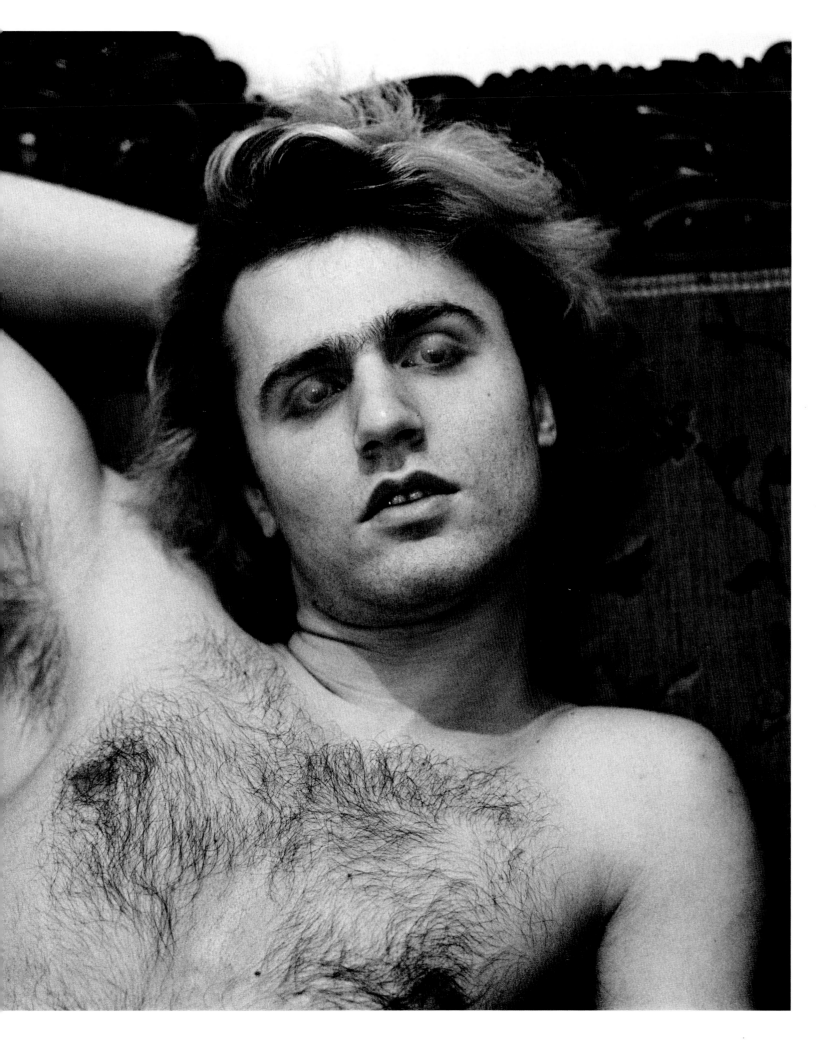

HUBERT'S OBITUARY

OR THIS WAS WHERE WE CAME IN

Text by Diane Arbus Unpublished, 1966

Someone told me a story about an inveterate liar and I didn't know whether to believe it. It's the same with what I am about to tell you. Above all, I do not want to make you cry.

But it used to be that if, as your mother would say, you didn't know what to do with yourself, you would do it at Hubert's Museum. You'd go along that unmitigated 42nd Street to the Penny Arcade, past the scholars in the Shooting Gallery to the rear where you'd pay what once was a dime—that's why it was called a Dime Museum until it became a quarter or fifty cents—and descend, somewhat like Orpheus or Alice or Virgil, into the cellar which was where Hubert's Museum was.

Coming into the unholy fluorescent glare of it you'd see yourself dwarfed and fattened and stretched in several distorting mirrors and all around you like flowers a thousand souvenirs of human aberrations, as if the world had quite literally stashed away down there everything it didn't need. Coming Attractions it would say under the posters, New Acts, Next Week, Weird, Unusual, Primitive. Many of them were not exactly Coming Next Week like it said for the very good reason that they had already gone to a Far, Far Better Place. These were the Great Ones who had been there during Hubert's Forty (nearly forty, that is) Golden Years on 42nd Street which used to be a very high class street, they say. I'm not sure who Hubert was. Some say that there was another Dime Museum on 14th Street called Huber's and it was hoped that people would confuse them.

In any case they came, the Ladies and Gentlemen in their tiaras and tails to see Professor Heckler's Famous Flea Circus (it seems the intelligent people really appreciated that) and Mary Bevan (pronounced Bee-Van) from England who was billed as the Homeliest Woman In The World and Serpentina the Snake Girl who hadn't any bones or Londy the Giantess who later married a wealthy Texan. You couldn't even get in without a tie in those days. There was Mortado the Human Fountain, water spurting serenely from his hands, Ubangi ladies with lips as large as dinner plates, a four-legged girl and the charming Mr. Lentini who had only three and The Great Waldo who swallowed live goldfish, lemons, and live mice but later stuck his head suicidally in a gas oven for the love of a lady who spurned him. The walls were crammed with Immortals. There was an unforgettable little two-headed girl, a man with a tail, someone embracing an alligator, little Martin Laurello with the revolving head and the Gibb sisters, Siamese Twins, Doomed, it said, To Stay Joined Together Till Death. There was a man who weighed 975 pounds, another who lifted 100-pound weights with his tongue and yet another, not to be outdone, who smoked cigars with his eyes. I don't know if people really fainted when they saw Jean Libbera. He looked a bit rueful in a poster on the far wall, standing in a tuxedo sweetly holding the hands of his vestigial twin who grew, head inwards, sticking out of his abdomen and wore, the twin did, little patent leather shoes and a diaper to keep him from wetting his pants.

You could see exhibits too. For a penny when the machine worked you could see Eisenhower, Einstein, and Tony Curtis painted on the head of a pin. Or a shrunken human head. In one corner it said brightly: Special, the Pig is here, two hundred and fifty pounds, plays music, talks, dances; and elsewhere it offered a thousand dollars if you could prove the Bearded Lady wasn't.

Sometimes you'd be leaning up against a box and it would turn out to contain a sleeping rattlesnake or you'd peer behind a poster right into a cage full of an army of rats waiting to be fed to the snakes after the show. Oh yes the show. That really was the thing.

It took place on elevated stages. They were very fond of saying that. "Ladies and Gentlemen," they would say to us as we stood there (that was the way it was, we stood) seedy and motley as a bunch of miserable sinners hoping to be converted, our eyes coming up barely on a level with their knees. The show was circular like the seasons or the stars. As inexorable as all that the fleas would follow the fire-eater and the Musical Glasses precede the Dancing Girls. Long after it came round to where you had come in you'd hang around to see it over and the more you knew exactly how it was going to be the better it was.

"Believe me when I tell you," Charlie would say. He was really not to be believed, that Charlie, the great Mr. R. C. Lucas, also known as Woofoo, Impresario Extraordinary, Inside Talker whose like I think that I will never see, he of the glittering eye who talked like a spider, so sweet and scary at once in his old fez ringed round with a beaded snake—"Believe me when I tell you Nature have been kind in moulding a human frame long you shall not forget . . . she wears a string of beads in costume fashion around her neck and one around her waist and when she is through dancing she leaves nothing to your wildest imagination. . . ." And into the Blowoff we went even though it cost extra, where Woogie who was really Charlie's wife as Princess Wago, the African Dancing Venus, undulated in the awful rosy darkness under her pythons and boa constrictors ("Who, may I remind you, eat nothing dead . . . must kill their own prey . . . rats, rabbits, hamsters . . . nonpoisonous, kill mainly by constriction . . ."). She made it seem so fine. The rule was that if you leaned on the rail, which was likely, you had to touch the snake. There

was always some big man or two, absolutely terrified of snakes, backing away in a cold sweat while everyone giggled and the snake slithered among us, Biblical as all get-out.

Did Charlie say that the Dancing Girls walked better than the average girl can dance or danced better than the average girl can walk?

It was Catharsis, like Aristotle said. "I was born of perfectly normal parents," said Susie the Elephant Skin Girl, blinking patiently. "Over my entire body the skin grows in the same condition in which you see me now. . . . Everything is lacking in my skin . . . ," and she would hold out a corner of her scanty satin skirt in a curtsy turning all the way round to show us. "I can never cry either," she admitted as we looked up, juvenile delinquents and all, hushed and polite as if this was our church.

Imagine Albert-Alberta, a creature half man and half woman, seductive as a nightmare, a veritable French psychological novel, but symmetrical, flirtatiously revealing a powdered perfumed sequinned female left breast with a rugged muscular hairy male right hand while our mouths fell open in disbelief. Or Charlotte the Gorilla Girl, terrible, toothy, and hairy all over because it seems her pregnant mother had been frightened in the zoo.

More than anything we came to see Prof. Heckler and His Trained Fleas. He stood in a special chamber on a sort of podium. Sometimes if you were lucky you could see the place on his forearm where he fed them. He spoke so solemn and judicious and deadpan. There were chariot races and a juggling flea and a flea merry-go-round but my favorite thing was when Cousin Charlie kicked the football. You couldn't even exactly see Cousin Charlie and yet you saw him kick that football all the way from there to there. They danced too. Like the Professor said: "When one is able to place a dress on a tiny thing like a flea small enough to permit them to walk and waltz it is sufficient for people of intelligence that they cannot help but realize they have been well repaid for their visit had they seen nothing else. . . ."

It was so educational, instructive, elevating even. Take Andy Potatochips (that is what they called him). He was the most cultivated dapper little midget you could ever hope to see. He was Russian but he could say something to us in any language we could talk back in. "*Il fait beau ce soir, Mlle., n'est-ce-pas?*" he might ask. "*Oui,*" I'd reply. You could sit in the Electric Chair, too. Estelline was such a pleasant motherly sword-swallower who taught us how we could swallow a bent wire coat hanger if we didn't happen to have any swords around the house. And Sealo the Seal Boy. He was the most cheerful man I have ever known.

Presto was a magician who looked like a rabbit himself. "I don't really do this," he'd say. "It just looks like it." We'd hear melodies like "I'm Looking Over A Four Leaf Clover," which Harold Smith rubbed from the rims of water glasses. Ramon Batiste was a legless man. He did the twist with his torso, for that was all there was of him, poised on the bottom end of an upside down Pepsi-Cola bottle. He wore his hair like the last of the Mohicans although I think he was Cuban. Handsome, too. He'd perch on the back of a collapsible chair very like a bird or a monkey, holding the seat with his long-looking arm and fixing his gleaming eye on a girl. "Do you like me?," he'd ask and she would nod. "Shall I do it?," he'd ask, starting to collapse the chair. She would begin to catch the fever and smiling like Ava Gardner she'd nod some more. "Why do you want me to do it if you like me?," and they'd both laugh gloriously, whereupon he'd pull up with his hand the seat of that chair little by little till it reached its pinnacle and he stood in the end impossibly on the chair's two legs for a beautiful instant before he fell.

But Oh, there was Congo. The Jungle Creep. Terrible as anything. Sometimes he'd slam his old lavender feet into the cutting edge of saws till we winced or borrow a hair from a girl's head and mix it in a dirty bucket chanting some humbug voodoo while it turned into a writhing fake snake which he hurled at us. Or woo some fat boy among us whose blood he wanted. Then he would swallow a lighted cigarette with anguish, drinking some brackish water while the smoke continued to issue from him, his eyes turning purplish, till he coughed it up still burning in a splendid finale.

We had our awe and our shame in one gulp. What if we couldn't always tell a trick from a miracle? If you've ever talked to somebody with two heads you know they know something you don't.

Medical Science being what it is they don't hardly make 'em like that anymore and the laws prevent pretending or people are rich enough nowadays to hide their relatives away instead of selling them to the Carnival like they used to.

I told you not to cry.

If you feel like it you can go on over to Hubert's tonight, anyway. The price is back to a dime like it was in the beginning. You can still see the people painted on the heads of pins or the Crime Exhibition. No one is there except the pictures on the walls of all the people who used to be there. As Mr. Schaefer the owner points out: prices being what they are these days, at a dime, even if you just want to go to the bathroom it's worth it.

NOT TO BE MISSED: THE AMERICAN ART SCENE
Text by Geri Trotta *Harper's Bazaar*, July 1966
Members of New York's art world

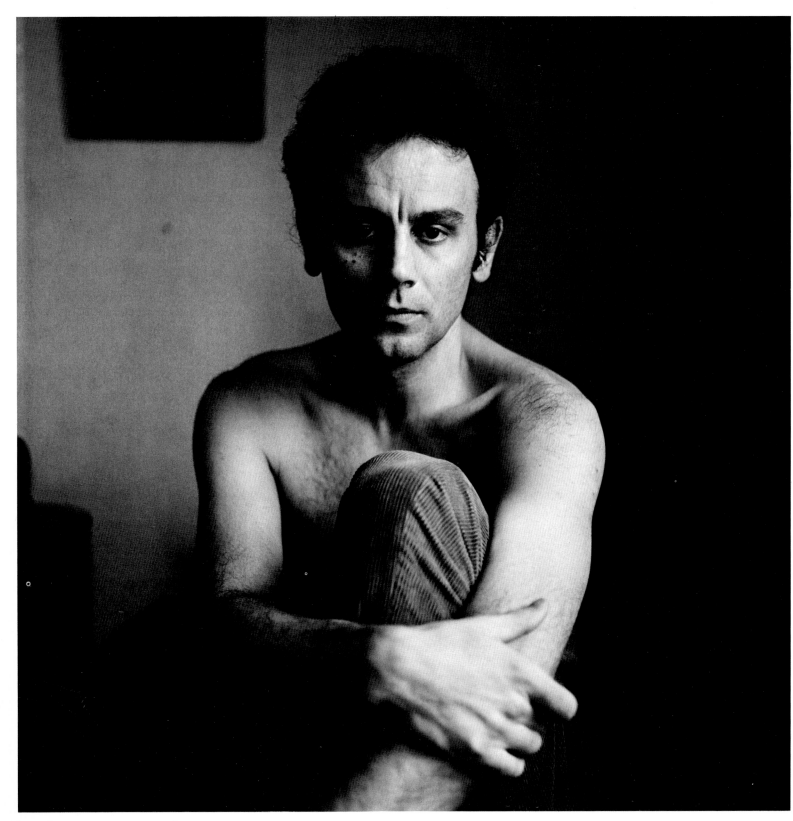

Lucas Samaras

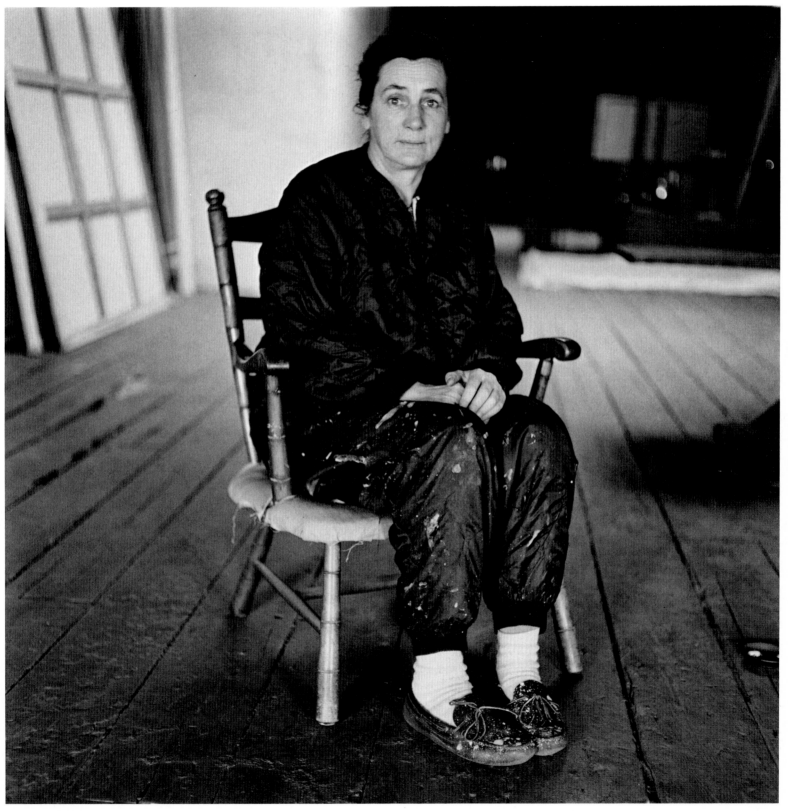

Agnes Martin

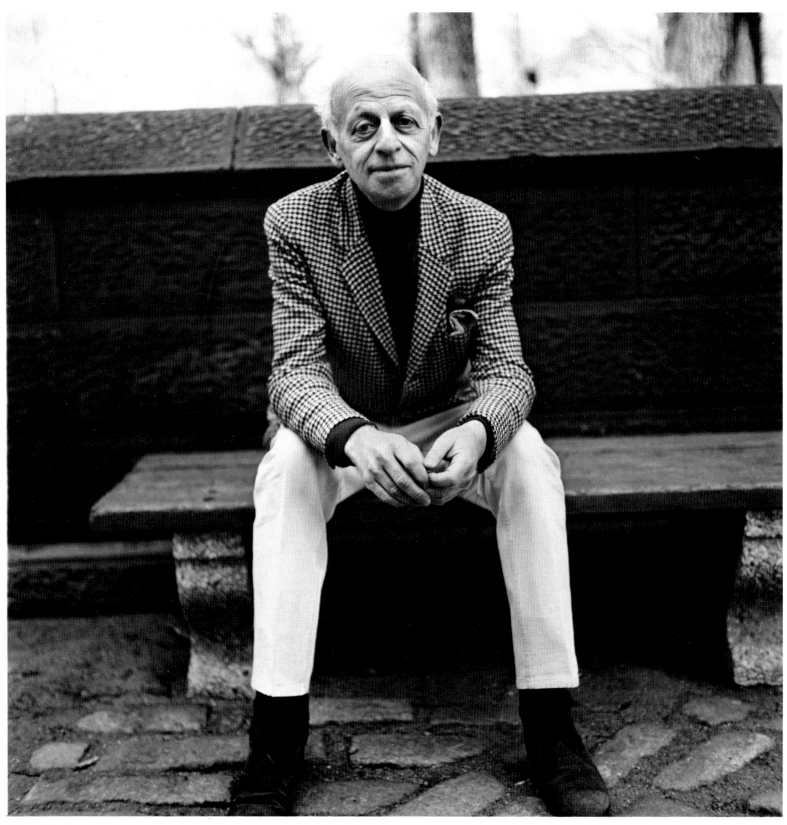

Richard Lindner

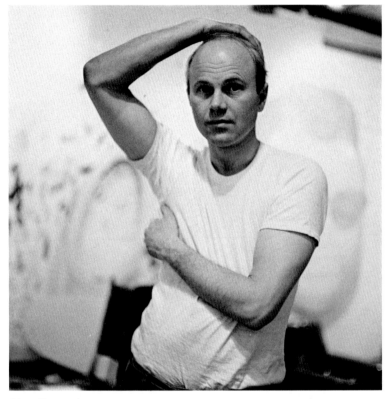

James Rosenquist

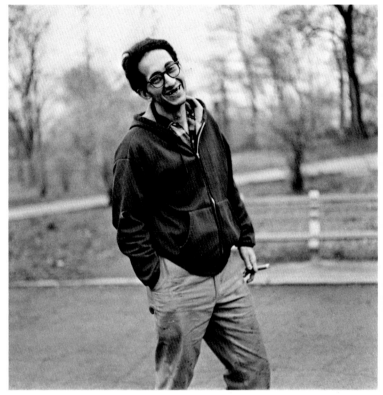

Frank Stella

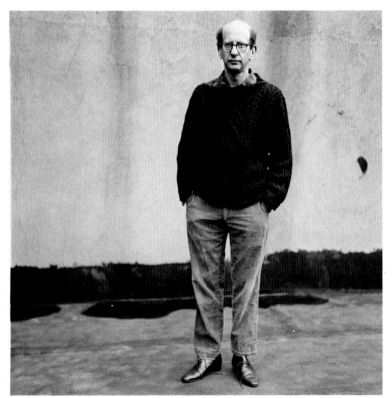

Marvin Israel

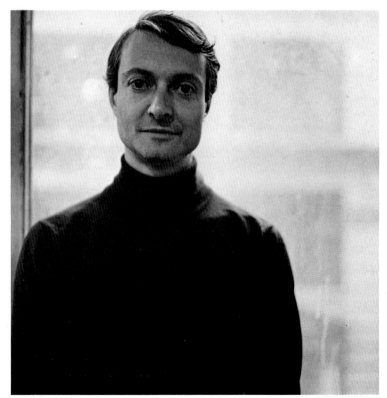

Roy Lichtenstein

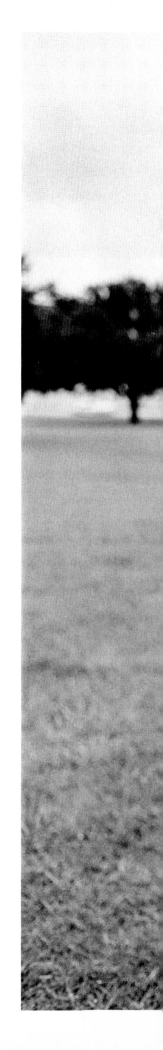

JUST PLAIN H. L. HUNT
Text by Tom Buckley *Esquire*, January 1967

H. L. Hunt, Texas oil baron, at his Dallas home,
modelled after Mount Vernon

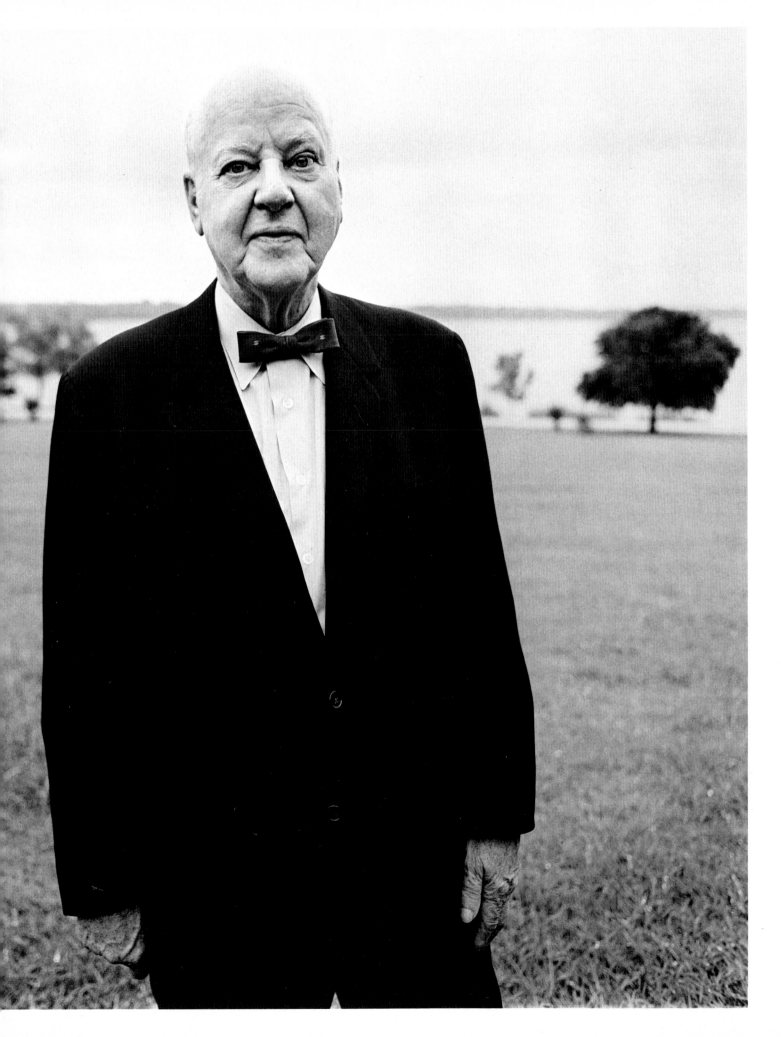

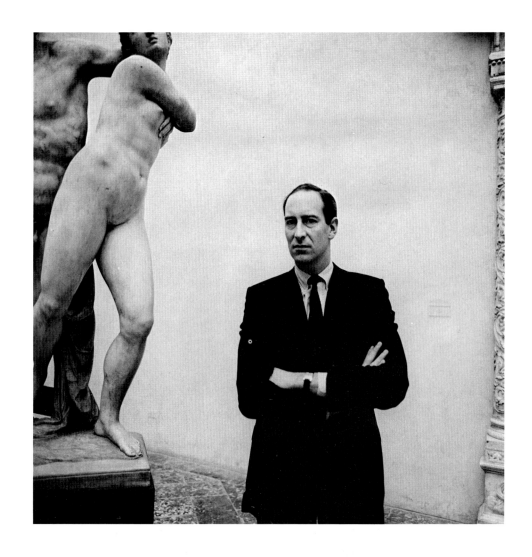

THOMAS HOVING TALKS ABOUT THE METROPOLITAN MUSEUM
Text by Geri Trotta *Harper's Bazaar*, April 1967

Thomas Hoving, former Commissioner of Parks, after he became
Director of The Metropolitan Museum of Art

THE TRANSSEXUAL OPERATION >
Text by Tom Buckley
Esquire, April 1967

In 1958, at the age of fifty-two, this man became a woman,
legally and physically.

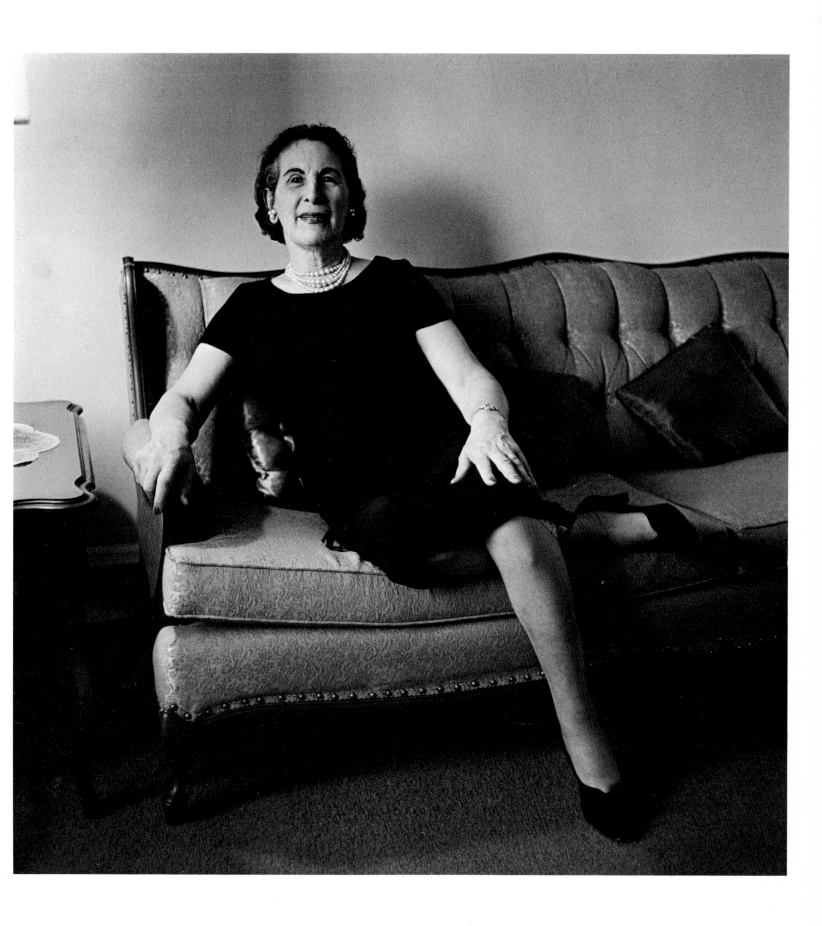

PAULINE PETERS ON PEOPLE: DR. GLASSBURY'S WIDOW
Text by Pauline Peters *Sunday Times Magazine* (London), January 7, 1968

Betty Blanc Glassbury, National President of Composers, Authors, and
Artists of America, in her New York City apartment

GOD IS BACK, HE SAYS SO HIMSELF >
Text by L. M. Kit Carson *Esquire*, February 1968

Mel Lyman, folk singer and author of *The Autobiography of a World Savior*

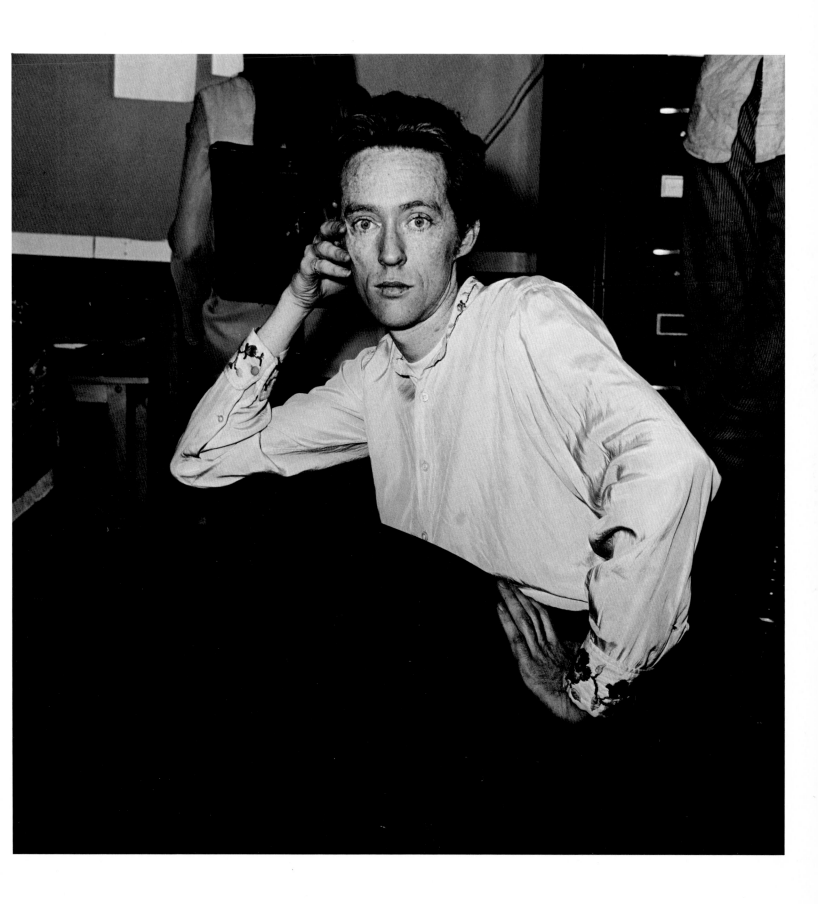

THE NEW LIFE
Poems by Sandra Hochman *Harper's Bazaar*, February 1968

Anderson Hayes Cooper, son of Gloria Vanderbilt and Wyatt Cooper

PAULINE PETERS ON PEOPLE:
HOW TO TRAIN A DERBY WINNER
Text by Pauline Peters
Sunday Times Magazine (London),
March 21, 1968

A race for pre-toddlers
in suburban New Jersey,
featuring a saliva contestant

PAULINE PETERS ON PEOPLE : HOW TO TRAIN A DERBY WINN

In the unsaddling enclosure (above): Rene Montero, Diaper Derby winner, 1967, led in by proud trainers Snr. and Linda. Right: candidate for a saliva test; an also-ran dissolves into tears. Overleaf: report on a crawling

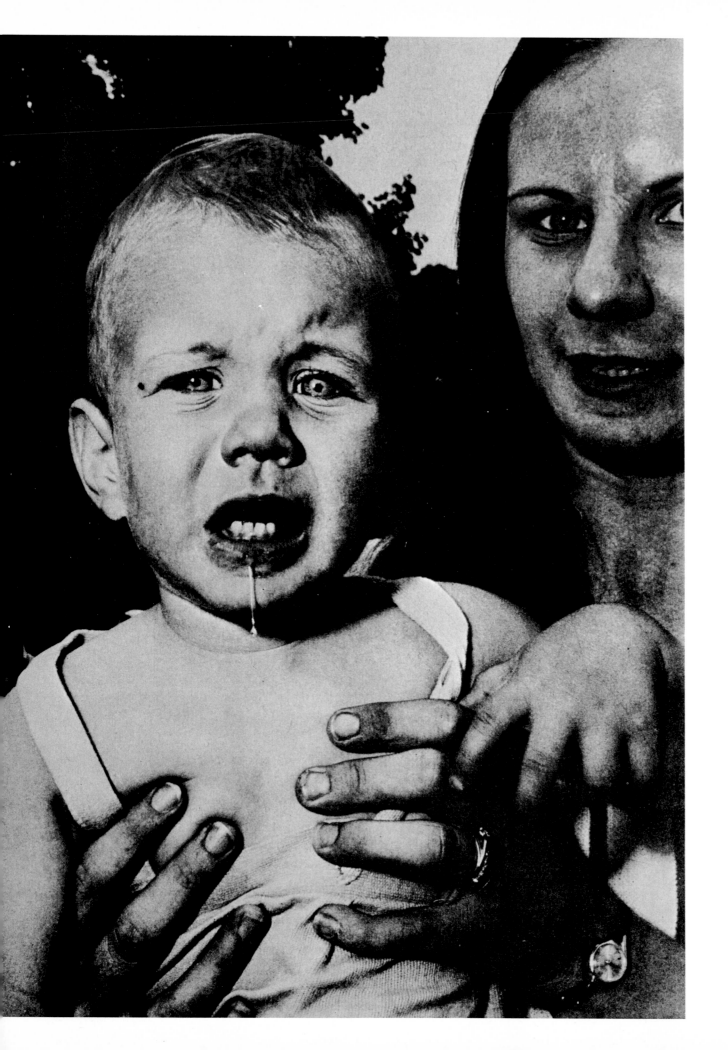

PLEASE DON'T FEED ME
Text by Hunter Davies *Sunday Times Magazine* (London), April 14, 1968
Campers at Camp Lakecrest for overweight girls in Dutchess County, New York

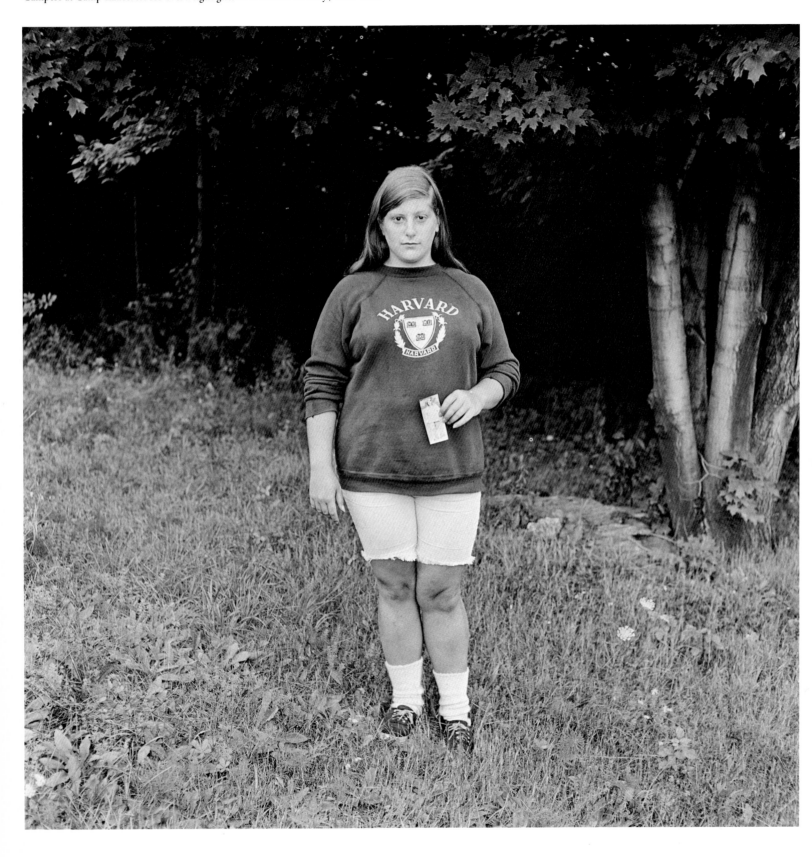

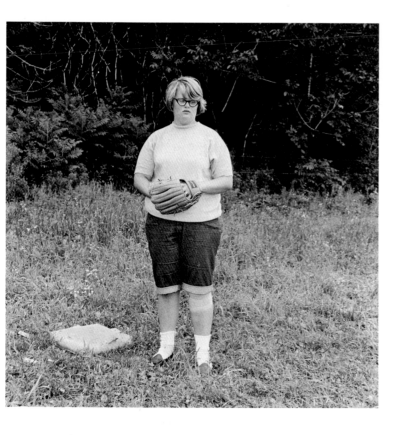
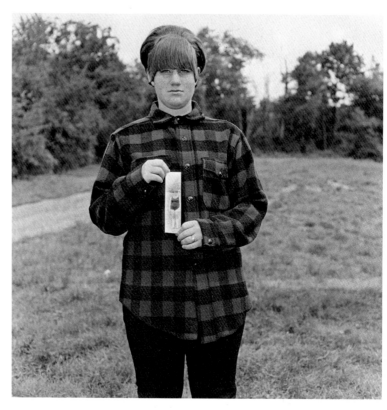
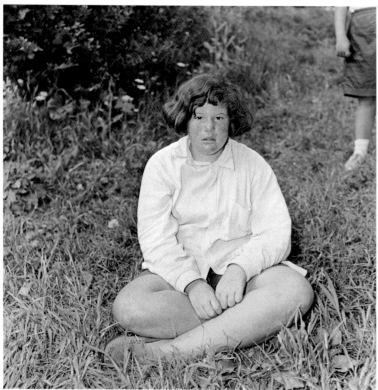
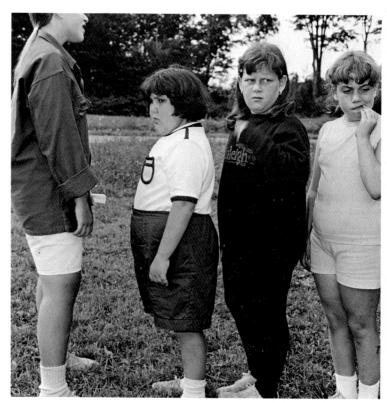

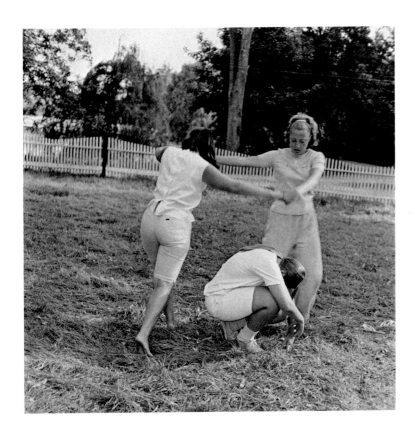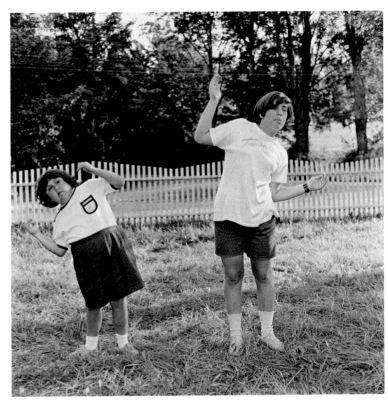
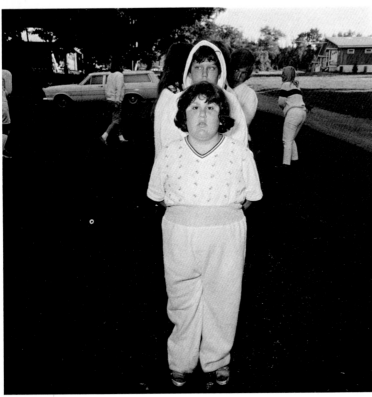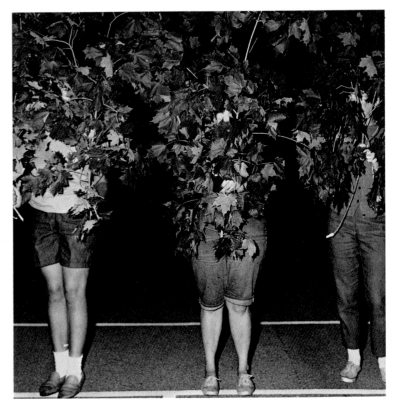

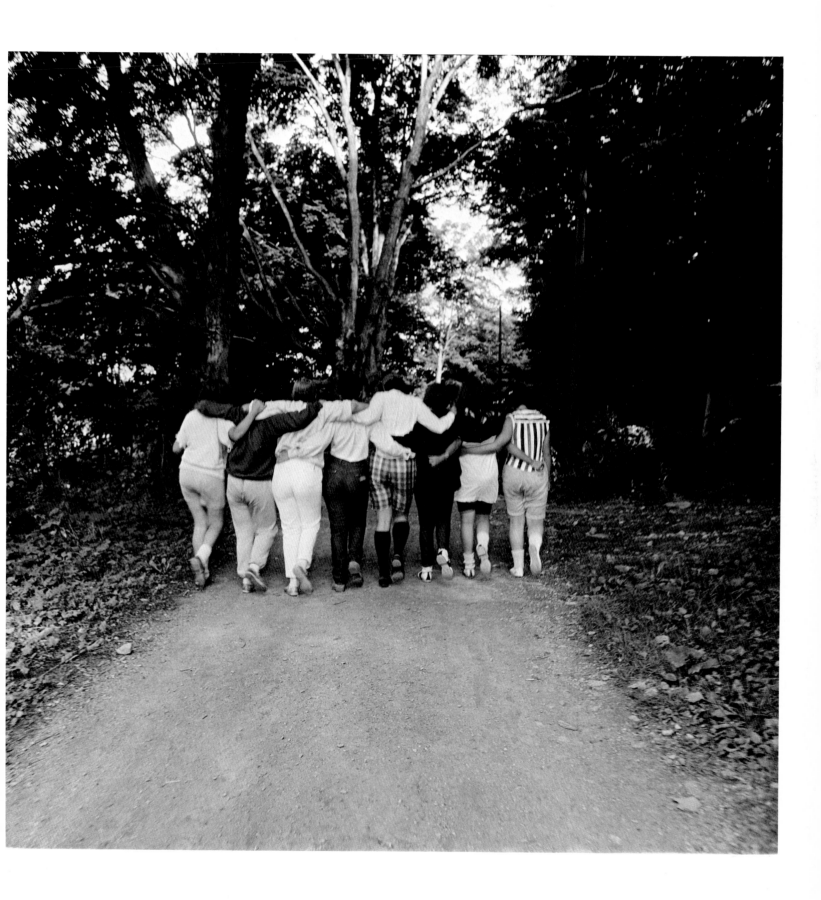

Let Us Now Praise
Dr. Gatch

by Bynum Shaw

He believes it is wrong for people in America to die of starvation;
he is willing to do something about it

Almost ten years ago the telephone rang in the office of a young doctor who had just set up practice in the small coastal community of Bluffton (pop. 556), near Beaufort, South Carolina. The call was a plea for help: on Daufuskie Island, a remote Gullah settlement accessible only by boat, an old woman lay in unconscious limbo. Her family could not tell whether she was dead or alive.

Dr. Donald E. Gatch, then not yet thirty, slipped a flashlight into his medical bag and set out on his errand without a second thought. There was no money on Daufuskie, but there was need. He paid $20 for the thirty-mile round-trip ride, and from a public landing he hiked to a sea-weathered shanty where the old Negress lay on a rude bed. There was no light in the house, and when Gatch called the patient's name there was no response. Automatically, he took up her wrist to check for pulse. As he lifted her arm, her leg—her entire body was full of maggots. Medical books don't cover that condition, not the complete infestation of the body. How do you treat maggots?"

The patient died, and Dr. Gatch believed then and he believes now that although the immediate cause of death might have been listed as some "acceptable" disease—like pneumonia, the real cause of death was plain hunger. That pathetic case made a profound impression on the young doctor, and in the intervening decade he has been seeking out and doing battle with the hunger and parasites of Beaufort County. In the war thus far, the worms have been winning.

It has been, of course, a war in which there have been few allies, for it has been waged on the level of the dirt-poor outcasts of the Great Society. Beaufort County, ideally located and wonderfully warmed, has been striving with considerable success to

build a tourist trade. It has a rich patina of history and is mightily endowed with the mossy legacy of the plantation South. Talk of intestinal parasites tends to blight the charm of live oaks, cypress knees, wisteria and sailing regattas. But the *Ascaris lumbricoides* (roundworm) and *Trichuris trichiura* (whipworm) are there, along with the *Tillandsia usneoides* (Spanish moss).

Dr. Gatch established that, beyond doubt, six years ago. With a team of doctors from the Public Health Service's National Institute of Allergy and Infectious Diseases at Columbia, S. C., he conducted stool tests of two hundred twelve residents mainly along Goethe (pronounced goatie) Lane in Bluffton. The findings, subsequently published in the January, 1963, *Public Health Reports*, showed that 7.8 percent had one or more species of worms. More than eighty percent of children under five were infected. Those figures, comparable to rates found in Colombia, Egypt, South Africa and the Cook Islands, suggested to the researchers that tidewater South Carolina might "represent one of the areas of highest endemicity for the continental United States." Health authorities in Beaufort County accepted the study as valid, deplored the condition aloud and for the most part went on about their business.

Only Gatch kept talking and agitating and relating worms to malnutrition. Gatch is not the ordinary member of the medical profession; he abhors the fraternal society; not a Southerner, he regards even the poor or illegitimate Negro as a human being; he reads books and listens to music of every beat; and gradually he came to be regarded as a medical troublemaker, tolerable only as long as his voice echoed meaninglessly across the forsaken rice paddies that encircle Bluffton.

But last November Gatch committed what can only be regarded in Beaufort County as the unpardonable sin. He went up to Columbia, the state capital and, before a citizens' inquiry investigating hunger and poverty, engaged in what The Beaufort *Gazette* sadly described as "running his mouth." What Gatch did was to say that in Beaufort County people were dying of starvation, that they

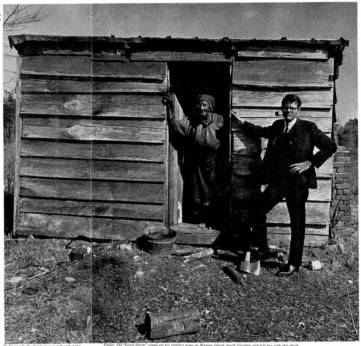

On his rounds, Dr. Gatch stops to talk with Addie

Taylor. The "Grace Storm" wiped out her family's home on Wassau Island, South Carolina, and left her with this shack.

Photographed by Diane Arbus

LET US NOW PRAISE DR. GATCH
Text by Bynum Shaw *Esquire*, June 1968

Dr. Donald E. Gatch, crusading country doctor who
fought hunger and parasite disease in a poor community
of South Carolina's affluent Beaufort County

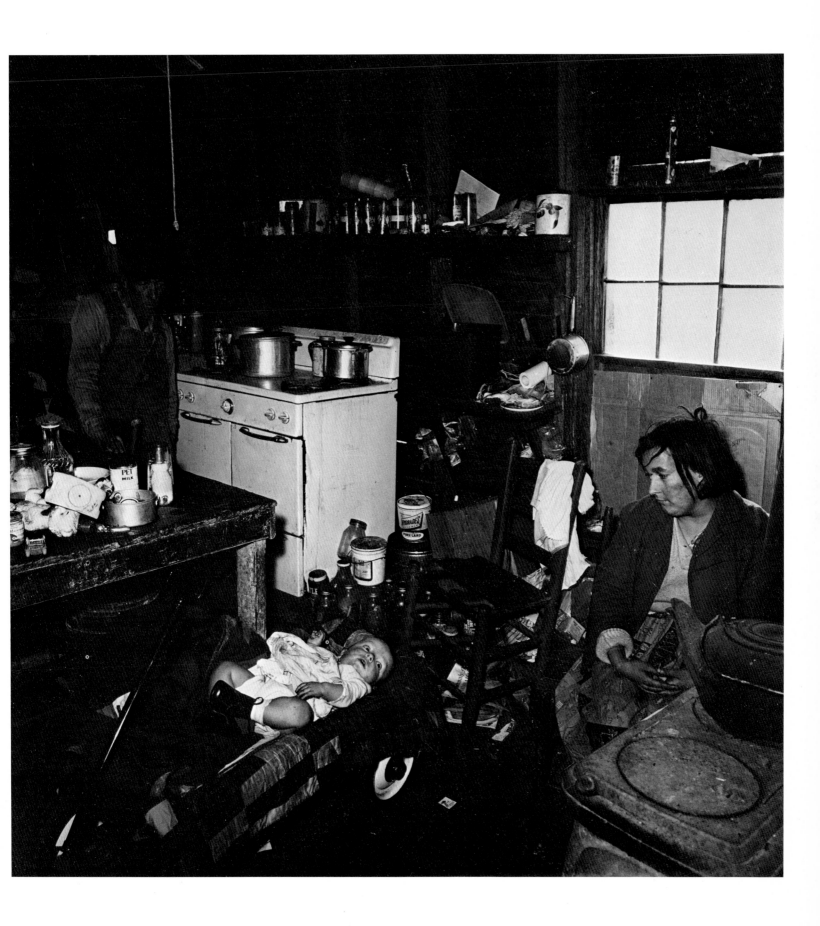

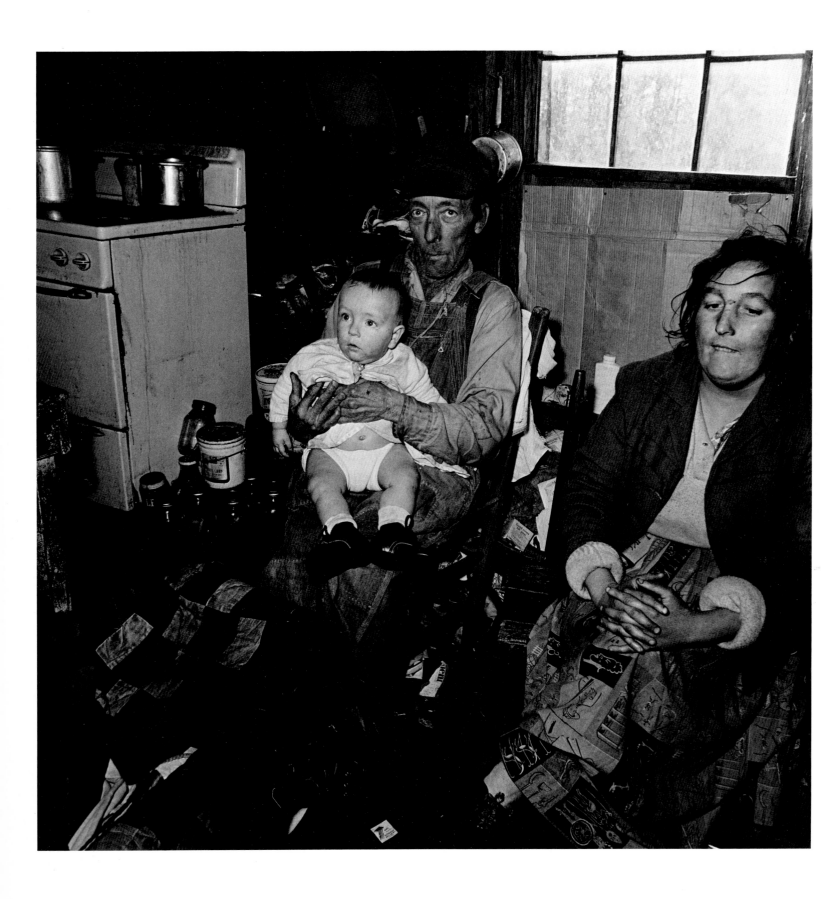

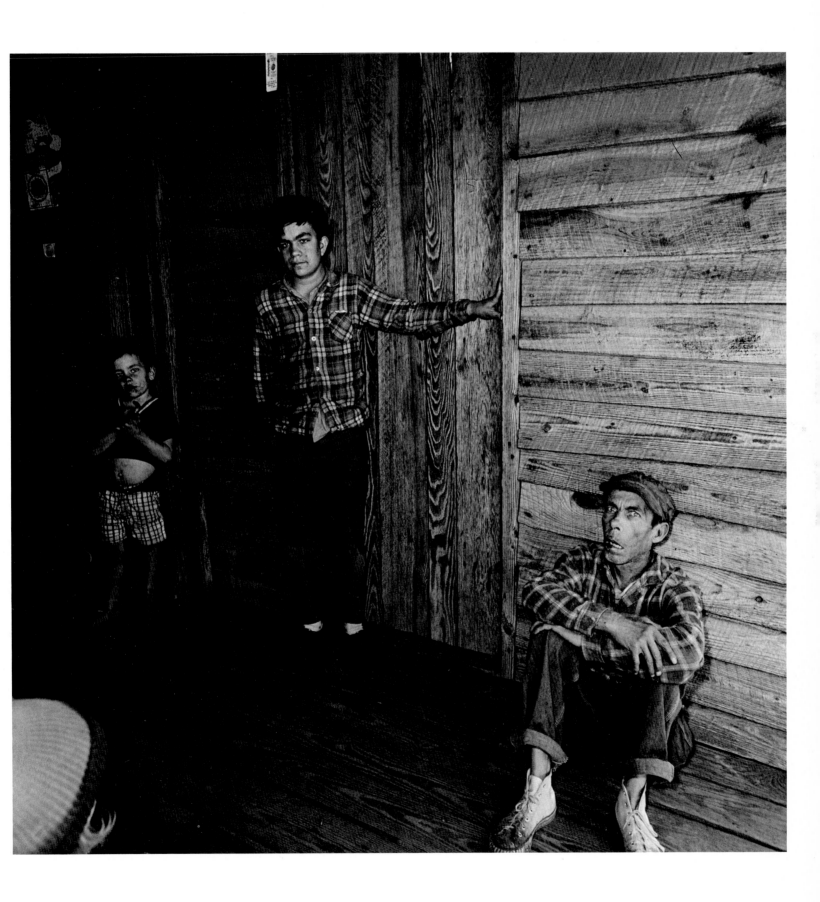

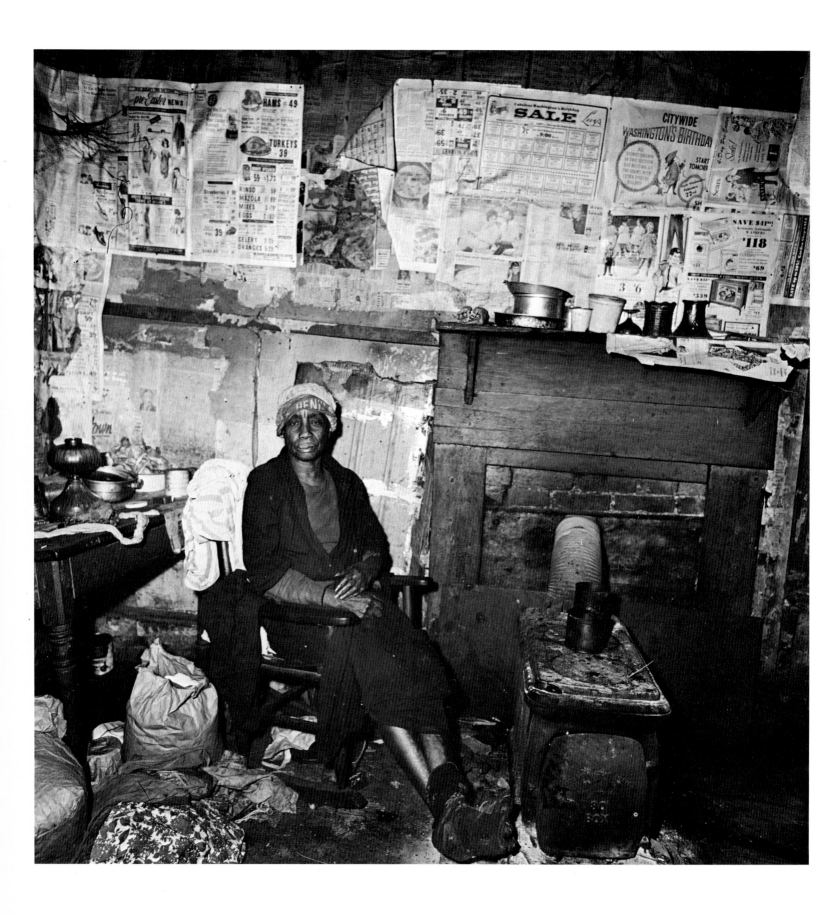

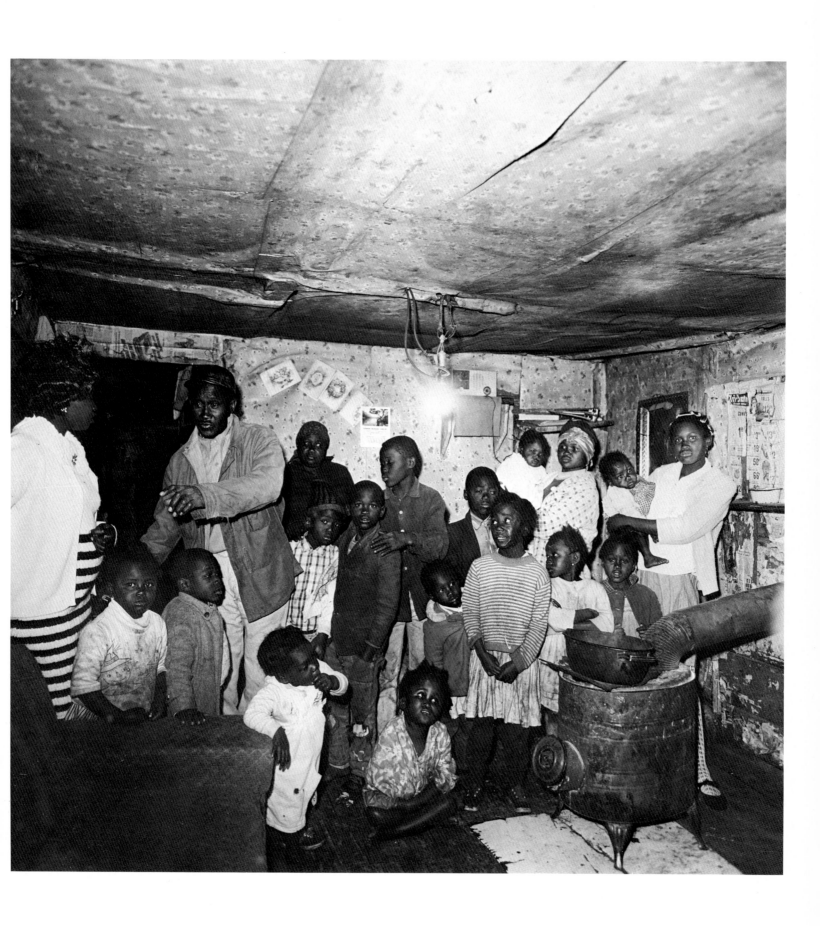

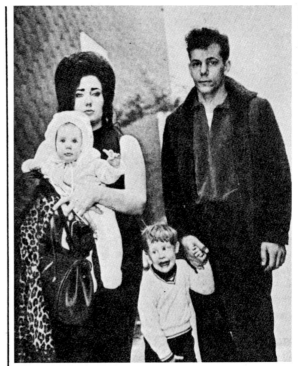

Two American families

Photographs and captions by Diane Arbus

Richard and Marylin Dauria (above) with two of their three children, Richard Jnr. and Dawn. They live in the Bronx, New York; they met in school and were married when Marylin was 16. Richard, an Italian immigrant, is a garage mechanic. Marylin, who is 23, says she is often told she looks like Elizabeth Taylor. She is not Irish but she told me she had dyed her hair black to make herself look as if she is. Richard Jnr. is mentally retarded, and the family is undeniably close in a painful, heartrending sort of way. After I had photographed them they piled into their car to go to visit one of their parents. It was a Sunday.

Nat and June Tarnapol (right) with Paul, aged four, one of their three children, in the garden of their home at Westchester, Connecticut. They are an upper middle class family, Mr Tarnapol being a successful agent and publisher in the pop music business. I think it's such an odd photograph, nearly like Pinter, but not quite . . . the parents seem to be dreaming the child and the child seems to be inventing them.

56

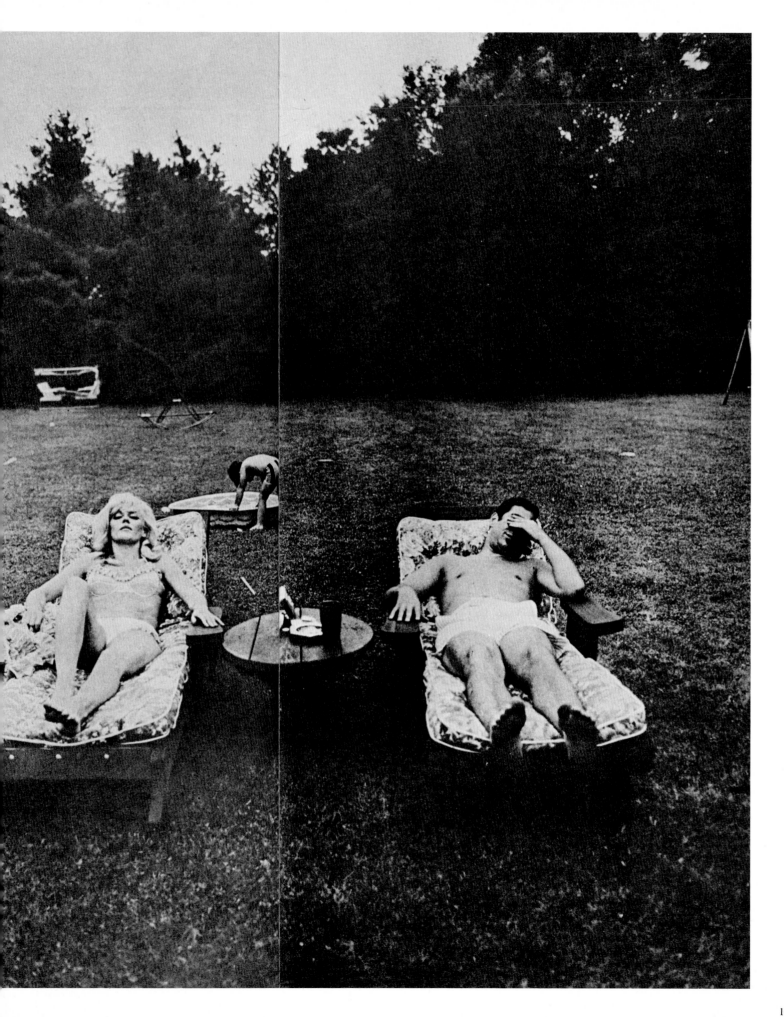

TIPTOE TO HAPPINESS WITH MR. TINY TIM
Text by Francis Wyndham
Sunday Times Magazine (London), July 14, 1968
Male falsetto tenor, whose recording "Tiptoe through
the Tulips" marked an unexpected commercial triumph

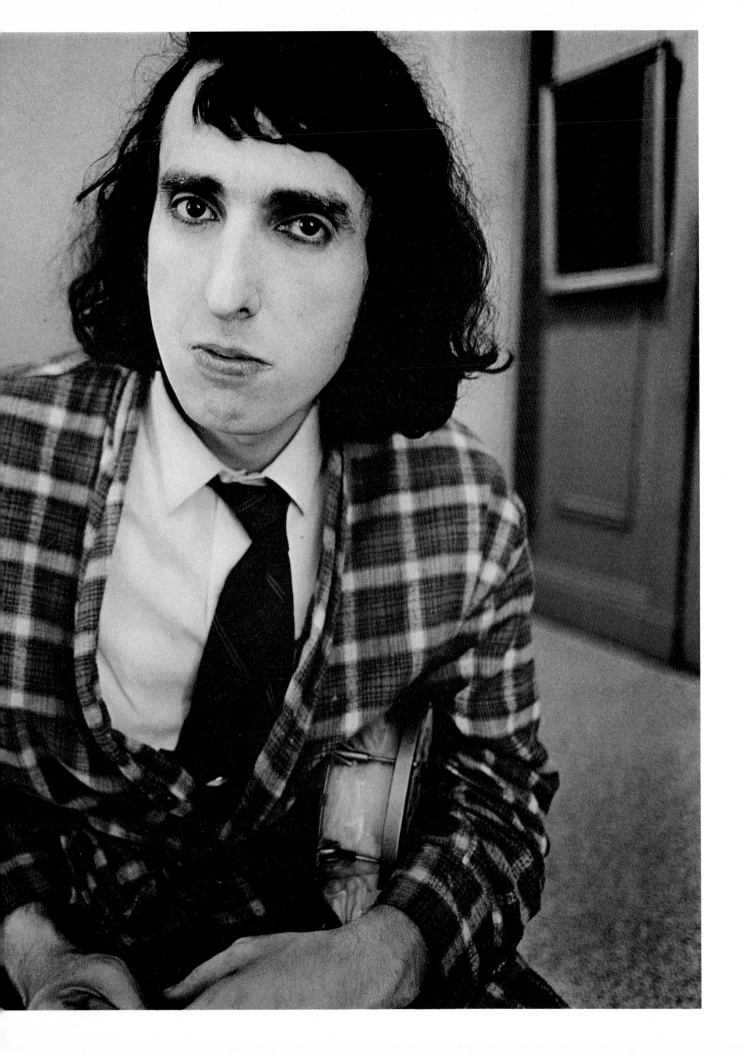

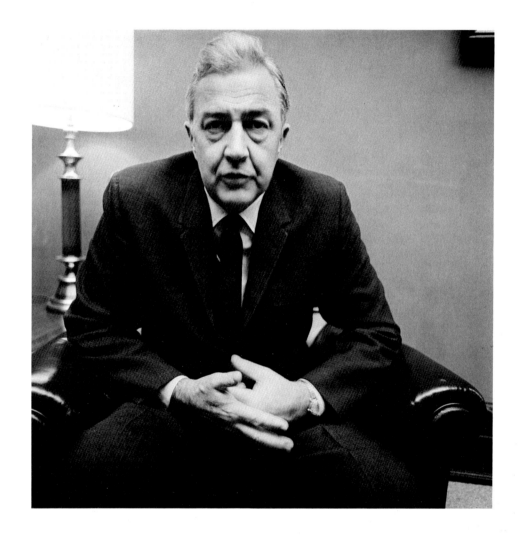

EUGENE McCARTHY
Unpublished, 1968

Senator McCarthy, who failed to capture the Democratic
presidential nomination, on election night in 1968

ON A PHOTOGRAPH OF MRS. MARTIN LUTHER KING
AT THE FUNERAL >
Poem by Paul Engle *Harper's Bazaar*, December 1968

Mrs. Martin Luther King Jr. on the front lawn of her
Atlanta home

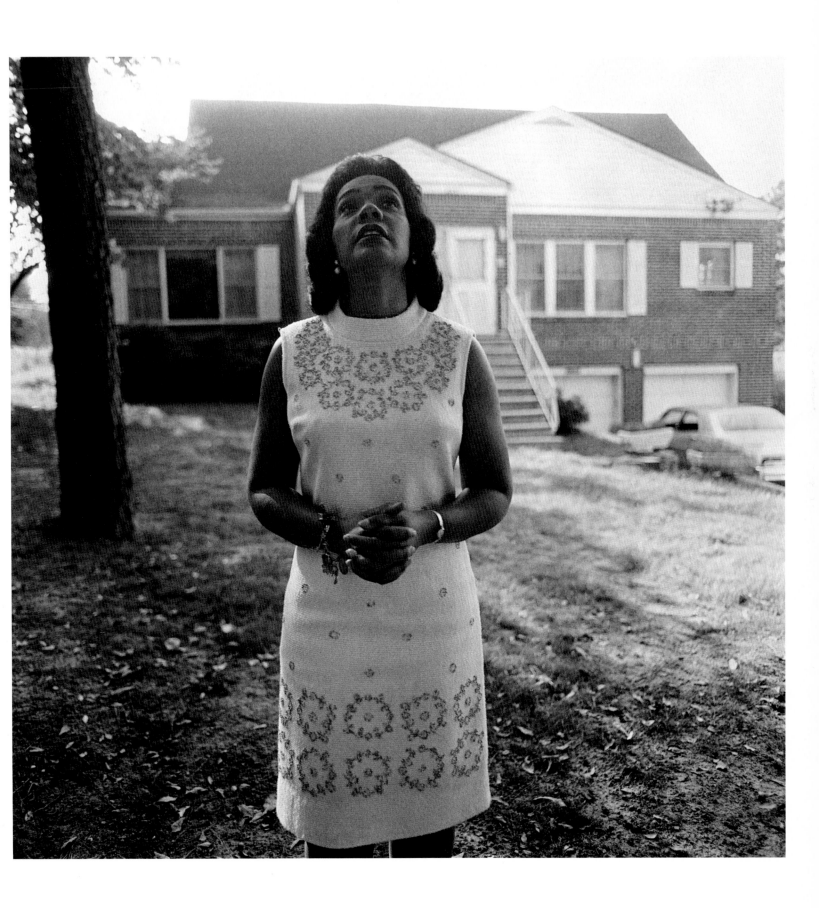

HOW FAT ALICE LOST 12 STONE
(YES 12 STONE—THE WEIGHT OF AN AVERAGE MAN!)
AND FOUND HAPPINESS, GOD AND THE CHANCE OF A HUSBAND
Text by Doon Arbus *Sunday Times Magazine* (London), January 19, 1969

Weight watcher Alice Madeiros after losing 168 pounds, and members of
the Vernon Avenue, Long Island, chapter of Weight Watchers International

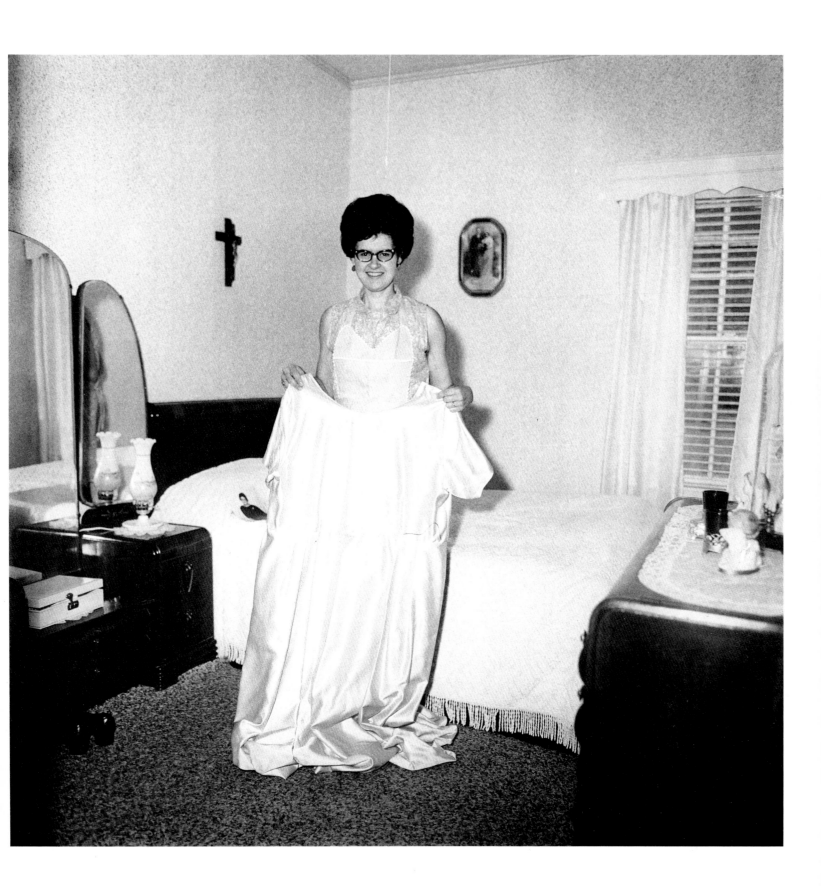

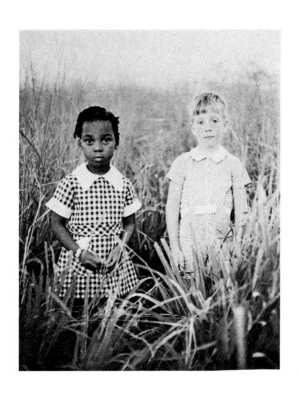

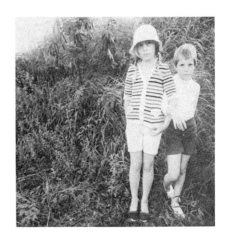

READY FOR ACTION
Text by Patricia Peterson *The New York Times Magazine,* part II,
Children's Fashions, March 16, 1969

Local and vacationing children photographed in 1967 and 1969 in St. Croix,
Virgin Islands

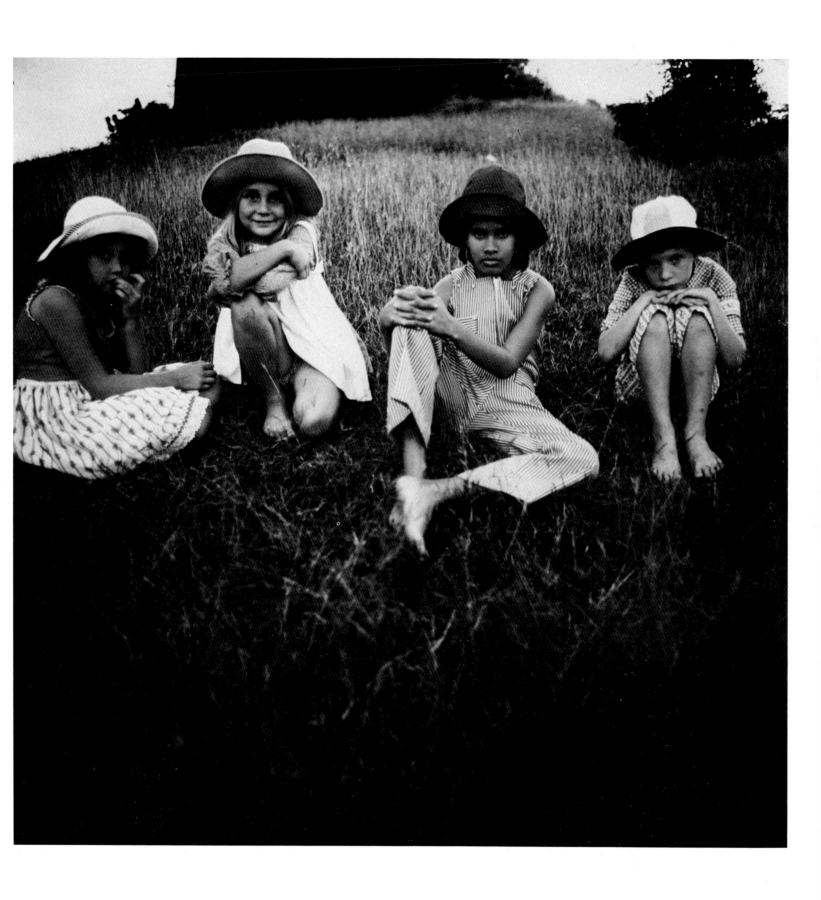

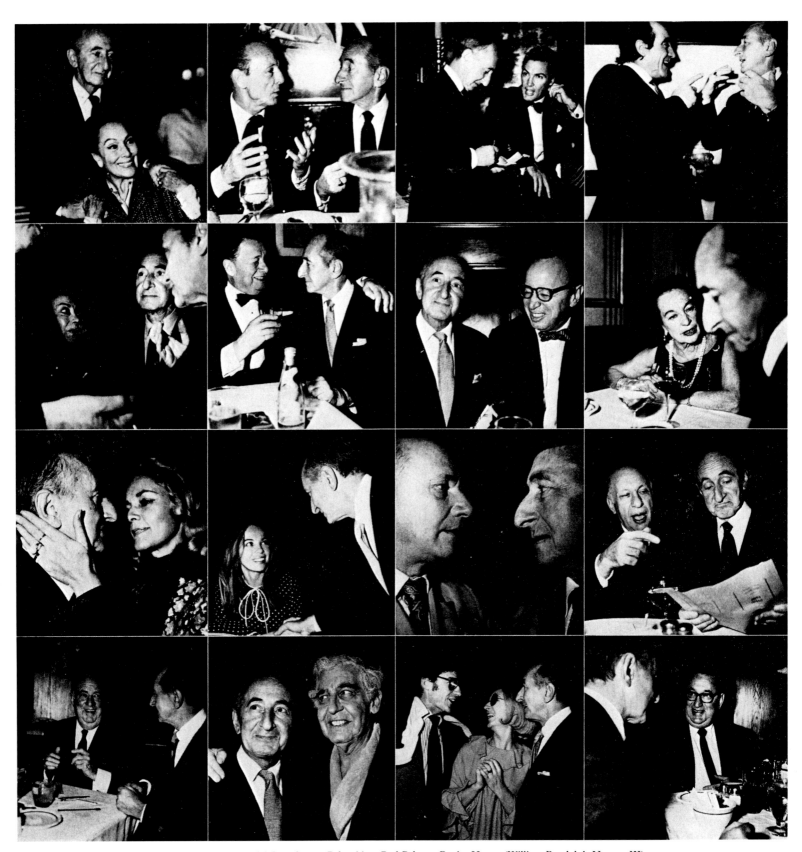

Leonard Lyons with: Top row, left to right: Dolores del Rio, George Balanchine, Bud Palmer, Bucky Hearst (William Randolph Hearst, III).
Second row: Mrs. Marc Chagall (right), Toots Shor, Arthur Schlesinger, Jr., Lucia Chase. Third row: Lauren Bacall, Leslie Caron, Donald Pleasence, Harold Clurman.
Bottom row: Johnny Meyer, Milton Berle, Sybil Christopher (the former Mrs. Richard Burton) with Roddy McDowell, Joe Levine.

LEONARD IN THE LYONS DEN
Text by Alfred Bester *Holiday*, March 1969

Celebrity columnist Leonard Lyons, whose "Lyons Den"
was syndicated in more than 100 newspapers nationwide

THREE POEMS
Poems by Jorge Luis Borges *Harper's Bazaar*, March 1969

Argentine poet and prose writer Jorge Luis Borges with his
wife in New York's Central Park

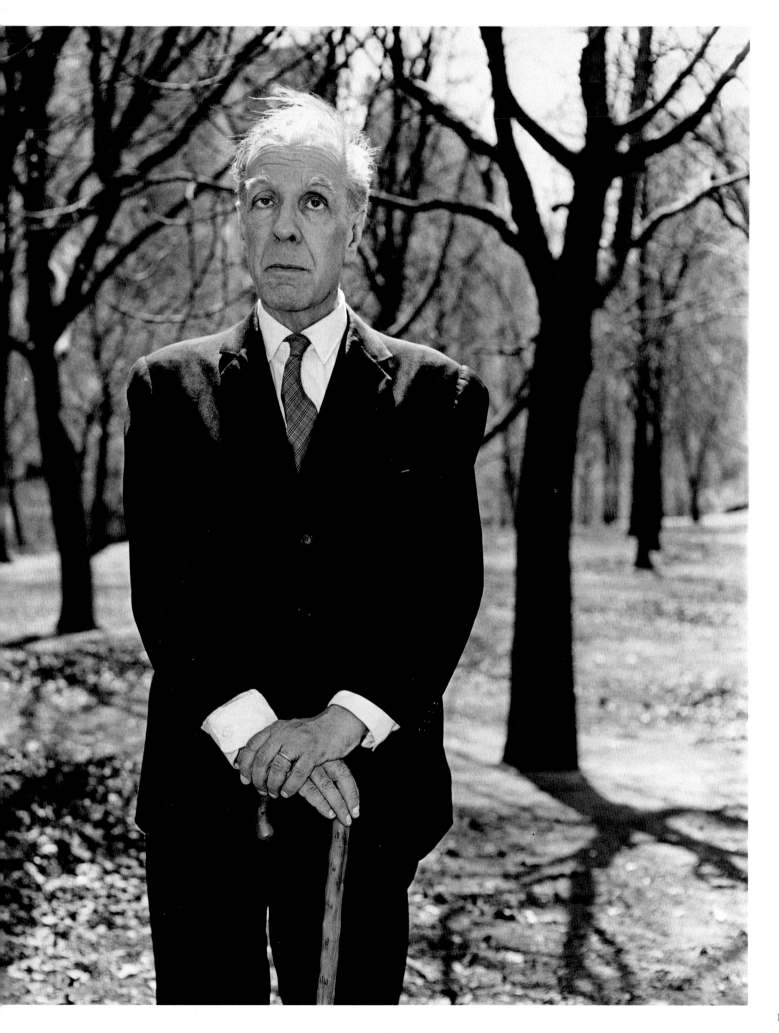

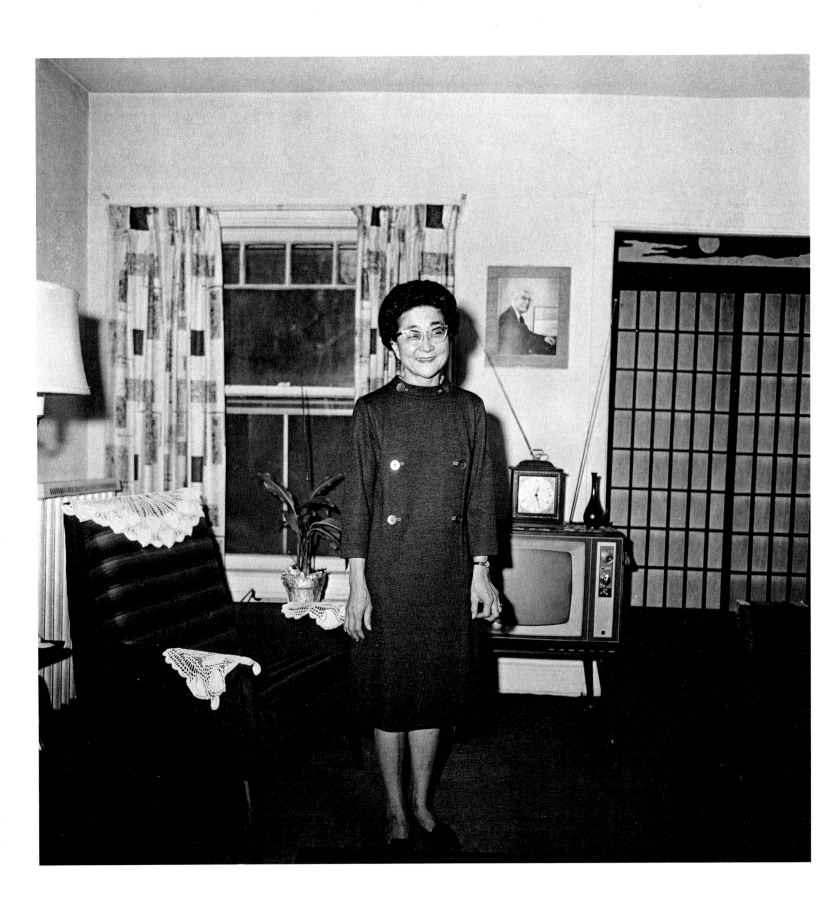

TOKYO ROSE IS HOME

Text by Diane Arbus *Esquire*, May 1969

Now that you have lost all your ships you really are orphans of the Pacific. How do you think you will ever get home?

So said Iva Ikuko Toguri d'Aquino, or so they said she said, though she denies it. That was the Act of Treason: that she "did speak into a microphone concerning the loss of ships" one day in 1944 in a Tokyo radio station.

"Isn't it funny?" she says now.

She was born on July 4th in 1916 to a Japanese-American couple in California. Her father was a merchant, a small businessman. She graduated from U.C.L.A. with a degree in zoology and worked as a stenographer temporarily with the hope of eventually doing medical research. In 1941 her father sent her home to Japan to visit a sick aunt. It was a little like Red Riding Hood. Shortly before the outbreak of war she applied for a passport to return home but it was denied; second-generation Japanese-Americans were not exactly on the preferred list. When the war broke out she could no longer communicate with her family. They were interned in California and she was registered as an enemy alien in Japan. None of her letters reached them and she didn't receive any of theirs. She was under the surveillance of the Japanese Thought Police. She was frequently invited to become a Japanese citizen but persistently refused to. Some of her neighbors were openly hostile. Meanwhile she supported herself by working at various secretarial jobs and finally became a typist for the Broadcasting Corporation of Japan. There she met and befriended the American soldiers from the Bunka Prisoner of War Camp who were broadcasting propaganda for the Japanese. They were subsequently pardoned because they had acted under duress and under the "immediate threat of death or bodily harm." She herself was chosen to broadcast as a disc jockey on a semiclassical musical program for Allied soldiers. She broadcast fifteen minutes a day and was paid about $40 a month. She used to bring food, medicine, cigarettes, blankets, whatever she could scrounge up for the prisoners, concealed under her clothing. She was happy to be with American soldiers doing what she could to help them. "It was manna from heaven," she says now, "to be among people who thought and felt as I did." She was convinced America would win.

Meanwhile, across the Pacific, thousands of G.I.'s apparently spent their idle hours in the steaming jungle foxholes listening to the radio, and the biggest delight of all was this lady, this comic-strip evil seductress, this Dragon-Lady-next-door who kept telling them to go home. They called her Tokyo Rose. It didn't seem to matter that there was a number of ladies broadcasting on a number of programs at different times. They all sounded alike. It was Tokyo Rose and she got to be as famous as a movie star. Like Betty Grable and Peter Lorre rolled into one. A sort of invisible pinup girl. That was how Iva d'Aquino became Tokyo Rose and got to be famous without even knowing it.

When the war ended in 1945 she was imprisoned by the American military authorities in Japan for a year, during which she was questioned, investigated, and finally released.

In 1948 a Gold Star Mother, hearing that Tokyo Rose had applied again for a passport to return home, protested to Walter Winchell that anyone who made derogatory remarks about the United States oughtn't to be allowed back, and Winchell in turn demanded on his radio program that the Attorney General do something about it. Feelings were running high. Tokyo Rose was a symbol. "It was eeny meeny miney mo," Iva d'Aquino says, "and I was It."

She was arrested again on complaint of the Department of Justice, brought to San Francisco, indicted on eight counts of treason, and held there for a year in prison awaiting trial. Her father said he was proud of her for not changing her stripes. Several lawyers rallied to defend her without pay because she had no money. The trial went on for three months. The prosecution witnesses were given a free trip from Japan to the U.S. and $10 per day while they testified. There wasn't any money with which to produce all the forty-three witnesses on her behalf, so nineteen of them signed depositions in Japan and F.B.I. agents were permitted to counterquestion them in advance of the trial. There were only six records of actual broadcasts, obtained at the time from private collectors, but during the trial one of the prosecuting attorneys slipped and dropped one of them so then there were five.

She was convicted of just one of the eight charges of treason against her, the "so-called statement concerning ships," of which there was no record, tape, or transcript. The foreman of the jury apologized to her for the verdict. She was confined in the Women's Penitentiary in West Virginia and fined $10,000, but since she couldn't possibly pay the fine she was told that if she ever did get $10,000 she was to pay it then.

In 1956, sometime after her release from jail, the Government instituted deportation proceedings against her until her lawyers finally established that it would be illogical: a treasonable citizen couldn't be an undesirable alien too.

Iva d'Aquino lives in Chicago now managing her father's gift shop and helping to counsel the young Japanese students her father sponsors for special studies in U.S. universities. The same lawyers who have stood by her for twenty years have recently petitioned for a Presidential pardon on her behalf.

"I could have done without all this," she says, smiling, "but it's a lot of water under the bridge now. . . ."

MAKE WAR NOT LOVE!
Text by Irma Kurtz *Sunday Times Magazine* (London), September 14, 1969
A radical feminist group and feminist leaders

The Red Stockings

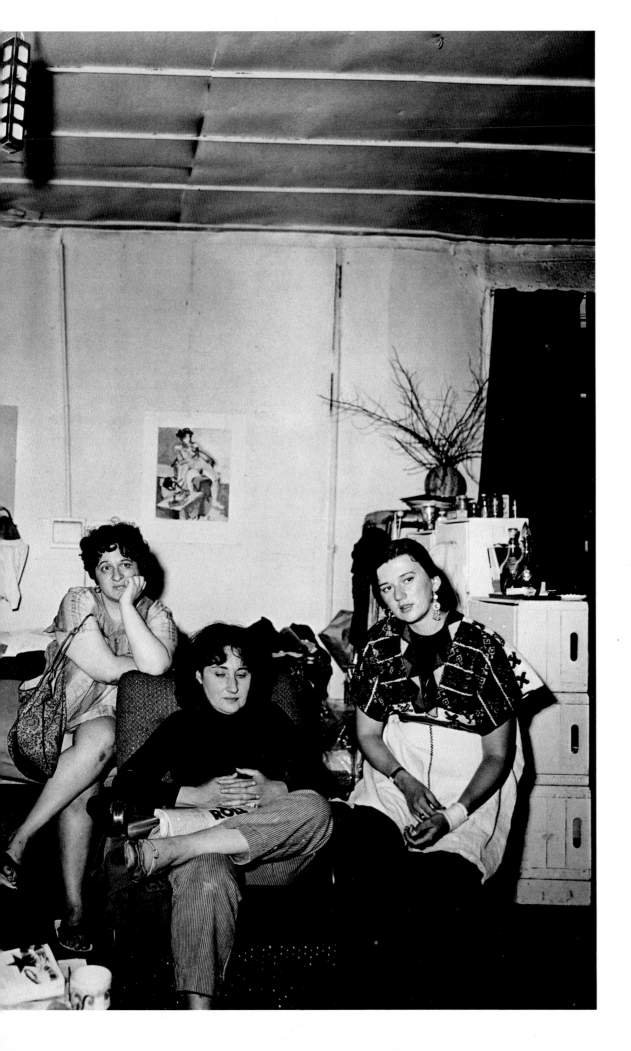

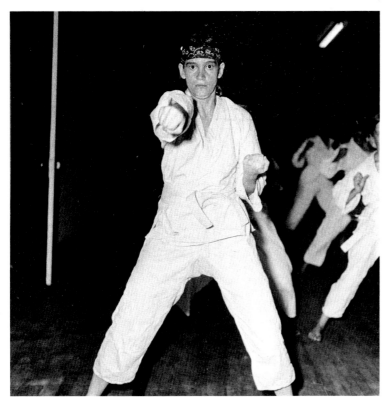

Roxanne Dunbar

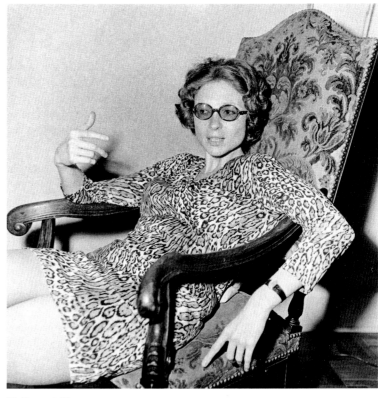

Ti-Grace Atkinson

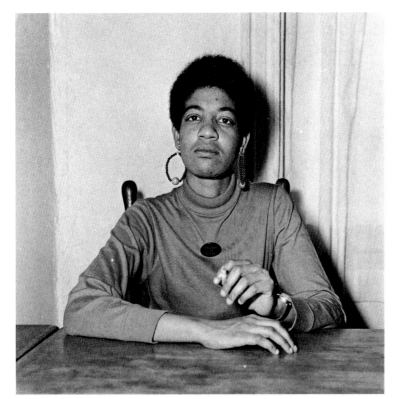

Unidentified feminist

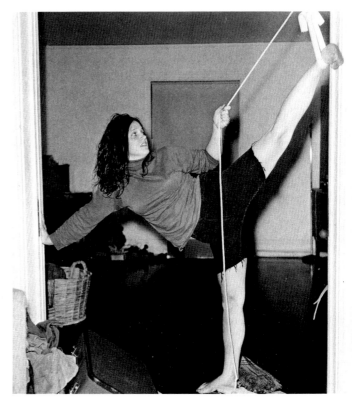

June West

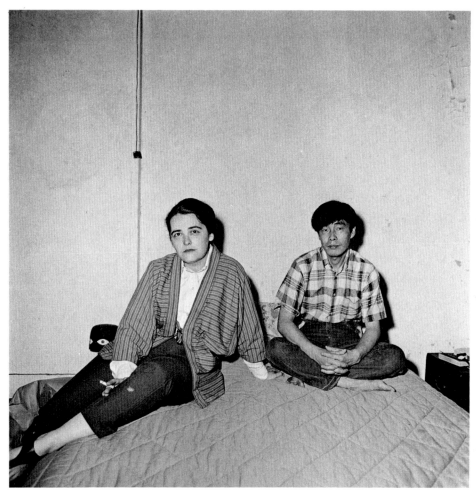

Kate Millet with Fumio Yoshimura

Get to know your local Rocker

by Peter Martin / Photographs by Diane Arbus

It is a Sunday afternoon, nearing the end of the silly season of rusty-buckled sandals, sunglasses and amazing optimism. The roads are quiet at this hour: the crowds jammed into Brighton earlier in the day and now they are sheltering from the wind and occasional drizzle, gaining strength and irritability for the long slog home.

A high powered motorcycle thunders out of the town, turns off the main road and stops. The anxious rider, wearing a studded and painted leather jacket and jazzily daubed bone-dome, dismounts and runs up the steps of the Day-Go, a small roadside café. No sooner inside the café, which is full of youths dressed as he is, the messenger is talking excitedly. 'A bunch of bleedin' Mods!' he gasps. 'Just stormed the Little Chef. Must've been fifty or more Mods outside, chanting, and a dozen of the lads, Rockers, inside, ready with the coke bottles. The café owner bolted the door to keep them apart. It held out till the fuzz come. Most of them have gone now.'

The story told, little pockets of chat break round the café. Some of the younger boys, two or three sixteen year olds, seem eager, if a little shuffle-footed and nervy, to go into town to 'have a look'. 'What the 'ell do you think you're gonna do about it then?' a burly Rocker sneers at one of the young boys. 'It's over, there's nothing anyone can do about it except get himself arrested and yer mummy wouldn't like that. Better leave it alone.' Which they do.

Rockers like these exist in almost every town. The odd thing is that though Teddy Boys, Beatniks (as a fad) and even Mods have faded out, the Rocker still endures. He began, as we know, over ten years ago, a hybrid of the Teddy Boy and a pale Hell's Angel. It was always said that the infamous lout with his leather jacket and early Presley sneer was about to put the boot in; his target, the very foundations of our society. It never happened, of course, but, as with every generation,

older citizens had an element of youth they could really love to hate.

The Rocker seemed on the wane until 1964, the big newsyear for Mod and Rocker conflicts. Like the Rockers, the Mods were a smallish and easily recognisable group of straining individualists. Out of ego, coquetishness and boredom, they set about any Rockers, the only and obvious challengers with their leather armour and tough manner. Since then, on Bank Holidays and other idle weekends, it has become a tradition among some youths, seaside visitors with time on their hands and only the return fare in their pockets, to 'have a bit of a lark' with the Rockers. This year has been no exception and Brighton, Southend, Great Yarmouth and Skegness, among other places, have seen some of the old action. But now the Mods, per se, no longer exist. The squeeze on one hand and the flood of new fashion for the young in general on the other, though they have not visibly affected the Rockers, have swollen the ranks of the Rest. Consequently, the outnumbered Rockers are now the losers.

Like most youthful phases, Rockers should have faded out. The essential public concern which, if anything, must have been supportive of the Rocker spirit in times past, was lacking. It seemed unlikely that the Rocker could exist without the public awareness of, and concern for his somewhat wild culture. But he does.

Basically, Rockers continue to be Rockers because of motorcycles, popular with young people because they need only to be sixteen to get a motor-cycle licence and second-hand motorcycles are far cheaper than cars. There is also the excitement: put a sixteen year old astride what is just a power unit with wheels and let him race up to 70 mph; few other things can create that kind of excitement. And to share this experience motorcyclists gather in their own cafés in most towns all over the country.

In Brighton, it used to be the Little

Chef where the hard core of the town's Rockers met; the kerb outside used to be lined with all sorts of beautiful machinery, looking characteristically aggressive. (The younger Rockers, ashamed of their small, cheap 'bikes, used to park them out of sight as the older Rockers considered it a little infra dig if such junk was parked alongside their machines; there to symbolise the strength and experience it must take to handle powerful hardware properly.) Such was the reputation of the Little Chef that no non-Rocker youth would pass by there on the same side of the road, certainly not if he was in school uniform.

But the police and other people didn't much like the noise of the bikes and, although some of the Rockers still use the Little Chef, most of them moved to the Hi-Lo further from the centre of the town. Eventually, the Rockers had to move on again, for more or less the same reasons, out to the Day-Go café on the outskirts of Brighton.

The ages of the Rockers that use the café these days range from 16 to 22.

Some of the younger boys get a motorbike first, then a leather jacket; others buy the jacket, visit the café and try to get their faces known while they're deciding to buy a bike or saving for one.

A young Rocker has his peers to look up to and emulate but it doesn't do for him to be too clever; nothing amuses an older Rocker more than to see the 16-year-old, leather jacket still creaking with newness and boots, too gleaming ever to have seen any experience on a motorbike, swaggering like he's just burned up and lost the local Police Panda car.

Mick Mair is 22, slightly balding and smokes Holland House aromatic tobacco in a curly pipe, he is a classic example of a Rocker who has passed through all the phases. Recalling his first bike and leather jacket, Mick pulls on his pipe, grimacing with slight embarrassment. 'I 'ate to fink

'Well, I've sort of got to like bikes, 'aven't I, he's 'ad seven,' says Jenny, who is soon to marry Paul and become Mrs. Amey. Her attitude is typical of the rockers' girls. 'Most of the boys,' says another rocker, 'fall foul of marriage or motorcars'

60

GET TO KNOW YOUR LOCAL ROCKER
Text by Peter Martin *Nova*, September 1969

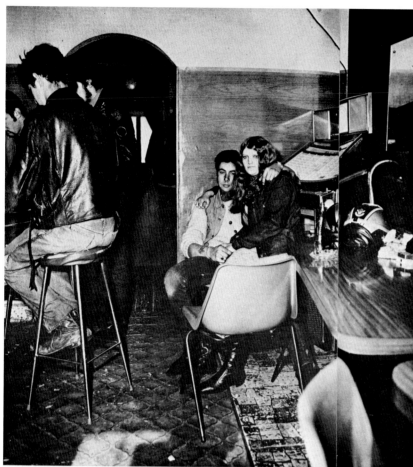

It is part of the Rocker culture that women, girl friends are to be dominated. But the shouting, the threatening and great show of domination is just that: show

about those days. When I was 16 I fought I was the greatest, a real King of the Plastic Cowboys. But it takes years to earn respect as a Rocker.

Mick has had seven bikes. 'I done it all,' he says, somewhat philosophically, 'the racing style with clip-on handlebars, the American style with the handlebars right up in the air. Now I've got the Norton Atlas 650, a fast touring bike. 300 quid it cost me. I was lucky: a kiddie put his bird up the spout and needed the cash sharpish, like. I do rallies and stuff like that with it.'

Paul Amey, 20, one of Mick's closest friends, also had seven bikes but his first was a big one, a Triumph Six-Fifty Thunderbird. He does lazy, confident things with his eyelids when he talks and is one of the few lads at the Day-Go whose slouchy arrogance is graceful, no longer affected but now natural with practice. Like Mick's, his leather jacket is festooned with metal motorcycle badges. Both boys also have a number of tattoos but it is perhaps a measure of a difference in their temperaments that Paul has a huge blue eagle tattooed right across his back. 'Tattoos ain't to make you seem 'ard,' he says. Paul is, however, one of the Rockers that the others would least wish to cross. And that he started fiddling bikes when he was only 14 goes down well with everybody.

One of the toughest looking of the Day-Go crowd is 'Mick from 'enfield' who has a shock of unkempt blonde hair, wears a thick, lined, sleeveless jerkin over his leather jacket. He works with Paul on the sea defences along the South Coast. 'The sea knocks the groynes down and we build 'em up,' he says, 'it's pretty regular work.' There are two other young men who work with Paul and 'enfield Mick': one is another Rocker but the fourth is a 'peanut'. A 'peanut' could be anyone who isn't a Rocker but it usually indicates a boy who has been or still is a Mod. The nickname is subtly derived, as Paul explained: 'You know one of them KP nut tins? Well, if you have a few nuts inside and rattle it about, it sounds just like a scooter. And that's what the Mods ride, don't they, bleedin' scooters? So we calls 'em "peanuts".'

Paul's phrase 'bleedin' scooters' is an apt introduction to the gamut of marvellous prejudices the Rockers feel for the 'peanuts' (and the Rockers somewhat defiant role is typified in Paul's comments about the 'peanuts' hairstyles: 'Well it's too bleedin' easy to be a peanut, isn't it? I mean if yer mum means at yer for 'avin' long 'air you just get yer 'ead shaved and, whoops, you're a peanut.' 'Anyway,' another Rocker explains, scooters was made for women. It's not a man's contraption. It's right, you know: they weren't meant for blokes.' 'Hairdriers' is another name the Rockers have for

scooters, understandable because the shape of the back end of a scooter, where the faring is shaped and ducted around the engine, is similar to that of a woman's hand hairdrier. 'Mind you,' one Rocker winked, 'most peanuts 'ave two 'airdriers. One for rattling around on. The other for doing their 'air. Well, I mean, looking at 'em you can't tell the blokes from the birds, can you?'

The Day-Go Rockers have very few brushes with non-Rockers. Partly this is because the café itself is out of the town centre and unknown to strangers who might be looking for trouble. Also, few if any of the Day-Go boys would volunteer for trouble as most of them have too much to lose; 'If you can't get a Rocker his bike,' is the principle they fear. The younger boys with cheap bikes or none at all seem to be more trouble-prone. One part-time rocker I talked to – not a regular at the Day-Go – told me of his marvellous machine and that he had not long been out of prison. It turned out his bike wasn't quite as he had de-

to have a go, aren't we?'

After the old truism about giving someone a role and they'll rise to it, the Rockers do enjoy a certain obliqueness with authority. As we were talking in the café, a Rocker flashed by on his bike with the police in pursuit. Minutes later it came back by some mysterious bush telegraph that the police hadn't booked him. The whole café cheered. One boy then said, 'Even the fuzz is human.' 'Yeah,' another joined, 'I met a copper once that was human.' Another wit leaned over to counter with a grin, 'He's an 'abitual liar, that bleeder.'

The extent to which some of the boys, and they are probably a minority, are truly submerged in their anti-authority role (which occasionally takes on criminal nuances), was characterised in a story one 20-year-old boy told. He knew a fellow who he didn't wholly approve of, who had committed armed robbery. 'With a real gun,' the boy said, 'and it was loaded with real bullets and do you know what he got, hahaha-

scribed it and he had not come from prison but from Borstal. The boy was not, though, merely lying: he wanted to associate himself with all that is notorious about Rockers, all that made him, as Mick says, feel that much less insignificant.

Not that the Day-Go boys are all model citizens. Of trouble, a few said that if they go away for the weekend it is easier to have fun – they meant trouble – because there is little chance of police being able to trace strangers. Being a Rocker does somehow commit the boys to meeting part of their reputation. 'If there's a bunch of us and a bunch of peanuts,' Mick says, 'well, if they start, we're sort of obliged

hahahaha, he got, hahahahaha, 14s 6d! Fourteen and bleedin' six! With a real gun! What a bloody nutcase!'

The majority of misdemeanours, of course, are traffic offences which have risen since the imposition of the 70mph maximum speed limit. The temptations to do more than crash the speed limit are often too great.

Mick Mair's last road offence was a show of acrobatics and, in relating the consequences, he throws some light on the Rocker's sense of public prejudice. 'It was one of those days when there happened to be about 40 of us out for a ride. I works me way up to the front of the bunch,' and here Mick winces at his own silliness and bad luck, 'and

Mick and Tom Mair: not related only competitors and companions in armour. Each owns a highly specialised machine but, as both of them insist: 'His is rubbish.'

Both enjoy respect as senior Rockers who have done it all; whose jackets have taken on a beaten look; who've got and learned to ride bigger and better bikes

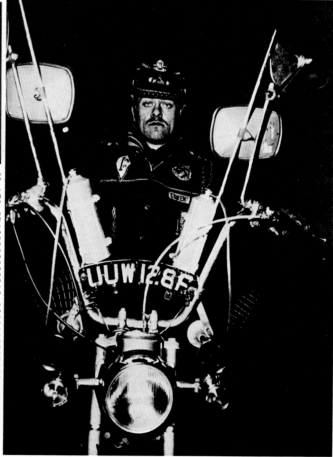

then I starts to perform, don't I?' He throws up his eyes: 'There I was, kneeling on the saddle, waving me arms and legs about and then the fuzz appears, dunnit? But the way it was put in court got me. The law said I was l-e-a-ding a *gang* of leather jacketed motorcyclists. Sounded terrible! You should have seen the magistrate's face! Anyway, I'd turned up in what I call me demob suit – sort of smart and diabolical at the same time – and I was lucky to get off with a three month ban, real lucky what with "*leading a gang of leather-jacketed motorcyclists*".'

There is something romantic, almost idealistic, about their status as mini-outlaws and this is borne out by their legends. There have been two accidents outside the Day-Go café and any one of the Rockers can recount the details of either. One involved a Rocker who was killed outright by a car. 'Dragged along by the sump for about 50 yards,' one of his friends recalled. 'Terrible thing was that he gave one of his kidneys to a kid a short while before. Death Straight, this stretch is.' There is also a story of a ghost of a Rocker which is supposed to appear at a crossroads but no one was sure exactly where this was. Another tale is of a Rocker who gave a girl a lift, asked her address and, when he got near to where she lived, discovered that she was missing from the pillion seat. He called at the address she had given him to discover the girl had died since two years before.

It is part of the Rocker culture that women, girlfriends, are to be dominated. But the boys' shows of domination – shouting, ordering or even

threatening them to fetching a cup of tea – is just that: show.

Another essential part of being a Rocker is the telling of stories. Some, like that of Mick Mair's acrobatics, are both amusing and exciting but the general run of stories is not so interesting. Between games on the pintable, a 17-year-old boy revelled in all the split-second details of a recent accident he'd had. By his action, the damage to persons and vehicles was minimal. Certainly, the story was heroic and true. But they had heard it all before, and even the scuffs and tears on the boy's jacket had lost their intrinsic interest. The act of telling is all, because it is so much a part and, indeed, proof of being a Rocker.

There is, of course, a degree of friendly inter-Rocker rivalry. Tom Mair, no relation to Mick, has a Triumph and Mick a Norton. One afternoon Mick brought to the café a tape-recorder on which he had recorded a mock motorcycle race with engine noises and commentary done by himself. The commentary ran, 'Brrrrr-oooooooowwwwww, and here comes Mick Mair leading on his beautiful six-fifty Norton,' and you hear the bike roaring healthily off into the next lap before: 'Put-put-put-put-chg-chg-chg-chg,' and here, on his clapped-out Triumph, eight laps behind in this six lap race, is Tom Mair.' The café roars with laughter and Tom is reaching for something to throw at Mick, a roll or a cake.

The real sense of membership, of belonging among all Rockers is no more apparent than when they get together. The Fifty Nine is a motorcycle club in

Paddington, the largest in the world. It is run by a priest. One Saturday evening I went there with some of the Day-Go boys.

Several of them went on bikes and I took four other Rockers, including Paul and his girlfriend, in my car. The journey from Brighton was uneventful except for a small incident. In a line of steady traffic, our car was closely scrutinised by a policeman on a motorcycle. It seemed as if he swerved when he saw the car was full of long-haired youths in studded leather jackets who were studying him and his surprise with cheeky amusement. He stopped us, checked us, and bewildered, left us.

As one man, the boys cheered, fully aware of why he had stopped us.

'We ought to start a newspaper and write things about other people,' Jenny said.

The dance at the Fifty Nine Club was amazing, a complete and well preserved anachronism of 1958. The upstairs dance-hall was filled with about 600 young Rockers. A Rock 'n' Roll group was playing, the Wild Angels. The piano was Honky-Tonk with the front taken off; the pianist's hair was long and greased, sculptured at the front into a huge elephant's trunk; the lead guitar was painted sunglasses; and the singer, who wore a draped jacket, was on his knees and swinging the mike about in the first number. The Rockers loved it. A few jived but most just stamped their boots. When Jailhouse Rock was played the house was so near to coming down that one of the organisers asked that they shouldn't stamp so hard as the floor

might go through. It was a riot of terrible noise, violent dancing, pushing and laughing to the roof in near hysteria.

And in the middle of it was a spotty 16-year-old boy wearing a new pair of boots. He, most of all, was the explanation of why Rockers endure. There was no one more gauche, more artless in the whole place. Even as he stood, he squirmed with self-consciousness. He would carefully fit his thumbs into his new heavy belt and then inspect the smartness and newness of one of his boots before placing it, satisfied with his stance. Then he would put all his wit and talent – and it wasn't much – into acting out the scowl he put on his shy face. And there he stood.

Later in the evening this spotty boy had the prettiest girl in the place on his shoulders. She was not ashamed to be with such an artless boy. They were both Rockers, that was it. And moreover, for this boy who had been strutting, puffing his chest and scowling one could see that it was all worth it. All the telling off from his parents; all the trouble at school over his hair and dress; all the prejudice of police, publicans, dance-hall managers, even strangers; everything. Tonight he was playing King of the World and not one of the 600 people around him minded, no one took exception to his pathetic charade of toughness. And soon he would be a real Rocker; his jacket would take on a beaten look; he would get and learn to ride bigger and better bikes; he would be accepted, probably revered. And nothing anyone could do would convince him that all he might suffer was not worth it.●

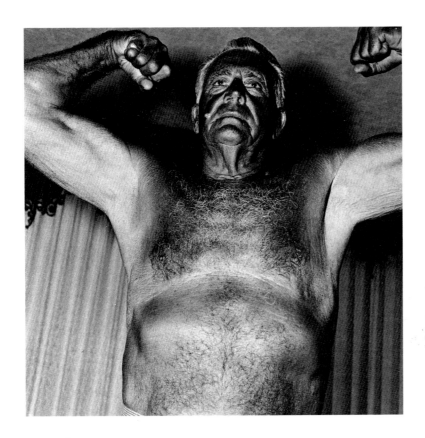

"BUT LADIES, I AM 76 YEARS OLD." THE WORLD'S MOST
PERFECTLY DEVELOPED MAN NOW LIVES AMONG THE AGED
IN FLORIDA. BUT AGE, TO CHARLES ATLAS, DOES NOT MEAN
BEING REDUCED TO A SEVEN-STONE WEAKLING AGAIN.
Text by Philip Norman *Sunday Times Magazine* (London), October 19, 1969

Charles Atlas, who was crowned "World's Most Perfectly Developed Man"
in 1922 by *Physical Culture* magazine, at his Palm Beach home

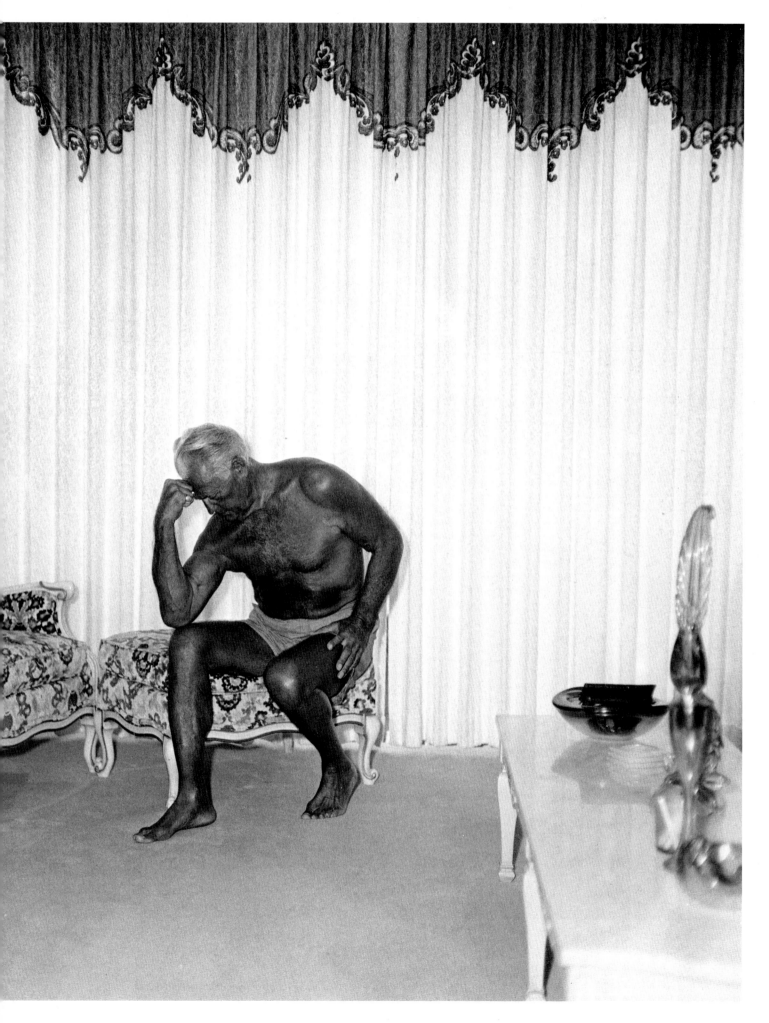

Norma Falk/Queen Elizabeth

PEOPLE WHO THINK THEY LOOK LIKE OTHER PEOPLE
Interviews by Pauline Peters and Margaret Pringle *Nova*, October 1969

Some who answered ads in the London newspapers for look-alikes

Winston Churchill look-alike

JACQUELINE SUSANN: THE WRITING MACHINE
Text by Sara Davidson *Harper's Magazine*, October 1969

Jacqueline Susann and husband Irving Mansfield in their Beverly Hills
hotel room after she entered the *Guinness Book of World Records* for selling 6.8
million copies of *Valley of the Dolls* in the first six months after publication

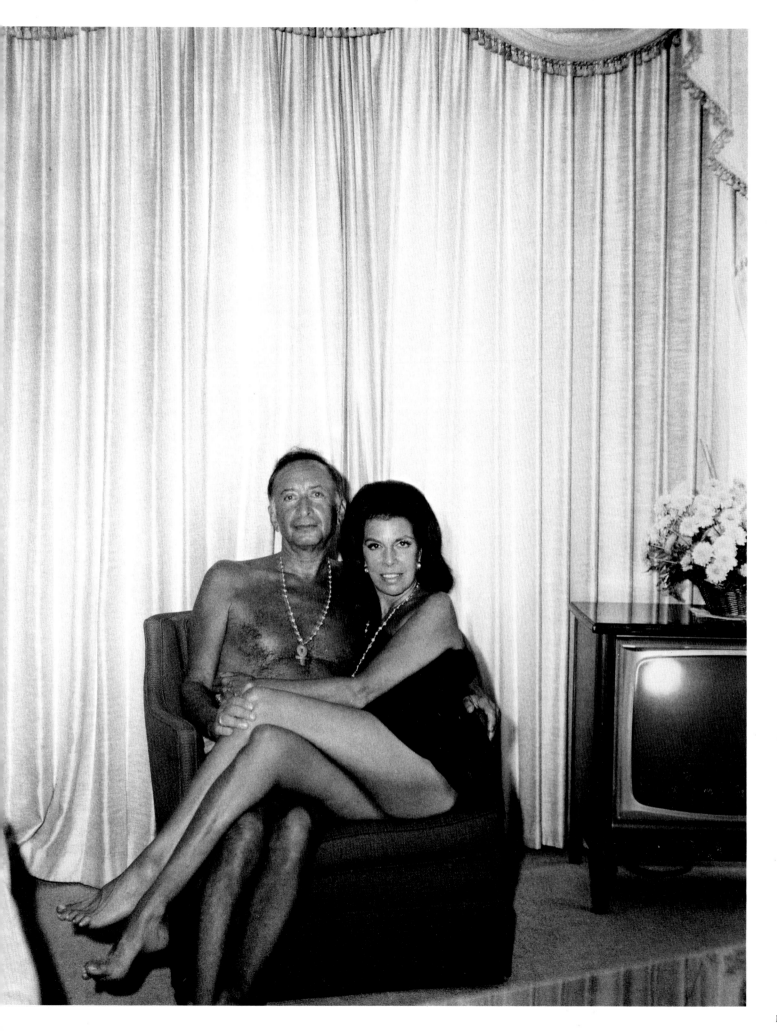

MADAME TUSSAUD'S WAX MUSEUM
Unpublished, 1969

Four tableaux of famous wax figures

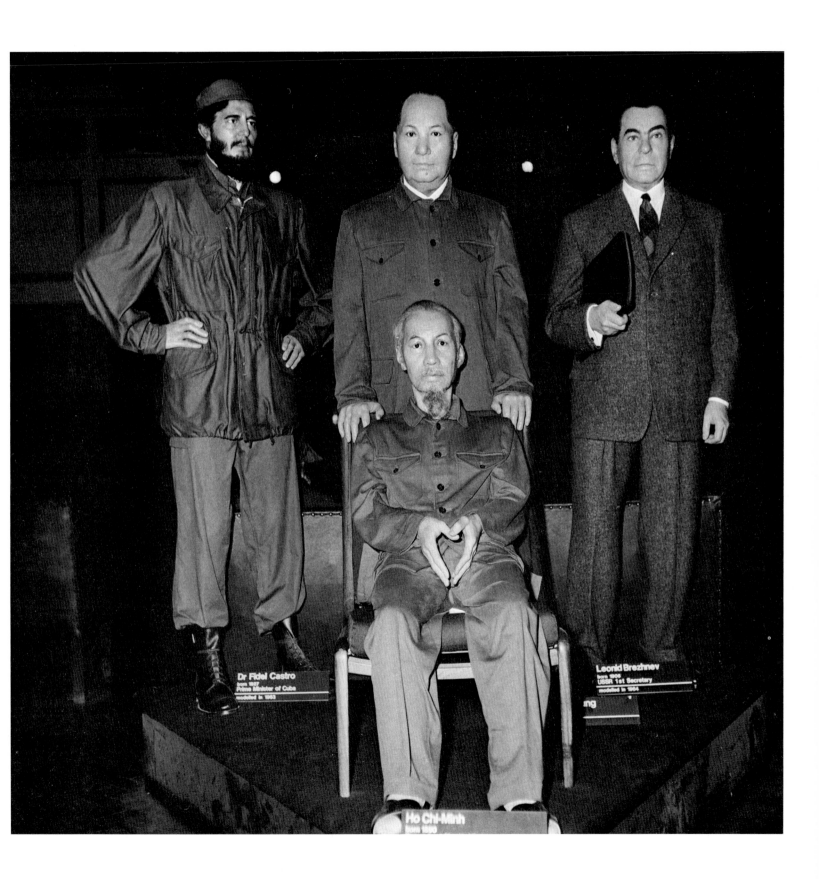

Dr Fidel Castro
born 1927
Prime Minister of Cuba
modelled in 1953

Ho Chi-Minh
born 1890

Leonid Brezhnev
born 1906
USSR 1st Secretary
modelled in 1964

137

JOAN CRAWFORD FAN
Unpublished, *Sunday Times Magazine* (London), 1969

CONVERSATION: IDA LEWIS AND REV. ALBERT B. CLEAGE JR.
Interview by Ida Lewis *Essence*, December 1970

Rev. Albert B. Cleage Jr., pastor of the Shrine of the Black Madonna in
Detroit, and author of *The Black Messiah*, a theological statement on the
Black Revolution

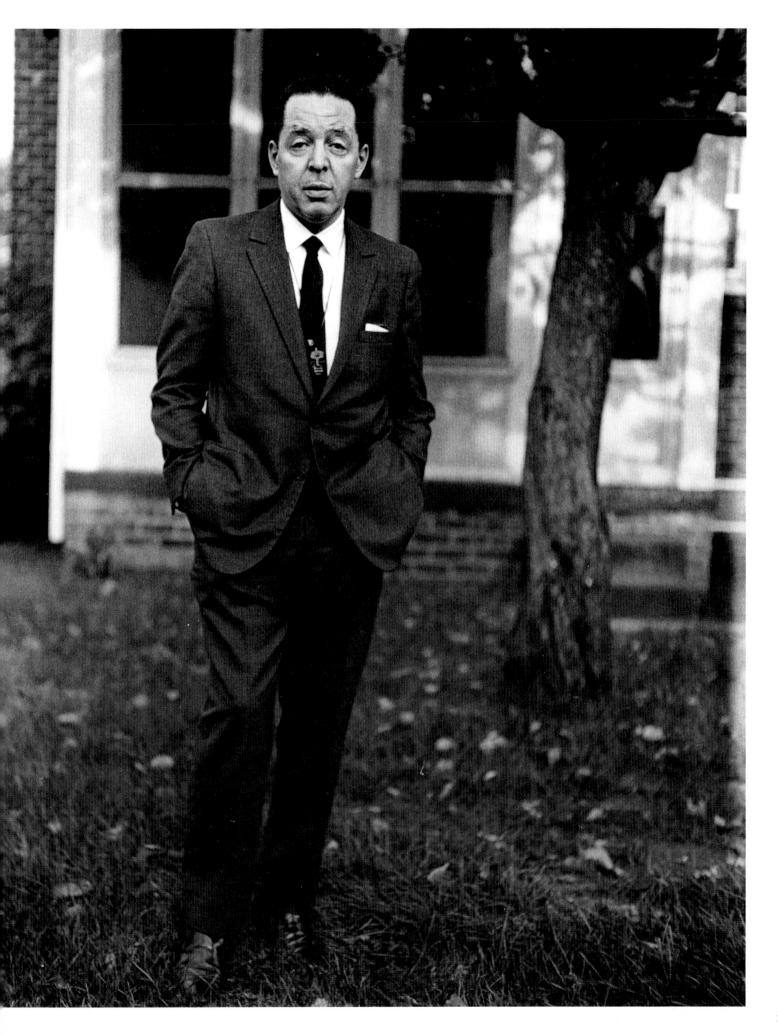

THE AFFLUENT GHETTO
Text by Ann Leslie *Sunday Times Magazine* (London), January 1, 1971

Two custom-built leisure communities in America

Sun City, retirement community

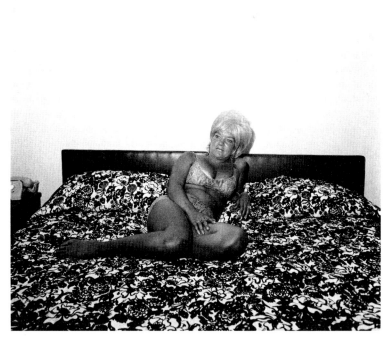

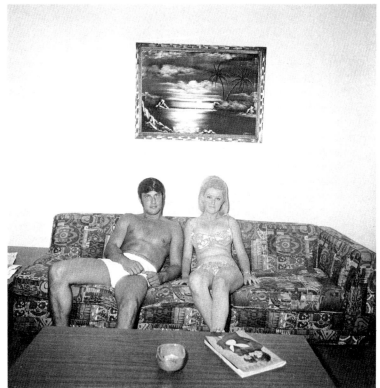

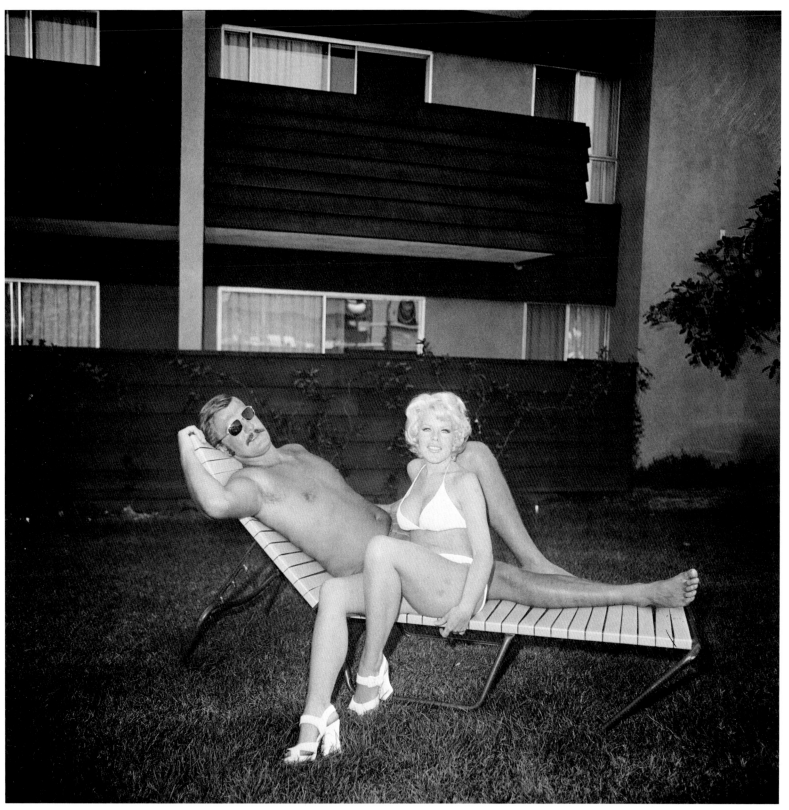

South Bay Singles Club

The Last of Life....

by Gina Berriault

An introduction to a brand-new species, suddenly mutated, that must be reckoned with, kept separate, and observed

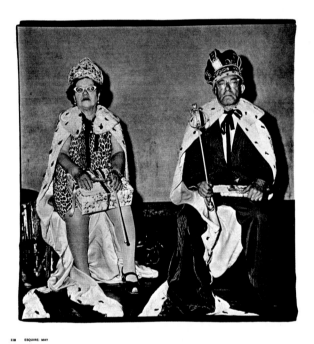

Yetta Granat, seventy-two, and Charles Fahrer, seventy-nine, had never met before their names were picked from a hat at a senior citizens' dance in New York. They reigned for the evening as king and queen of the ball.

What it looks like is a picket line against God. They are old, some very old, and they are dancing in the church, up there on the stage where on Sundays the pastor preaches, all holding a long, false vine of flowers, the women in diaphanous, pastel gowns and gold shoes, the men in chorus black and berets, and all singing, with their strained, untunable voices, WE LOVE LIFE AND WE WANT TO LIVE, demanding of Him what He has denied everybody so far. Below the red bow ties and the ribbons round the necks, the bodies, sashed and corseted, are deceptively similar to what they were decades earlier, the feet nimble, tricking the dictates of the baby grand; above, the faces are stunned by age, irretrievable. The spectators, some with mouths fallen open, not with enthrallment but with the stun of their own oldness, are in clothes from the Goodwill racks or else their own for half a lifetime. A lone young man, a derelict who has wandered in from the Tenderloin in whose center the Glide Memorial United Methodist Church is situated, mingles well.

Some are onstage for the first time in their lives and some were entertainers in their youth; a motley troupe, they are drawn together by age and by their need to publicly resist it, as if to perform for an audience is to force His attention, too. She's throwing roses to the front row, her black-feather picture hat back in use to adoringly frame her face, her fox-fur cuffs, almost as long as her gown, swinging again, her gold sandals, with little hourglass heels, in flirtatious touch with the stage that brings her again to life. Without the microphone her voice might sound like the chirp of a barely born bird. A couple of sailors and their girls in apricot gowns dance around one another; a buxom woman, twirling a black parasol, parades back and forth, declared to be Lillian Russell, at last fulfilling for herself the common wish to be mistaken for some famous beauty. Ages are sometimes called out, as if the performers are children and precocious. A chanteuse in a red, sequined dress promises great pleasures in Paris. A man in a tux, a woman completely in gold waltz together to his song: *In dreams I kiss your hand, Madame, your dainty fingertips/ Just when I hold you tight, Madame, you vanish with the night, Madame....*

The Tenderloin is that section of downtown San Francisco where whatever may be undesirable for some is desirably concentrated for others. Black facade bars; barkers at the entrances of bars before flappy black curtains beyond which are the completely nude go-go girls; male and female hustlers, black and white; porno movies; dirty-book stores and dusty bookstores; hotels that once had class and others that had none to begin. Eleven thousand of the city's old live in the downtown district that encompasses the Tenderloin, unable to afford the higher rents elsewhere that have risen with taxes and inflation and often prejudicially with the age of the tenant. Old women in the lobby of a Tenderloin hotel whose management caters to the old side by side of an evening on all the sofas, coats over knees, necks sinking forward as infants' do, staring out at the traffic. Some twenty chosen persons of the neighborhood, incapacitated for a time in body or spirit, are brought hot lunches in paper bags, prepared by Salvation Army volunteers and delivered by volunteers from the Council of Churches. But who are in all the rest of the rooms? One inmate, though she could be heard stirring around, failed to open the door to a friendly volunteer who left a calling card under the door on the first day and knocked every day for six days thereafter. At last, accepting this persistence as a sign of interest, she opened the door a crack.

Some appear more often. They come out to visit the O'Farrell Street Center, one of the many throughout the city called Senior Centers, granting at least the sound of respectability, even of prestige, to the old. A barbershop once, the center has display windows; but the members, growing less shy day by day, seem not to mind being observed. Across from me at the table where twelve or so sit over tea and cookies is a taciturn man who speaks only to say that he was born in Berlin, has lived in Palestine, and knitted and crocheted himself his jerkin of many colors, sectioned like a Mondrian. A thin, sallow man, in a black suit that is clean and pressed but whose fibers have sweated out the years, sits next to me. Seventy-six; his profile is biblical, his hair is thick and dark, he smiles almost always. Of Armenian descent, born in Boston, he came to the city in 1917. "I always worked," he says. "Always done a day's work. Then I went home and ate supper. Then I went down to meet my roommate who had a shoe-repair shop."

"Take your spoon out. You'll stick it in your eye," cautions an old woman, passing.

White, opalescent edges circle the irises of his large-lidded eyes. The last job he had was fifteen years with a wholesale dry-goods company, taking orders, packing merchandise. He plays the tambourine in the center's six-piece orchestra. Vacuuming has begun, it is almost closing time. A male senior is pushing chairs to the side, vacuuming under the tables. Above the dreary roar the plump woman across the table goes on talking to me. Around her grey curls is bound an orange yarn; earrings almost as large as real oranges swing unceasingly; on her nails, gold polish. She wears tight yellow pants, a beaded black sweater. Her eyes appear to be embedded in blue suns comprised of blue swellings under, blue cosmetic on the lids, and the rays of a constant smile that is both skeptical and ingratiatory. Outraged over the communal toilet's overflow and the moldiness of the first hotel, where the rate for her room was $125 a month, she moved out to another, a little nicer. Once a week she treats herself to a $1.49 meal—steak, potatoes, green salad. "I was on *The Joey Bishop Show*," she tells me several times. "I wore a red hat and a black velvet dress with white collar and cuffs." Her husband, dead now, was a realtor. Figuring she might not live to be sixty-five, she took her Social Security at sixty-two, losing almost twenty percent. We walk out together into the Tenderloin scene. Even in the cold wind her smile is fixed; her voice seems fleshed by the smiling cheeks. "I like the finer things in life," she says, her last words. The wind blows stronger at the corner where we part.

Over at the Glide, meanwhile, the Conference on the Aged is going on. In the Fellowship Hall, young and middle-aged delegates from around the country and the many old of the Glide's own Senior Center sit down together for refreshment: coffee or tea, pastry, a sliver of matzo. The Mistress of Ceremonies, an elderly woman who stands on a box to get close to the microphone and who, later, in the vaudeville, plays a child in a cape, reminds herself from the lined notebook paper: *Joke #1: etc. Joke #2: etc. Poem: Although the years bring aches and pains that render our muscles inert/ One consolation still remains, Thank Goodness our wrinkles don't hurt. A reminder that this is Passover. Jos. Addison said The essentials to happiness are something to do, something to love, and something to hope for. Blessing: Read from the napkin. Ivy Barnes' son passed away. Mr. Gadwake and the 1906 Quake. 9 boxes date nut toasties @ 8¢=etc.* It is a big dining hall with long tables, folding chairs, an upright piano. Somebody tears a sandwich in two and gives me half. The Chinese gentleman next to me, seventy-eight by his country's calendar, two years less by ours, hands me a poem from his briefcase, titled *Age*, that begins: *A man must be taught to be able to control his age/ And never let age control a man, said our Sage.* Rising every morning at five, he exercises every part of his body. "Trouble can start in a joint of the little finger." The delegates are introduced, rise to say a few words. A woman from Nashville urges them with her strong, authoritative voice to keep their "noggins alive." The grey matter on the inside, she tells them, is more important than the grey on the outside. Some faces seem not to be listening closely.

The delegates, by themselves later, confer about housing for the Aged of meager income. The Old are the most deprived of all groups—economically, to name only one kind of deprivation—and at the bottom of this heap are the Aged Blacks, more than familiar with discrimination and want. The White Elderly get used to these things a little later in life. In immense settlements of thousands, the Old live in mobile homes that are not going anywhere. Counties are erecting low-rent housing, though the choice is given to the residents around the selected site as to whether or not to permit such congregations. In these dwellings certain things for the peculiar welfare of the tenants must be considered: Suppose the tenant falls in the hallway. Will his arm be wedged between rail and wall? The space between is crucial. An alarm system should be installed in every room, and low enough so that the tenant, if only he can drag himself over to the but- *(Continued on page 28)*

Photographed by Diane Arbus

THE LAST OF LIFE

Text by Gina Berriault *Esquire*, May 1971

Yetta Grant, seventy-two, and Charles Fahrer, seventy-nine, had never met before their names were picked from a hat at a senior citizens' dance in New York. They reigned for the evening as king and queen of the ball

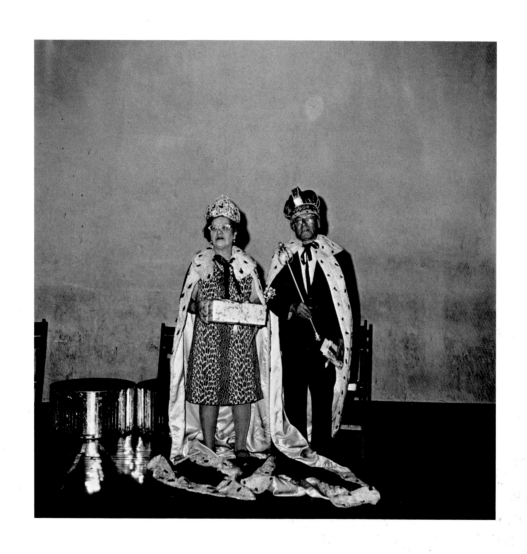

THE HAPPY, HAPPY, HAPPY NELSONS
Text by Sara Davidson *Esquire*, June 1971

Ozzie and Harriet Nelson and their sons Ricky and Dave, stars of radio
and of the television series *The Adventures of Ozzie and Harriet*

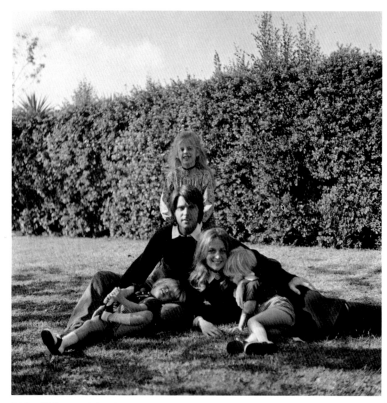

Ricky Nelson and family

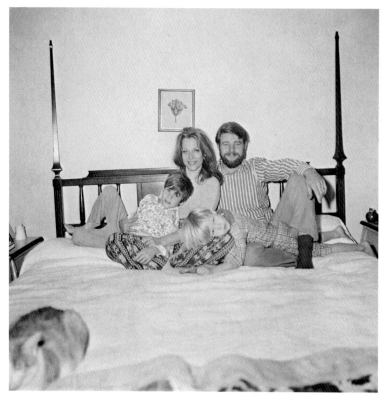

Dave Nelson and family

149

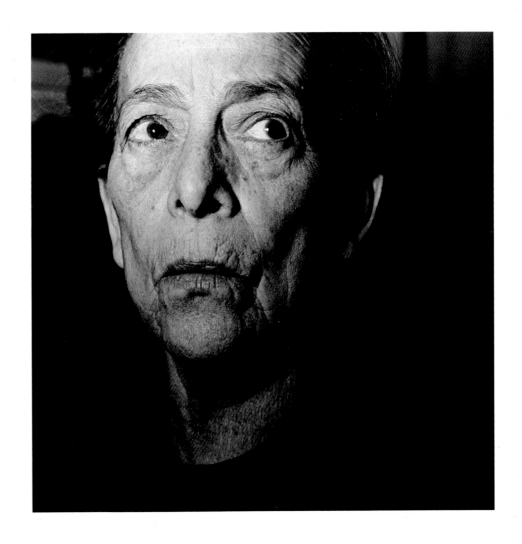

HELENE WEIGEL
Unpublished, *Harper's Bazaar*, 1971

Bertolt Brecht's widow, director of the Berlin Ensemble
in East Berlin

GERMAINE GREER >
Unpublished, *New Woman*, 1970

Australian-born feminist and author of *The Female Eunuch*

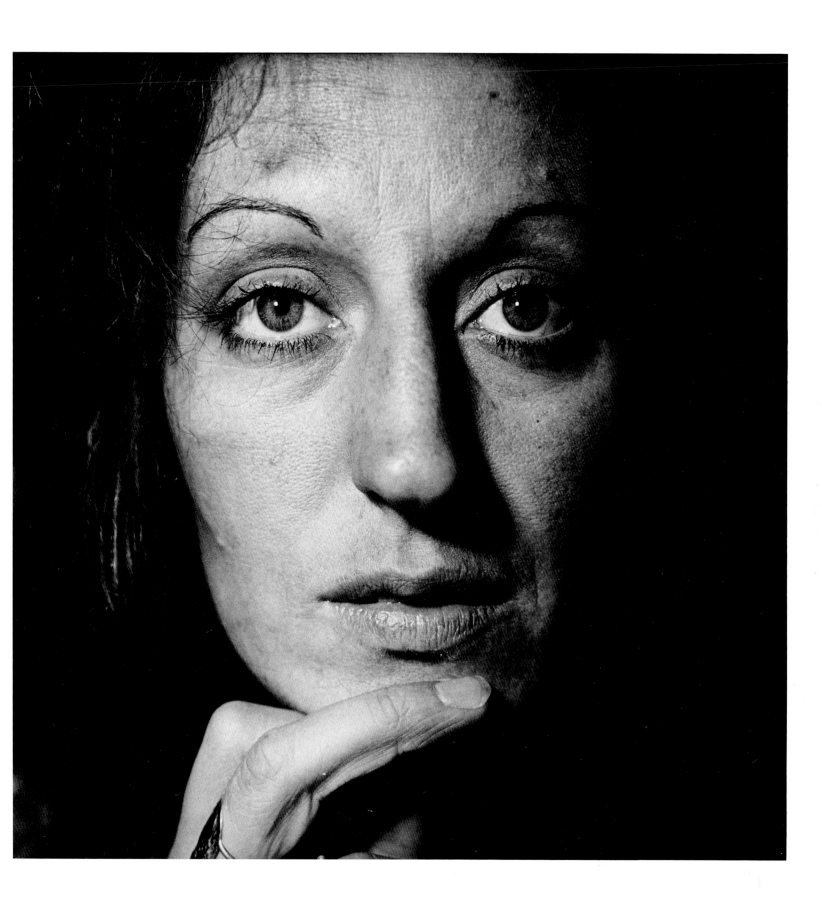

THE MAGAZINE YEARS, 1960–1971

by Thomas W. Southall

Sandwiched between articles on Manhattan museums, restaurants, and nightlife, Diane Arbus's portraits of six "typical" New Yorkers were a striking contrast to the rest of *Esquire*'s July 1960 special New York City issue. Titled "The Vertical Journey: Six Movements of a Moment within the Heart of the City," the article was intended to illustrate the dramatic extremes of life-styles and personalities found in New York. This portfolio of direct, unsentimental portraits, Diane Arbus's first published work, marked the beginning of her career as a commercial photographer.

Between the appearance of "The Vertical Journey" and her death at age forty-eight in 1971, she published over 250 pictures in more than 70 magazine articles. *Esquire* alone published 31 photographs in 18 different articles. *Harper's Bazaar*, the other main forum for her work, published 63 photographs in 22 articles. In the late 1960s, two London publications, the *Sunday Times Magazine* and *Nova*, became enthusiastic supporters of her work. Other magazines for which she worked with less regularity included *New York*, *Show*, *Essence*, *Harper's*, the *New York Times*, *Holiday*, *Sports Illustrated*, and *Saturday Evening Post*.

During her lifetime, Diane Arbus's magazine photographs were seen by a large audience and were instrumental in establishing her reputation, but they have since been overlooked and have become virtually unknown. Her portraits of writers, movie stars, artists, socialites, and other public figures, which constitute most of the work she did for magazines, form a cross-section of 1960s popular American culture. They add a broader perspective to the range of anonymous subjects—the ordinary people she discovered in New York City's parks and streets, and the nudists, transvestites, and carnival performers—that have come to be identified with her work, as depicted in The Museum of Modern Art's 1972 posthumous retrospective and in *Diane Arbus: An Aperture Monograph*, published that year. Although working for magazines was primarily important to her as a means of earning a living, she appears to have drawn no easy distinction between her approach to an assignment and her approach to a project of her own. As a result, the technical and stylistic changes evident in the photographs she took for magazines over the course of eleven years reflect the development of her work as a whole. They also demonstrate that her direct, apparently simple style was actually the result of a persistent effort to discover the techniques best suited to her photographic intentions and to find the most appropriate, most telling approach to the variety of subjects that confronted her.

Diane Arbus first started taking pictures in the early 1940s. Several years later, she and her husband Allan Arbus embarked on a career in fashion photography and soon began to establish a reputation for their work, which appeared in *Glamour*, *Vogue*, and other fashion magazines. In its April 1947 issue, *Glamour* published a short article on married couples with joint careers, "Mr. & Mrs. Inc.":

> Diane and Allan Arbus found their forte in photography . . . working very slowly and carefully, they compose in the camera instead of relying largely on cropping and other mechanical photographic tricks. Result, a distinctive Arbus quality which includes elements of portraiture and fantasy.

Although her husband was the one who actually took the photographs, she contributed a great deal to the general look of them, including the choice of models, the styling, and the concept, which was often inspired by the work she saw in *Harper's Ba-*

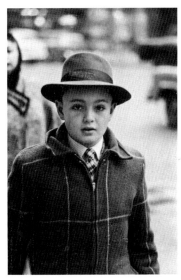

Photograph taken in 1956, an early example of Arbus's 35mm work

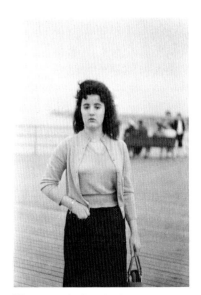

Woman on the boardwalk in Coney Island, where Arbus regularly photographed in the late 1950s

zaar or other magazines. She regularly took their portfolio to editors and art directors, discussed new assignments with them, and, in the process, became familiar with many aspects of the business.[1]

Throughout this period she continued to take pictures on her own and in the mid-1950s attended a photography course taught by Alexey Brodovitch, then art director of *Harper's Bazaar*. It was only around 1956, however, when she stopped working with her husband and was able to pursue her own work exclusively, that her interests began to take shape.[2] She was using a 35mm camera in the tradition of the street photographer. Her subjects were those typical of the serious amateur: children, shop-windows, people glimpsed at a distance on the street, in the park, and at Coney Island's beaches and bathhouses. Around 1957, she enrolled in a series of workshops taught by Lisette Model, some of whose work had been published by Brodovitch in *Harper's Bazaar* between 1941 and 1953, and whose earlier portraits of French Riviera gamblers and tourists and the denizens of New York City streets, bars, and jazz clubs prefigure, in style and content, some of the territory Arbus would later explore. Although Arbus remained unfamiliar with Model's photographs until years later, these workshops began to inspire a change in her methods. They encouraged her to become more specific, more daring, and more diligent in her work.

Around this time, she discovered Hubert's Museum, a flea circus located in the base-ment of one of 42nd Street's penny arcades, with its old posters of carnival perform-ers, its exhibits, and the live show put on by sideshow freaks. The performers soon grew accustomed to seeing her there several times a week, standing in the audience with her camera, watching the show over and over again, photographing their acts. It was here that she met Hezekiah Trambles, "The Jungle Creep," and Andrew Ratoucheff, the Russian midget, whose portraits later appeared in "The Vertical Jour-ney." She also found a female-impersonator club in lower Manhattan, Club 82, and by means of the same sort of dogged persistence eventually obtained permission to spend time in the dressing room, taking portraits of the performers while they ap-plied their makeup and got into costume for the show. She returned to the club many times and in the end made prints of almost fifty photographs she took there.

These two projects were significant as the first examples of a working method Arbus continued to employ throughout her career. The people she came to know at Hu-bert's and Club 82 introduced her to other people, other places, other events, and helped her begin to build a kind of network for developing and researching ideas for new projects.[3] Furthermore, although she probably did not originally conceive of her work at Hubert's and Club 82 as magazine stories, the work itself has certain perhaps inadvertent journalistic characteristics. She seems, in these instances, to have been less intent on extracting from the experience a single, entirely self-sufficient image than in portraying, through a series of photographs, the people and the atmosphere of a particular place.

1. Doon Arbus, interviewed by Thomas W. Southall (New York, N.Y.), December 1983.
2. The credit line "Diane & Allan Arbus" continued to appear on Allan Arbus's fashion photographs through the early '60s, several years after Diane Arbus had stopped working with him.
3. Southall interview with Doon Arbus.

When Diane Arbus began taking her work to magazine editors in the late 1950s, she was following in the footsteps of a number of other photographers, including Robert Frank, Louis Faurer, and William Klein, as well as Richard Avedon and Irving Penn, who had found in magazines a means of earning a living and getting their work pub-lished. Books of photography were rare in those days, galleries dealing in photo-

graphic prints were virtually nonexistent, grants were naturally hard to come by, and museums were still adhering to fairly rigid definitions of what constituted photographic art.

Arbus entered the magazine business during a period of change that continued well into the 1960s. Some magazines, such as *Harper's Bazaar*, had already established a long tradition of innovative design in the use of photography. Others, such as *Esquire*, were in the process of radically redefining their editorial and visual content. At the same time, many opportunities were provided by new magazines and newspaper supplements in both the United States and Europe, including *New York*, *Queen*, *Nova*, the *Sunday Times Magazine* (London), *Twen*, and *Paris Match*. Although the popular picture magazines, such as *Life*, provided their staff photographers with prestige, relative security, and generous expense accounts, other publications with less rigidly defined identities and less cumbersome bureaucracies were often able to offer their contributors more freedom.

This period of experimentation may have been inspired by the need for magazines to establish clear, exciting alternatives to the growing competition of television in the battle for an audience and advertising dollars. The result, however, had more than an economic impact. It created an atmosphere of healthy competition in which the staff and contributors of leading magazines were constantly attempting to challenge, expand, and redefine the nature of the publications themselves and the important cultural, political, and social issues of the day.

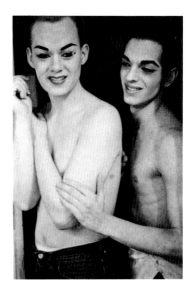

Female impersonators backstage at New York's Club 82 in 1962

In the fall of 1959, Arbus took some of her photographs to Robert Benton, art director of *Esquire*. Long known for its great fiction, Petty and Varga pinups, and men's life-style and fashion features, the magazine was developing a new character that emphasized contemporary events and topical issues. Under the leadership of Harold Hayes and Clay Felker, it was becoming a major publisher of the New Journalists, among them Gay Talese, Norman Mailer, and, later, Tom Wolfe. Although these writers differed greatly from one another in style, most of them employed a highly descriptive, frankly subjective prose, applied certain novelistic techniques to traditionally journalistic topics, and frequently depended for the effectiveness of these techniques on a personal involvement with their subjects. Referring to this style, Gay Talese commented, "I'm not so interested in what he did and *said* as I'm interested in what he *thought*."[4]

Esquire's shift from fiction to reporting the contemporary scene inspired the magazine to seek out young photographers whose work embodied a personal viewpoint. In 1959 Robert Frank illustrated an article on Hollywood with a series of dark, grainy photographs similar in style to his work in *The Americans*, which had just been published in the United States. That same year, Bruce Davidson's study of a Brooklyn teenage gang was published with an accompanying text by Norman Mailer.

Esquire's founder, Arnold Gingrich, later described the photographer's new role:

> The exigencies of monthly magazine deadlines preclude reportage as such, whether with a camera or with a typewriter. . . . So what's left to show you, like what is left to tell you, must be largely interpretive by the time a monthly magazine comes around. . . . The photograph plays a dual role as historian and as commentator.[5]

Arbus's work seemed a perfect visual complement to this evolving approach.

4. "A Discussion Conducted by Professor Leonard Wallace Robinson of the Columbia Graduate School of Journalism with *Esquire*'s Editor Harold Hayes and Writers Gay Talese and Tom Wolfe, Exponents All, of The New Journalism," *Writers Digest*, 50:1 (January 1970), p. 34.
5. Arnold Gingrich, "Publisher's Page," *Esquire* (May 1967), pp. 6, 64.

Benton had not met Arbus before she came to show him her pictures. He was intrigued by the photographs he saw, but doubted the magazine would publish them. Hayes, assistant to the publisher, reacted to the work with equal enthusiasm. He was particularly struck by the portrait of Hezekiah Trambles, who reminded him of the sideshow geek played by Tyrone Power in the movie *Nightmare Alley*.[6]

At first they considered assigning Arbus all the photography for the special New York City issue, but soon decided her vision was too tough, had too singular a perspective to sustain an entire issue. Instead, they began working with her in an effort to add examples of the upper stratum of New York society to the range of subjects she had already photographed. Hayes suggested she look into Beauty City, a twenty-four-hour hair salon on 47th Street and Broadway, "which you might like to compare with an *haut monde* salon such as Arden's."[7] He also suggested she photograph in the city morgue, which eventually resulted in the final picture of the portfolio. From the start they appear to have intended to emphasize social contrasts by pairing upper- and lower-class subjects. Although the idea was not new—Weegee's sardonic photographs of New York City's socialites and transients were well known at the time— Arbus brought to it an unswerving directness all her own.

Benton, Hayes, and Toni Bliss, Hayes's secretary, worked with her from October through the following March, identifying appropriate subjects and helping her secure the necessary introductions, permissions, and releases. This was an extraordinary amount of time and attention to devote to the work of an unknown, untried photographer. Many of their ideas, such as the proposal to photograph Lauren Bacall and Leland Hayward in their dressing rooms before the opening of *Goodbye Charlie*, or to do portraits of Elizabeth Taylor's children, which Arbus referred to as "a splendid thought,"[8] or to take pictures in The Tombs, a city prison whose director demanded a substantial "donation" in exchange for his consent, had to be abandoned because of the difficulty in obtaining permission. A series of letters documents *Esquire*'s futile attempts to arrange for Arbus to photograph Joan Crawford. According to a memo written by Bliss, Crawford, in reply to this proposal, had said that she never heard of Diane Arbus and that she would have to see samples of her work before agreeing to pose. The movie star's suggestion that "the photographer who did the pictures of me in *Town and Country* was so good. Why can't he shoot these?" did not promise to produce the sort of portrait the editors had in mind.[9] Toni Bliss finally sent a note to Hayes:

> Personally, I wonder if the great Miss Crawford might not scare the living daylights out of Miss Arbus. I imagine she'd react more favorably to Bruce [Davidson] and the Magnum name, don't you? Or Derujinsky?[10]

Meanwhile, Arbus continued proposing additional ideas for the project. In the fall of 1959, as the notion of photographing Joan Crawford was about to be abandoned, she wrote Benton a letter:

> Joan Crawford doesn't look so very splendid, besides that's rather enough of her. Maybe there are better closets. . . . I have been peering into Rolls Royces and skulking around the Plaza and Thursday evening I am to meet a half man, half woman to see if she (it is referred to as she) will take me to her house. . . . I was looking for some club that would be good for the upper in the sense of respectable like the D.A.R. or the W.C.T.U. or a society for the suppression of something or

6. Harold Hayes, interviewed by Thomas W. Southall (New York, N.Y.), November 1982.
7. Note from Hayes to Arbus, February 2, 1960.
8. Postcard from Arbus to Toni Bliss, undated, c. November 1959.
9. Memorandum from Bliss to Hayes, undated, c. October 1959.
10. Ibid., different memo.

155

other like vice or sin. Maybe his secretary could find one such. Brady once photographed the D.A.R. and it was, in the French sense, formidable. Here is something promising from your *Daily News* [she attached a clipping announcing the Opera Ball, where she later photographed Mrs. Dagmar Patino]. Meanwhile, please get me permissions, both posh and sordid. . . . The more the merrier. We can't tell in advance where the most will be. I can only get photographs by photographing. I will go anywhere. The Edwardian Room and the Salvation Army.[11]

Over the course of a four-month period, Arbus took a remarkable number of photographs intended for what was to result in a relatively small portfolio. According to records kept by Bliss, their subjects included a horse show, stockyards, a children's dancing class, a carnival, the Police Academy, a narcotics ward, elderly people on Welfare Island, Roseland Dance Studios, people in the subway, the Bowery Mission, a Cub Scout den meeting, a youth-gang meeting, Bergdorf Goodman's children's shop, a clothing thrift shop, a pet funeral and crematorium, a condemned hotel, municipal lodging, and Cathy Hart, daughter of Moss Hart and Kitty Carlisle.

Originally the photographs in "The Vertical Journey" were to have been accompanied by extended captions, but these were eventually edited down from Bliss's records and Arbus's notes to a few terse lines. At the time, Benton, Hayes, and perhaps even Arbus herself were unaware of the possibilities inherent in her talent as a writer. Her own response to the problem of captions, particularly those that might be interpreted as critical of the subjects, was cautious:

> Maybe the comment has to be implicit in the pictures. . . . If these are shattering enough, anything like comment or judgment on the subjects would betray both them and us.[12]

"The Vertical Journey" established *Esquire* as a forum for Arbus's work. More important, perhaps, the magazine's support encouraged her to believe in herself as a professional. In Hayes and Benton she found enthusiastic collaborators. Although she was never formally on staff—the magazines she worked for had few, if any, staff positions for photographers—she frequented the *Esquire* offices, regularly took new work to Benton and Hayes, and submitted ideas for projects. By the end of 1960, she wrote them a letter proposing a project on eccentrics:

> About eccentrics. . . .

> Edith Sitwell says in what is the prettiest definition: ANY DUMB BUT PREGNANT COMMENT ON LIFE, ANY CRITICISM OF THE WORLD'S ARRANGEMENT, IF EXPRESSED BY ONLY ONE GESTURE, AND THAT OF SUFFICIENT CONTORTION, BECOMES ECCENTRICITY. Or, if that word has too double an edge, we could use some others: the anomalies, the quixotic, the dedicated, who believe in the impossible, who make their mark on themselves, who-if-you-were-going-to-meet-them-for-the-first-time-would-have-no-need-of-a-carnation-in-their-buttonhole.

> Like the very irate lady who appears at night pulling a red kiddies express wagon trimmed with bells and filled with alley cats in fancy hats and dresses. And a man in Brooklyn called The Mystic Barber who teleports himself to Mars and says he is dead and wears a copper band round his forehead with antennae on it to receive his instructions from the Martians. There is also a very cheerful man with only half a beard and someone who collects woodpecker holes as well as a lady in the

11. Letter from Arbus to Robert Benton, undated, c. October 1959.
12. Ibid.

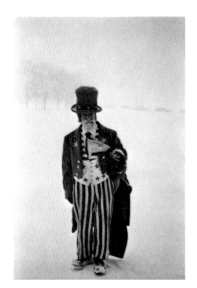

Uncle Sam in Washington for the
Kennedy Inauguration, 1960

Bronx who has trained herself to eat and sleep under water. I have heard of some-one who lived for a year in a wooden box which measured 3 feet by 8 feet and a man who built himself a robot 7 feet tall which obeys orders and inhales when smoking. Or a man who walks down Broadway carrying a divining rod proclaim-ing the potency of the Holy Water in the Bronx. There used to be a negro man dressed all in black who carried a hangman's noose and a single rose, and I know a lady who searches ceaselessly for something she has lost and never finds. And oh, the glorious, furious veiled lady in the fuchsia silk gown trailing to her ankles, car-rying a lace parasol which has the word BOO scrawled many times across it. Of course there is a lady in Mt. Kisco with a lion in her living room and a man who has invented a noiseless soup spoon and a little woman with 500,000 wishbones. And an 80-year-old man about 4 feet high who pretends to be Uncle Sam because he thinks people would like to think he is. (He has invited me to accompany him to the Presidential inauguration so I can watch him be the first man to shake the hand of Dwight D. Eisenhower when he is no longer President.) As well as the lovely people who built their houses of broken crockery, like the one in California or the one in Chartres. Surely there must be another somewhere nearer. There is a man reputed to be the heir to some fortune or other who sews himself a weekly costume of varicolored scraps of fabric with, for example, one pants leg of red and the other, orange. A hermit would be splendid. I remember one who turned up in the newspaper having his census taken. There used to be a man on Eighth Avenue limping along with a flute and a bandaged head, a living replica of The Spirit of '76. And there is a man who has 82 skeletons and 26 mummies in his basement, as well as someone who can write the Gettysburg Address on a human hair, although that might be rather hard to see. All we need are a few of the most lyrical, magi-cal, metaphorical, like the man in New Jersey who has been collecting string for 20 years, winding it in a ball which is by now 5 feet in diameter, sitting mon-strous and splendid in his living room. And I have heard of a one-eyed lady miser who can be found in the Automat.[13]

These are the Characters In A Fairy Tale for Grown Ups.

Wouldn't it be lovely?

Yes.

Diane.[14]

When *Esquire* decided not to use "Eccentrics"—they felt the photographs were too similar to those of "The Vertical Journey" and, perhaps, too difficult to publish—she offered the project to Marvin Israel, art director of *Harper's Bazaar*. By this time, she had already taken several of the portraits that would appear in the final portfolio, had probably chosen all of the subjects, and may even have started writing the text.[15] Perhaps because this project, in its original conception, was about singular individu-als rather than social archetypes and their milieus, the portraits themselves were much more composed and deliberate than those of "The Vertical Journey." She had even used a studio flood to photograph Prince Robert Rohan de Courtenay; this was one of the first examples in her work of the use of artificial light.

"The Full Circle," published in November 1961, represented a significant develop-ment in Arbus's work as a portrait photographer, introduced her as a writer, and

13. A letter from Hayes to Arbus dated February 16, 1961 refers to her having photographed Bishop Ethel Predonzan, of Jamaica, Long Island, for "Eccentrics." Three years later, in California, Arbus again photographed Predonzan and wrote an accompanying profile (see pp. 48–52). The project was never published.
14. Letter from Arbus to Benton and Hayes, undated, c. November 1960.
15. Letter from Hayes to Arbus, August 25, 1961, indicates return of her submitted manuscript for the project: "Enclosed is the copy for your idea about 'eccentrics.'"

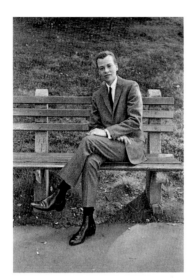

Harper's Bazaar refused to publish the portrait of Miss Stormé de Larverie

may have come closer to fulfilling her concept than any magazine project she took on in later years. Still, it involved one compromise. *Harper's Bazaar* had in the end refused to publish the portrait of the sixth eccentric, Miss Stormé de Larverie, "The Lady Who Appears to Be a Gentleman."[16] The photograph and its accompanying text did not appear until February 1962, when *Infinity* printed it along with the rest of the original project. This exception aside, the article in its published form faithfully represented the idea she had conceived and developed.

Although "The Vertical Journey" and "The Full Circle" might be considered two distinct, but equally successful, ways of presenting Arbus's work in a magazine, they did not establish a trend. Neither *Esquire* nor *Harper's Bazaar* ever assigned her another purely photographic portfolio, although the latter did in a few instances publish, as illustrations of poems or essays, photographs she had taken earlier. Not until late in her career, after the 1967 "New Documents" exhibition at The Museum of Modern Art that began to establish her reputation as an artist, did her work again appear in a magazine in the format of a photographic portfolio. Similarly, it was only around 1964, three years after the publication of "The Full Circle," that she got her next assignment to write the accompanying text for her pictures.

Rather than adopting her first two published articles as models, magazines began to explore other ways of using her as a photographer—sometimes with mixed results. The assignment she received from *Show* magazine in 1962 to illustrate an article on the making of a television commercial may be the best example of how far wrong such an experiment could go. Although the contrived story-board sequence successfully mimics the planning of a commercial, the nature of the job appears to have confounded Arbus, and the individual photographs demonstrate little involvement on her part. In fact, she was so disappointed with the results that she wanted her name dropped from the credits, but the author of the article, Alan Levy, said that he wanted to share a byline with her

> as badly as I wanted anything in 1962. It mattered to me that I had worked with her and I wanted it on the record. So I bullied her, writing at least one impassioned letter, complaining that she was hurting me. At 3 o'clock on the last afternoon before the issue was to be locked up, she phoned and said: "All right."[17]

The photograph she took of a peace march to accompany *Esquire*'s 1962 article "Doom and Passion along Rt. 45" was more successful. The author, Thomas B. Morgan, a regular contributor to the magazine, whose 1959 profile on Sammy Davis Jr. had been a prototype of the New Journalism, was also, coincidentally, Arbus's landlord at the time. When *Esquire* commissioned him to cover the peace march from Hanover, New Hampshire, to Washington, D.C., he suggested that she do the photography. She joined him and the march in its seventh week as it passed through Woodbury, New Jersey.

This assignment was as close as she ever came to covering an event-oriented story, the traditional territory of the photojournalist. Her photograph, and the manner in which Morgan reported the event, were, however, distinctly nontraditional. The article emphasized the emotions and psychological hardships of the march rather than the timely aspects of an event that, by publication date, was long past. Although Arbus took a number of photographs for the article, the only one published, and the only one Morgan saw, was the emblematic silhouette of the marchers moving across a

16. Caption material for "The Vertical Journey" dated March 25, 1960 indicates it was while working on this project that Arbus first discovered Miss Stormé de Larverie, who was appearing dressed as a man in the Jewel Box Revue's female impersonator show, "25 Men and a Girl," in which Miss de Larverie was the only real woman.
17. Alan Levy, *Arts* (Summer 1973), p. 80.

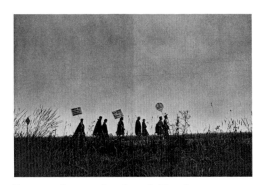

Peace marchers passing through New Jersey,
Esquire, November 1962

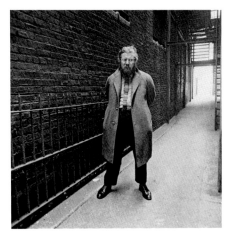

Peter Ustinov, *Harper's Bazaar*, June 1963

18. Letter from Thomas B. Morgan to Thomas W. Southall, undated, c. November 1983.
19. A comment by Arbus on the subject of 35mm versus 2¼ formats appears in *Diane Arbus: An Aperture Monograph* (Millerton, N.Y., Aperture, 1972), pp. 8–9.

gray horizon. The layout was a dramatic break in the visual pacing of the magazine. The photograph bled across two full pages without caption. Graphically it did more than just introduce the article: it appeared independent of and equal to the text that followed. Morgan would later say:

> Diane's photograph and her attitude toward the hopes embodied in the peace walk were more bleak and pessimistic than mine. I believe she felt the walk was an exercise in futility. I felt it could have a meaning in the future, that such efforts might change things a little. Neither of us suspected what was to come [later] in the sixties.[18]

The two children's fashions layouts that *Harper's Bazaar* assigned her in 1962 were closer to her developing interest in portraiture. In both instances, she chose non-professional children as her models, photographed them outdoors with a Rolleiflex camera, and attempted in various ways to portray them as real children. This was not an entirely new approach. A few photographers, including Saul Leiter, had been working in a similar direction for the same magazine, but these assignments were Arbus's first attempts to deal with fashion as a form of portraiture, a theme she explored in greater depth in her later work for *Harper's Bazaar*'s "Fashion Independents," a series intended to portray fashionable people wearing their own clothes, and for the *New York Times Magazine* children's fashions supplements.

In 1962 and 1963, the magazines Arbus had been working for began to discover that her real strength lay in portraiture. By this time, she had abandoned the 35mm in favor of the Rolleiflex, a twin-lens reflex camera that was a standard tool of the studio photographer. Its 2¼-inch-square negative was larger than the 35mm negative and was capable of rendering the greater detail and clarity she was beginning to search for in her work. The more passive square format seemed to lend itself to her direct, central compositions.[19] Furthermore, the Rolleiflex, held at waist level, had the advantage of permitting her to maintain a more natural contact with her subjects and to see in reality, rather than only through the lens, what she was photographing.

Even her earliest published portraits made with this camera—James T. Farrell and Norman Mailer for *Esquire*, Marcello Mastroianni for *Show*, Peter Ustinov and William Golding for *Harper's Bazaar*—display many of the distinctive characteristics now commonly associated with her work. Intuitively, she was beginning to bridge the gap between the controlled studio portraiture of Richard Avedon and Irving Penn and the apparent spontaneity of street photographers and the photojournalists: Eugene Smith, Margaret Bourke-White, and the Magnum photographers. The camera she had chosen, her later use of flash, and her deliberate compositions resembled the techniques of the studio photographer. Unlike the studio photographer, however, she did not invite her subjects to come to her: she went to them, to their neighborhoods, front yards, homes, hotel rooms. For the most part, her portraits were not simply about faces and their expressions. They were also about bodies, clothing, furniture, wallpaper—all the details and appurtenances of an individual's identity. The merging of these disparate techniques seemed truly revolutionary at the time. Many of her portraits appeared to be simultaneously as artless and innocent as a snapshot and as factual and unequivocal as an X-ray.

Naturally, not every assignment promised to give her the same degree of satisfaction, nor were the results equally successful. Nonetheless, in the course of mastering her method and technique, she remained surprisingly consistent in adhering to her own

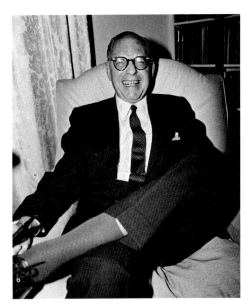

Publisher Bennett Cerf, *Esquire*, March 1964

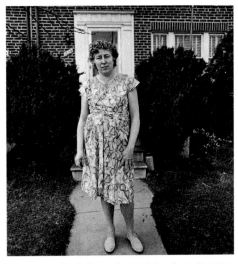

Alternate print Arbus submitted for *Esquire*'s 1964 article on Madalyn Murray

20. Geri Trotta, interviewed by Thomas W. Southall (New York, N.Y.), December 1983.
21. Harold Hayes, "Editor's Notes," *Esquire* (November 1971), p. 8. Hayes cited *Vogue*, a magazine in which Arbus never published, rather than *Harper's Bazaar*.
22. Irving Penn, *Photography within the Humanities*, ed. by Eugenia Parry Janis and Wendy MacNeil (Danbury N.H., Addison House, 1977), p. 127.
23. John Gruen, interviewed by Thomas W. Southall (New York, N.Y.), November 1983.
24. Bynum Shaw, "Nevertheless, God Probably Loves Mrs. Murray," *Esquire* (October 1964), pp. 110–112, 168–171.
25. Bynum Shaw, interview by Thomas W. Southall, February 1982.

standards, regardless of the particular magazine or subject involved, or the attempts of an editor to dictate her approach. When she went to photograph the Gish sisters, one of the rare instances in which an editor accompanied her on a sitting, *Harper's Bazaar* editor Geri Trotta tried to persuade her to take a picture of them under a snow-laden tree as a symbol of their silent-film roles in *Orphans of the Storm*, but Arbus simply refused.[20] Projects as diverse as her portraits of four soothsayers for *Glamour*, her portrait of the fashion designer Alix Grès for *Harper's Bazaar*, her photographs of the students at a Santa Claus school for the *Saturday Evening Post*, and her portraits of Lee Harvey Oswald's mother and of the publisher Bennet Cerf for *Esquire*, all bear the markings of her distinctive style. As Hayes wrote in 1971:

> Invariably an Arbus portrait carried with it such power of evocation that it transcended the character of magazines as dissimilar as [*Harper's Bazaar*] and *Esquire*. . . . In nearly every case her subject would be framed by his most natural, obvious setting—H. L. Hunt in his front yard, James T. Farrell, barefoot in his living room—and posed facing straight-eyed and unblinking toward the center of her camera lens, always with the same curious expression, as though seeking from the beholder some special understanding. Only those who have been photographed by her know what sorcery she must have employed to persuade such confrontation.[21]

At the same time, in committing herself to an assignment, she could never afford to lose sight of the fact that it was a job and her primary responsibility was to produce results. As Penn observed in a talk he gave at Wellesley College in 1975:

> Working professionally leaves little room for failures. . . . Always having to produce a publishable result forces you to play it safer than you'd like. . . . In journalism, and even more in advertising photography, the unforgivable sin is to come out of a sitting without something that can be put on the printed page. That's worse than banality.[22]

The demands Arbus made on her work combined with the necessity of producing something that fitted the needs of the magazine made her particularly dependent on her ability to win the cooperation of the people she was photographing. Not being granted enough time was one of the first obstacles to overcome. When critic John Gruen and his wife, the painter Jane Wilson, were asked to pose for *Harper's Bazaar*'s "Fashion Independents" article "On Marriage," they had allotted about an hour for the sitting. Arbus arrived at ten in the morning, managed to persuade them to break their luncheon date, told them that the longer she spent on a sitting the better the photograph was likely to be, and continued working with her apparently willing but weary and somewhat bewildered subjects until five in the afternoon.[23] On the other hand, she had to be equally adept at waiting for a sitting to begin, as she was frequently obliged to do, sometimes for hours, when someone she was scheduled to photograph found himself preoccupied with more pressing matters.

She resorted to other tactics as well in her attempt to win the cooperation of her subjects. In 1964, during the height of the controversy over the issue of prayer in public schools, *Esquire* assigned her to photograph the atheist Madalyn Murray, who had recently been proclaimed "one of the most hated women in America."[24] The article had already been written when Arbus received the assignment, and its lengthy title included the observation that Mrs. Murray was too honest to wear a girdle. When Arbus arrived for the sitting, as a joke she brought Mrs. Murray a present—a girdle, which can be seen in the final published portrait, lying on top of the dresser.[25]

Perhaps the most illuminating account of the problem she sometimes faced during a sitting and the urgency she felt in overcoming it lies in her description of photographing Senator Eugene McCarthy on election night in 1968:

> McCarthy was fun and very complex and the picture is very good, haunted. He looks like a defrocked priest. I nearly got the classic brushoff of 4½ minutes, with him contriving to present his face to me without being there at all. It was Panicking. But I resorted to mentioning my brother [poet Howard Nemerov] shamelessly and he knew his poetry so then he really began to talk to me and let me hang around and watch and listen while he telephoned his condolences to Humphrey, composed sample comic telegrams to Nixon, spoke to one of his daughters, did a TV interview and read me something and told me dirty stories about Lincoln.[26]

In the end, some of her subjects felt they had been duped. After seeing the photographs she took of him in 1963, Norman Mailer said, "Giving a camera to Diane Arbus is like putting a live grenade in the hands of a child."[27]

From the beginning and throughout her career as a commercial photographer, she was granted considerable independence in fulfilling an assignment. Many projects were her own ideas that she persuaded editors to support. In other instances, such as *Esquire*'s 1965 article "Familial Colloquies," and the "Affinities" and "American Art Scene" articles for *Harper's Bazaar*, she participated in choosing the specific people to fulfill the concept the editors had proposed. The selection of the final image for publication was almost always left in her hands, and she usually submitted a single print, accompanied by an alternative when she happened to be particularly unsure. This trust in the photographer's judgment was customary for most of the magazines for which she worked. On the rare occasions that Arbus turned in entire contact sheets, it was only because she was so dissatisfied with what she had produced that the selection of the picture to be published seemed to her a matter of indifference and she was willing to leave it up to the editors.

While the consistently distinctive style of her work earned her the respect and cooperation of her editors and was frequently responsible for her getting certain assignments, it also narrowed the range of the sorts of jobs the editors considered suited to, or worthy of, her talents. Throughout her career—probably because of the nature of the magazine itself, and in spite of the efforts of its new art directors Ruth Ansel and Bea Feitler to alter it—her work for *Harper's Bazaar* remained almost entirely limited to her portraits of artists, writers, and other cultural figures, and to the photographs she took for "Fashion Independents."[28] She worked on three articles for this series. In only one of them—her portraits of Mrs. T. Charlton Henry, an elderly Philadelphia socialite who had been on the best-dressed list for years—does she appear to have succeeded in her attempt to deal with the clothes as she would have dealt with them on any other occasion, as simply what the person happened to be wearing.[29] Both the 1964 article "Young Heiresses," which included a portrait of Mia Farrow, and the 1966 "On Marriage," for which she had to photograph eight couples, including the Gruens, were a disappointment to her. In the latter instance, she even went so far as to mimic the styles of other photographers in her effort to satisfy the demands of the assignment.

Esquire could afford to be more adventurous in the sorts of jobs they offered her, which included the former "Debutante of the Year" Brenda Frazier; a folk singer who claimed to be the new Messiah; a transsexual; and a series of photographs of a cru-

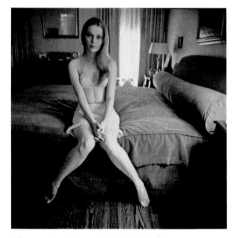

The young heiress Mia Villiers-Farrow
Harper's Bazaar, April 1964

26. Letter from Arbus to Peter Crookston, undated, c. November 1968.
27. Op. cit., Hayes, "Editor's Notes."
28. Marvin Israel left *Harper's Bazaar* c. April 1963. Ruth Ansel and Bea Feitler, who succeeded him as art directors and remained at the magazine until 1972, had been his assistants.
29. Photographer Deborah Turbeville was fashion editor for the series "Fashion Independents" during this period and accompanied Arbus on several sittings, including Mrs. T. Charlton Henry

sading southern doctor, Donald E. Gatch, and his patients. This last assignment was meant to be a cover story, but because of a curious circumstance it did not turn out that way. As with most of her work for *Esquire*, Arbus was assigned to photograph Dr. Gatch only after the article had already been accepted for publication. When the author, Bynum Shaw, had visited Dr. Gatch to research his article, he had found him wearing jeans, a sweater riddled with holes, and a pair of glasses missing a stem. A month or so later, however, when Arbus arrived to accompany the doctor on his rounds, he was dressed in a three-piece suit, which he presumably felt was more appropriate attire. As a result, the editors thought that the man in her photographs bore so little resemblance to the persecuted, overworked doctor described in Shaw's text that they decided not to put the picture on the cover as they had originally planned.[30]

In spite of the variety of assignments Arbus received from *Esquire*, however, the editors continued to consider many subjects, such as politicians, inappropriate or, in the words of Samuel N. Antupit, art director of the magazine from 1964 to 1968, "too easy a mark" for her.[31] On one occasion, they were on the verge of having her photograph the Republican vice-presidential candidate Spiro T. Agnew but because of a pressing deadline found themselves obliged to use a caricature instead, of which Arbus said:

> I think (but I didn't exactly say it like that because it seemed a bit sour grapes) looks awful since he IS a caricature and it's sort of a vulgar looking one so you tend to assume it can't be true.[32]

Sometimes they refrained from offering her certain projects on the assumption that she would turn them down. As Antupit said, "You could never force her to do anything."[33] On the other hand, when the *Esquire* staff talked, as they frequently did, about wanting an illustration "in the Blaze Starr style"—referring to Arbus's 1964 portrait of the burlesque queen—they did not necessarily consider assigning Arbus the job.

Esquire appears not to have considered assigning her a text piece until after the article on Mae West that she did for *Show* under art director Henry Wolfe, who had been Benton's predecessor at *Esquire*, was published in January 1965, a few months before *Show* went out of business. Later that year, however, she wrote the captions for the "Familial Colloquies" article and in August she received a letter from Hayes confirming the assignment for an article, "Minority Pin-ups," that she had proposed:

> For an acceptable story—hereafter referred to as "Minority Pin-ups"—we will pay you at the rate of $250 per page, regardless of the amount of text or photography on the page. . . If for any reason this story fails to work out, we will pay you a spread guarantee of $400—*twice* the usual amount for an unsuccessful story, since you are submitting both text and photographs.[34]

Arbus made portraits of a number of young women for the article and wrote a first draft of the text intended to accompany one of them, but the story was never published.

It was probably during the same year that she proposed doing a story on a nudist camp, a project she was already pursuing on her own but for which she was eager to obtain the magazine's support. Although Hayes may well have suspected that the chances of actually publishing the article were slim—and indeed, it never appeared in

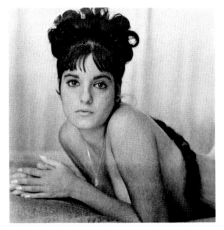

Portrait for the unpublished *Esquire* article on minority pin-ups

30. Southall interview with Shaw.
31. Samuel N. Antupit, interviewed by Thomas W. Southall (New York, N.Y.), July 1982.
32. Letter from Arbus to Crookston, November 12, 1968.
33. Southall interview with Antupit.
34. Letter from Hayes to Arbus, August 9, 1965.

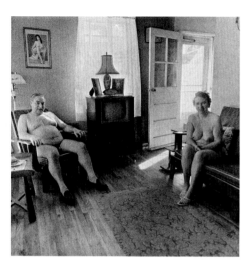

Arbus began a series in 1963 on nudists and was later assigned by *Esquire* to do an article, on the subject, which was never published

the magazine—he did officially assign it to her, a draft of the article was written by Arbus, and in the end the magazine paid some of her expenses. This appears to be an example of a remarkable willingness on *Esquire*'s part to lend itself, on certain occasions, to the support of her work, even when it seemed unlikely the magazine would derive any direct benefit from doing so.

Naturally, the magazine had to protect its own interests as well, and there are also examples on the other side. From the outset, Arbus had regarded the press pass or letter of accreditation as one of the most important assets of being a commercial photographer. It afforded her access to people and places she would probably have been unable to photograph without it, and she often used it when she was working on ideas not specifically intended for magazine publication. In August 1961, after *Esquire* had rejected "Eccentrics," Hayes wrote asking her to "destroy or return . . . whichever you prefer" the letter of accreditation he had given her in connection with the project. Arbus answered:

> Dear Harold:
>
> Enclosed is the letter of accreditation which I am both destroying and returning since I couldn't decide which I preferred. Thank you for it.
>
> It seemed to me, though, that your most recent letter, this one of August 25th, was somewhat lacking in human warmth. It would have been a splendid one to send to the Telephone Company. If I am to deduce that you are feeling injured or outraged or infuriated, I now challenge and dare you to lunch with me. Benton too. RSVP.
>
> Yours,
>
> Sincerely,
>
> Cordially,
>
> Truly,
>
> Frankly,
>
> Fondly,
>
> Diane[35]

Since many of the projects that interested her could only be pursued with the support of a magazine and its credentials, the press pass, or the hope of obtaining one, continued to be a significant consideration in working for them. In 1969, when she foresaw the possibility of doing some work for a new magazine, she sent its editor the following letter:

> . . . when you get someone to redesign your logo would you send me some stationery and if it's possible make me a press pass, something like this. [She enclosed a drawing to show what she wanted.] It is terribly useful to flash credentials and sometimes *Esquire*'s are good but other times their attitudes are too well known and just provoke suspicion.[36]

On more than one occasion, she tried to get an assignment not for the sake of publishing the pictures, or even being paid, but simply as a way of making it possible for her to do the work:

35. Letter from Arbus to Hayes, August 28,1961.
36. Letter from Arbus to Crookston, undated, c. 1969.

163

I have been trying to get *Look* to let me do Death Row in a penitentiary. I think it requires a magazine that rich and influential to get the necessary permission.[37]

When the Time Life Library of Photography assigned her a single photograph for one of its books, the assignment itself seemed of secondary importance:

I've been working on an assignment which has opened a lot of doors I wanted open and has got me going at a great old pace. . . . It's about LOVE and it's for Time Life Books so nearly nobody says no.[38]

In this respect, her personal and professional work continued to overlap. In addition to approaching an assignment with many of the same photographic intentions she would have applied to a picture taken for herself, she attempted, whenever possible, to make her relationship with magazines serve her own ends as a photographer.

In 1964, one of the more productive years of Arbus's magazine career, her photographs appeared in eleven separate articles. Although she published more than fifteen photographs in each of the following three years, however, they appeared in only five different articles. In 1967, three of her photographs were published in *Esquire*, one in *Harper's Bazaar*, and twelve, including the cover, in the *New York Times Magazine* children's fashions supplement. This was the first of the three issues on children's fashions for which she did all the editorial photographs. The other two appeared in 1969 and 1970. They were the only serious color work of her career and the only true fashion photographs she took after the two early features on children's fashions for *Harper's Bazaar*.

Patricia Peterson, fashion editor of the *New York Times Magazine*, had established a policy of using only nonprofessional children as models, which coincided with Arbus's own inclinations toward fashion and photographing children. For each of these assignments, the two of them visited a Caribbean island and chose their models from among the native children and the tourists they found there. In one instance, Peterson discovered twin boys whom she deposited on their father's lap for Arbus to photograph.

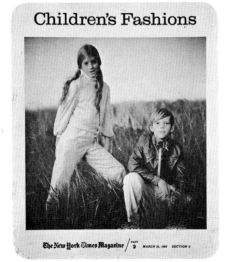

Children's Fashions

The New York Times Magazine / PART 2 MARCH 16, 1969 SECTION 6

Color cover, the *New York Times* children's fashions supplement, March 1969

What made these issues of the *New York Times* children's fashions supplement seem revolutionary at the time was not merely the fact that the children in the photographs looked like ordinary children. As she wrote to Allan Arbus in 1970:

. . . there was a bit of trouble; Pat said it was because the cover photo was of a black girl and a white boy about 4 years old, holding hands. Pat has been incredibly sweet. They wanted a retake which I think she has effectively blocked. . . . She was full of appreciation for the most minor virtues of the photos . . . and as for the miscegenation, junior style, it may end up being regarded as a major civil rights breakthrough, if they finally let it pass.[39]

Throughout the 1960s, Arbus continued to pursue independent projects in addition to the assignments she accepted from magazines. This independent work, supported by Guggenheim Fellowships in 1963 and 1966, was first seen in a unified presentation in 1967 when she was featured along with two other photographers who had done commercial work—Lee Friedlander and Garry Winogrand—in a show called "New Documents," organized by John Szarkowski at The Museum of Modern Art. Although the exhibition included five portraits of nudists that she had wanted to

37. Letter from Arbus to Crookston, July 4, 1968.
38. Letter from Arbus to Crookston, undated, c. 1971.
39. Letter from Arbus to Allan Arbus, January 16, 1970.

publish in *Esquire*, none of the thirty-two Arbus photographs had before appeared in magazines.

In addition to her portraits of housewives, teenagers, and children, they included photographs of midgets, a set of triplets, transvestites, and female impersonators, which particularly caught the attention of reviewers. As far as the public was concerned, the exhibition represented an entirely new view of Arbus's career.

Szarkowski, director of The Museum of Modern Art's Department of Photography, wrote an introduction to the exhibition that appeared as the wall label:

> In the past decade a new generation of photographers has directed the documentary approach toward more personal ends. Their aim has been not to reform life, but to know it. Their work betrays sympathy—almost an affection—for the imperfections and the frailties of society. They like the real world, in spite of its terrors, as the source of all wonder and fascination and value—no less precious for being irrational. . . .

> The portraits of Diane Arbus show that all of us—the most ordinary and the most exotic of us—are on closer scrutiny remarkable. The honesty of her vision is of an order belonging only to those of truly generous spirit.[40]

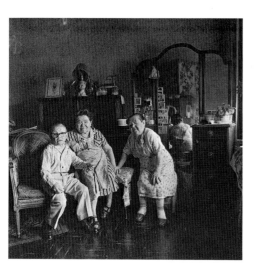

This 1963 portrait of Andrew Ratoucheff, the Russian midget who appeared in "The Vertical Journey," was included in the 1967 Museum of Modern Art exhibition

For the most part, discussions of Arbus's work dominated the critical response to the show. In his review in the *New York Times*, Jacob Deschin wrote:

> She seems to respond to the grotesque in life. Even her glamour shots—for example a pretty young nude woman glowing as if self-illuminated—look bizarre. . . . She looks at nudity frankly, audaciously and naively, as if it were some novel phenomenon. At the same time there is occasionally a subtle suggestion of pathos, now and then diluted slightly with a vague sense of humor. Sometimes, it must be added, the picture borders close to poor taste.[41]

On the other hand, Marion Magid, reviewing the exhibition in *Arts* magazine, wrote that at first it seemed to have

> the allure of a sideshow . . . because of its emphasis on the hidden and the eccentric. . . . In the end, the great humanity of Diane Arbus's art is to sanctify that privacy which she seems at first to have violated.[42]

"New Documents," together with the 1966 George Eastman House exhibition "Toward a Social Landscape"—which included the work of Bruce Davidson, Danny Lyon, and Duane Michals, as well as Friedlander and Winogrand—marked the museum world's acceptance of a new genre in photography.

In 1967, the year he organized the "New Documents" exhibition, Szarkowski wrote:

> It can be reported without prejudice that many of today's best photographers are fundamentally bored with the mass media and do not view it as a creative opportunity. Even well-established and prospering photographers of talent, artists well beyond the first flush of youth, have tacitly accepted a double standard for their own work; their livelihoods are made according to the standards set by the magazines and agencies; their serious work is done on weekends and between assignments, in the hope of producing an exhibition, or a small book, or perhaps only a personal file that someone, someday, will look at openly and slowly and with plea-

40. John Szarkowski, Wall Label for "New Documents," February 28–May 7, 1967, The Museum of Modern Art, New York.
41. Jacob Deschin, "People Seen as Curiosity," the *New York Times* (March 5, 1967), Section 2, p. 21.
42. Marion Magid, "Diane Arbus in 'New Documents,'" *Arts* (April 1967), p. 54.

sure, without wondering how the picture might be made more "effective" by tighter cropping and the addition of a good caption.[43]

Arbus, however, appears to have defied the double standard and continued to hope that she could earn a living from magazines by doing some of her best, most serious work. With the exception of the Guggenheim Fellowships of $5,000 each, her income through the 1960s consisted almost entirely of the money paid her by magazines. Her fee in most cases was $150 a page, exclusive of film, processing, and other related expenses. In 1964, when she published twenty-four photographs in eleven different magazine articles, she earned a total of about $5,000.[44]

Ironically, "New Documents" did not significantly alter her commercial situation. As a matter of fact, having been hesitant about exhibiting her work for fear that it might impede her ability to continue to photograph anonymously, she was somewhat perplexed to find that the exhibition, which had earned her so much popular and critical attention, at the same time seemed with one important exception to have generated so little additional work.

One of the most important results of the "New Documents" exhibition was that it succeeded in bringing her work to the attention of Michael Rand, art director of the *Sunday Times Magazine* of London. The magazine had started in 1962 as a modest, unbound color newspaper supplement that Rand described as "unashamedly a vehicle for tapping a new rich vein of colour advertising."[45] The owner of the paper, Roy Thomson, had, however, permitted the contributors to determine much of the editorial content of the magazine, and by the mid-1960s it had developed into an innovative, lively, independent publication emphasizing the arts, current events, and topical issues. Its graphic layouts and bold use of pictures as diverse as Lord Snowdon's portraits and the searing war photography of Donald McCullin were a contrast to the sedateness of its mother paper. The English curiosity about the peculiarities of American culture inspired Rand to search for American photographers and made him particularly interested in Arbus's work.

In 1968, her first year working with Rand and the magazine's deputy editor, Peter Crookston, five articles, most of which were suggested by her, were published in the *Times* accompanied by her photographs. Their subjects included the widow Glassbury, National President of Composers, Authors, and Artists of America, a portrait she had made five years before; a suburban New Jersey diaper derby; a camp for overweight girls; the pop singer Tiny Tim; and two American families in a double-page portfolio for which she wrote the brief accompanying text.

Money remained an issue throughout her early correspondence with Crookston. When she learned, after completing her third assignment for the magazine, that she was to be paid $120 a page rather than the customary $150 she thought had been agreed on, she wrote Crookston:

> Thirty dollars is unimportant but multiplied by the real and happy possibilities for working together as much as we might it should be considered. I had assumed my page rate with you was 150 dollars which is fine. (I did not charge for extra ¼ pages although everyone pays for them. *New York* pays automatically for a whole page when so much as a sliver of one's photograph spills onto an adjoining page but it seems tacky to mention that.) At the page rate of 150 I do charge film and

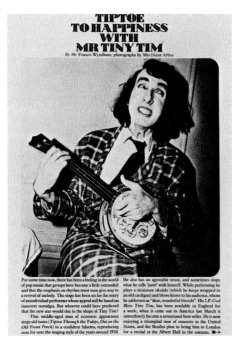

Tiny Tim, *Sunday Times Magazine* (London), July 1968

43. John Szarkowski, *Dot Zero* (Spring 1967); reprinted in *Creative Camera*, February 1969, pp. 62–63.
44. Business records kept by Diane and Allan Arbus confirm these figures.
45. Michael Rand, "Pictures Post Post," *British Photography 1955–1965* (London, The Photographer's Gallery, 1983), p. 7.

processing as well because shooting freely and delightedly takes too sizable a chunk out of a small fee. . . .[46]

In April 1968 the subject came up again:

> . . . part of my snobbery is to act excessively casual about money as if I didn't care if I ever got any and if I am to be supporting my small self soon I should know something about how much I make. But I know you are not so rich (your organisation that is)—American magazines aren't rich either, except the ones I don't work for—and I Don't Worry, and 150 per pg is agreeable. . . . There were three pps on the diaper derby used and two on the widow which comes automatically to $750 so my asking for 900 including Mrs. Henry [a suggested project that] seems to have fallen by the wayside and all the stuff at the home of the Diaper Derby winner wasn't meant to be high-handed. I think the fat girl looks nice which just shows how unreliable I am.[47]

Several months later, when she found herself still waiting for most of the money she expected to have earned from the magazine for completed projects, she asked them to hurry up their payments

> because I do not want to feel that I am impractical and imprudent to the point of idiocy and since I have so far received 300 actual dollars for working for you, I might easily feel that.[48]

In the fall of 1968, as she was in the process of completing "Two American Families," her fifth and final assignment for the magazine that year, she wrote Crookston:

> I enclose the bills because it is good for me. Please make them pay the full amount. Usually they send strange small assorted checks which don't appear to have any relation to the bill as if they were arbitrarily rewarding me according to how they felt about what I did.[49]

This preoccupation with money, however, persistent as it was, did not impede the flow of her ideas for the magazine. It formed only a small portion of her correspondence with Crookston, the majority of which was devoted to suggestions for future projects. One topic, to which she returned again and again in various different guises, was families:

> The average American family turns out to have been Harold [Hayes]'s idea. I called him to ask and he graciously gave it to you. As I remember they had concentrated on St. Louis (is that the geographical center of this US?) and some St. Louis computer firm had found the [most average] family with 2½ kids and the average income and some other average things.

> As I remember he was an electrician and I think also that the one so far unfortunate thing was that their two children were all boys which didn't seem quite so average as it was supposed to. The writer who did all this research is now based in Saigon which was the average assignment which broke up his plans.

> . . . Meanwhile I suspect the Mother of the Year is a dud. . . . She has 18 children and 78 grandchildren but they are scattered all over the states and she doesn't appear to have done very much except to have been active in her church and the family is not likely to assemble unless you paid their fare and then some which doesn't seem likely.[50]

46. Letter from Arbus to Crookston, undated, c. 1968.
47. Ibid., undated, c. April 1968.
48. Same letter as cited in footnote 37.
49. Letter from Arbus to Crookston, undated, c. fall 1968.
50. Same letter as cited in footnote 37.

"Two American Families," published on November 10, 1968, consisted of photographs Arbus later included in her limited-edition portfolio and which are now considered among her finest work: *A Young Brooklyn Family Going for a Sunday Outing*—a portrait she made in 1966—and a second photograph commissioned by the *Times*, *A Family on Their Lawn One Sunday in Westchester*. Concerning the latter, Crookston received this preview:

> I have been wanting to do families. I stopped two elderly sisters the other day and three generations of Jewish women from Brooklyn whom I am to visit soon . . . the youngest is pregnant. And especially there is a woman I stopped in a Bookstore who lives in Westchester which is Upper Suburbia. She is about 35 with terribly blonde hair and enormously eyelashed and booted and probably married to a dress manufacturer or restaurateur and I said I wanted to photograph her with husband and children so she suggested I wait till warm weather so I can do it around the pool! Last weekend wasn't warm weather, but the next may be. They are a fascinating family. I think all families are creepy in a way.[51]

Another subject that intrigued her was the phenomenon of beauty as both a blessing and a curse, something she had attempted to deal with on a more superficial level in her unpublished 1965 story "Minority Pin-ups" for *Esquire*. What she proposed to Crookston, however, was a subtler and more subjective approach to the idea:

> Think of this: That Beauty is itself an aberration, a burden, a mystery, even to itself. What if I were to photograph Great Beauties. (I don't know quite how they'd look but I think, like Babies, they can take the most remorseless scrutiny.) And they would talk to Pauline [Peters] about How It Feels. Often they Hate their noses or find their chins too long. Sometimes they feel painfully valuable like objects, and they are Taken Up and Made Much of. I once knew a beautiful girl for whom every suitor was like an impresario; they didn't just want to make love, they wanted to make her over. One man, Svengali-fashion, got her to eat nothing but applesauce for months . . . another made her stand on her head. Each one was a new discipline. She is now not so beautiful and I think she is a little relieved.[52]

Later she followed up on the idea:

> IF you do want to do that thing I wrote you about, about the stigma of Beauty, a marvelous example is Louise de la Falaise. I know her only slightly but she is marvelously perverse, headlong, doomed and wild. I think she is in Paris.[53]

The majority of her suggestions for photographs and articles never materialized:

> I wish I could do some variation on that Cruelty to Children story you once did. . . . In August there are two National Baton Twirling competitions which sound marvelous. I am checking on it. There is also, in Florida, an incredible lady called Bunny Yeager who is the Worlds Greatest Pin-up Photographer. I have ordered two of her books which I will send to you. I think I should photograph her and how she photographs. The books are called How I Photograph Nudes and How I Photograph Myself. Maybe it just stands alone and doesn't need me. But maybe it would be terrific.[54]

And:

> I am trying to get permission to photograph the filming of a dirty movie. Or rather I had permission but they revoked it. They shoot 3 at once. The set alone is remarkable. So seedy. And the men who make it are always looking over their

51. Letter from Arbus to Crookston, undated, c. May 1968.
52. Ibid., undated, c. 1969.
53. Ibid., undated, c. 1969.
54. Ibid., undated, c. 1969.

shoulder, furtive and turtle-necked and when they talk to me I try to assure them of my unimpeachable reputation and that I will not sic the cops on 'em, their eyes wander idly, uncontrollably up and down my anatomy like berserk balls on a pinball machine.[55]

Other ideas, such as an article called "The Affluent Ghetto," published in January 1971, took a long time to develop. Her first, tentative allusion to this project appears in a letter she wrote Crookston in 1969:

> There is something to be done about Singles (here) but I don't yet see how to do it. In the Catskills there are entire weekends devoted to the procurement of people for people. Also there are these strange things called computer singles cruises. . . . I don't see quite how it works, but computers pair off people going on the cruise, although the ads imply a certain amount of choice involved. It might all be too vague, too many people. I mean it needs the structure of a short story and particular characters. . . .[56]

Attorney F. Lee Bailey, intended for *Nova*, but never published

In 1969 Peter Crookston left the *Times* to become editor of *Nova*, a short-lived women's-fashion and general-interest magazine. Later that year, he and Rand arranged for their publications to cosponsor a trip to England that would enable Arbus to work there on projects for both magazines. In proposing the trip, Crookston said he would need a photograph of the rock group the Who (the photograph was never made) and suggested some other possible ideas. She responded:

> Let me do something about very rich people—beyond my wildest dreams—when I come over. Maybe at least some of the Wives of Famous Men should be Enormously Splendid. And I was wondering about those mysterious clinics where ladies are fed monkey glands and cow foetuses or are put to sleep for six months for the rejuvenation of it, somewhere in Switzerland. Dr. Niehans is the only name I remember. It sounds so Boris Karloff. Clearly it would be hard to photograph freely, but if that proves impossible it seems like it would be interesting verbally.[57]

And later, in another letter, she wondered about the possibility of photographing the British psychiatrist R. D. Laing, which didn't work out either:

"Lulu's Career is Important," *Nova*, January 1970, one of three articles published as a result of Arbus's London trip

> Also today I thought of something. Perhaps it's altogether too ambitious, or wrong for your magazine. . . . But . . . I've been reading R. D. Laing (*The Divided Self* and I forget the name of the other more popular one which I read a while ago). He seems so extraordinary in knowledge, his empathy for madness that it suddenly seemed he would be the most perfect guide. To do monologues by mad people under his guidance with his translations of the sense of what they were saying or doing and my photographs of how they looked or behaved. Of course there are legal problems and I don't know how exclusive he is, but you must know ways if you think it would be worth doing when I come over.[58]

As the date of her April departure approached, she wrote Crookston, "for coming to London . . . I have always thought it had the dirtiest secrets in the world. Does it?"[59]

Nova published three articles as a result of her trip to England. Two of them were Crookston's ideas: the British pop star Lulu, and a gang of young British rockers, the latter of which Arbus said she liked in print "really more than any published thing in a long time."[60] The third, an article on people who think they look like other people, was her suggestion. *Nova* was deluged with responses to ads Crookston placed in London newspapers in an attempt to find prospective subjects for the story. None of

55. Letter from Arbus to Crookston, undated, c. 1969.
56. Same letter as cited in footnote 36.
57. Letter from Arbus to Crookston, undated, c. 1969.
58. Same letter as cited in footnote 36.
59. Letter from Arbus to Crookston, undated, c. 1969.
60. Ibid., undated, c. 1969.

the projects she worked on for the London *Times* during her trip produced a published story.

As a result of Crookston's and Rand's receptivity to her ideas, much of the work she did for their publications may have come closer to fulfilling her intentions than anything since her first two projects with *Esquire* and *Harper's Bazaar*. Seen in its entirety, the work certainly includes some of the finest photographs of her magazine career. After 1969, however, her assignments from these two British publications, and from magazines in general, began to dwindle. Although *Harper's Bazaar* commissioned her to photograph Bertolt Brecht's widow Helene Weigel in 1971 during a trip to Germany, the last photographs by her actually published in the magazine were two portraits taken in 1969 of the Argentine poet Jorge Luis Borges. In 1970 Harold Hayes increased her page rate for *Esquire* and assigned her a project she had suggested about a carnival in Maryland. While this assignment produced three photographs that later appeared in the 1972 Museum of Modern Art retrospective and in the monograph—*Tattooed Man at a Carnival, Albino Sword Swallower at a Carnival*, and *Girl in Her Circus Costume*—Hayes did not succeed in publishing its results in the magazine. In 1970 and 1971, only two articles in *Esquire* were accompanied by her photographs.

There is probably no single reason for the decline in magazine projects. Part may be due to the changing nature of the magazines and their staffs. Arbus's relationship with each publication, like that of most freelancers, was based less on magazine policies than on personal contacts with supportive individuals. In 1968, Antupit left *Esquire*, and was replaced by a three-person art-director system. Although Ruth Ansel and Bea Feitler remained art directors at *Harper's Bazaar*, the experimental period at the magazine seemed to have subsided by the end of the decade and the beginning of the more conservative Nixon years. Few editors had the long-term personal commitment to Arbus that Hayes had, especially when it came to advancing funds without a guarantee of publishable results. There may have even been some concern that Arbus's increased reputation in both the magazine and art world made her a somewhat more difficult property. As her style and approach became more clearly defined, there may have been the feeling that she would be appropriate only for very specific, unusual projects.

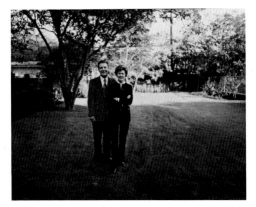

Ozzie and Harriet Nelson, June 1971, Arbus's last published assignment for *Esquire*

In the early 1960s, some editors regarded Arbus as someone who could be used to gain the trust of a subject who might have been defensive when confronted by a photographer with a more established reputation. By the end of the 1960s, Arbus's style had become well known. Additionally, it certainly did not help her to have the public, potential sitters, and editors increasingly associate her work with controversial subjects. Her marketability also was likely hurt by the controversy over her nude photographs of Viva that were published in the April 29, 1968, issue of the newly independent *New York* magazine. It so upset the public and advertisers that the magazine's survival was threatened by the loss, according to publisher Clay Felker, of over one million dollars' worth of advertising, most of which never returned to the publication. While editors and art directors may have enjoyed the publicity, this was the kind of issue that brought out the inherent conservatism of magazine management.

With magazine assignments declining, Arbus attempted to supplement her income with other projects. In 1969/70, she obtained a commission from The Museum of Modern Art to research and edit an exhibition of news photography, started teaching a photography workshop, applied for several new foundation grants—which she did

not receive—and produced a portfolio, designed by Marvin Israel, of ten signed prints that was to be the first of a series of limited editions of her work.[61] She had also begun to think, with very mixed feelings, about the possibility of doing a book. As she wrote Crookston in May 1968:

> The working title, if you can call it that, for my book which I keep postponing is Family Album. I mean I am not working on it except to photograph like I would anyway, so all I have is a title and a publisher and a sort of sweet lust for things I want in it. Like picking flowers. Or Noah's ark. I can hardly bear to leave any animal out.[62]

In November, she alluded to the prospect again: "I am going to do a book, not The Book, but a book, of all new things, a book about something."[63]

In 1969 the French publisher Robert Delpire approached her about doing a book of her photographs, but she told him she felt she wasn't ready.[64] Later that year, however, she appears to have begun considering another possible subject:

> . . . I took the most terrific pictures. The ones at Halloween . . . of the retarded women . . . they are very blurred and variable, but some are gorgeous. FINALLY what I've been searching for. And I seem to have discovered sunlight, late afternoon early winter sunlight . . . so lyric and tender and pretty. . . . I think about doing a book on the retarded. . . . I could do it in a year. . . . It's the first time I've encountered a subject where the multiplicity is the thing. I mean I am not just looking for the BEST picture of them. I want to do lots. . . . And I ought to be able to write it because I really adore them.[65]

It is not necessary to determine whether Arbus felt compelled to think about books, exhibitions, and the sale of prints primarily for financial reasons, or whether she simply began to consider them as additional, or more rewarding, outlets for her work. The fact remains that, in spite of the ups and downs of her eleven-year career as a commercial photographer, she never entirely abandoned magazines, nor did they ever entirely abandon her. Artistically as well as financially, they supported her work and provided her with a forum before any other resources were available to her and, in a number of instances, continued to do so afterward. She found the first audience for her work in magazine readers and her first professional encouragement in their editors and art directors. If they failed to provide her with unlimited freedom in choosing what to photograph, they placed demands on her that helped refine her technical and stylistic skills. Although not all her magazine work was equally successful or gratifying, there always was the potential of success—that an assignment could produce something really special. Considering the persistent necessity of balancing her artistic integrity with the specific needs of the magazines themselves, it may be surprising that so many of the photographs she took on assignment continue to hold their own when compared to some of her best independent work. They seem to proclaim that she was as intrigued and moved by some of the people she was assigned to photograph—Mme. Grès, Mae West, Dr. Gatch and his patients in South Carolina— as by the people she discovered on her own. In the end, some of these portraits may have profited by the passage of time, acquiring new significance as the once familiar faces of recent decades become as curious and mysterious as her anonymous discoveries have always been.

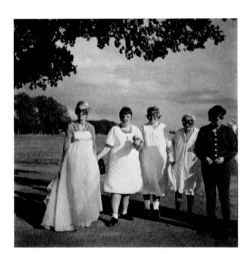

One of a series of photographs Arbus took on Halloween, 1969, at a home for the retarded

61. The portfolio sold for $1000 and only five of them were purchased during Arbus's lifetime. In 1983, one of the five sold at auction for approximately $40,000.
62. Letter from Arbus to Crookston, undated, c. May 1968.
63. Ibid., undated, c. November 1968.
64. Marvin Israel, interviewed by Thomas W. Southall (New York, N.Y.), December 1983.
65. Letter from Arbus to Allan Arbus, undated, c. November 1969.

BIBLIOGRAPHY

MAGAZINE PHOTOGRAPHS

This bibliography represents known magazine photographs published by Diane Arbus from 1960 to 1971. Unpublished photographs intended for commercial publication, while appearing in this book, are not cited below. An asterisk within a citation indicates that the original print is in the Esquire Collection, Spencer Museum of Art, The University of Kansas.

1960

Esquire * "The Vertical Journey: Six Movements of a Moment within the Heart of the City." (July 1960), pp. 102–107. Six portraits of New Yorkers. Text from notes by Diane Arbus.

1961

Harper's Bazaar "The Full Circle." (November 1961), pp. 133–137, 169–173, 179. Five portraits of eccentrics. Text by Diane Arbus.

1962

Infinity "The Full Circle." (February 1962), pp. 4–13, 19–21. Reprint of *Harper's Bazaar* article with one additional photograph (Miss Stormé de Larverie).

Harper's Bazaar "Bill Blass Designs for Little Ones." (September 1962), pp. 252–253. Two photographs.

Show "56 Seconds, $56,000, 150 People = ? Or the Sell behind the Shoe." (September 1962), pp. 86–89. The making of a television commercial in eighteen photographs. Text by Alan Levy.

Harper's Bazaar "Petal Pink for Little Parties, White-over-Pale for Parties." (November 1962), pp. 184–186. Three photographs of girls' fashions.

Esquire "Doom and Passion along Rt. 45." (November 1962), pp. 156–157, 272–275. Peace marchers in Woodbury, New Jersey Text by Thomas B. Morgan.

Esquire * "James T. Farrell: Another Time, Another Place." (December 1962), pp. 156–157, 272–275. Portrait of the novelist. Text by Richard Schickel.

1963

Show "Europe's Uncommon Market." (March 1963), pp. 65–73. Portrait of Marcello Mastroianni. Text by Frank Gibney.

Harper's Bazaar "Art and the Circus." (April 1963), pp. 162–163, 198–199. Portrait of circus performers. Text by Geoffrey Wagner.

Harper's Bazaar "Directors with Direction." (June 1963), pp. 80–81. Portrait of José Quintero, Franco Zeffirelli, Gian Carlo Menotti, Michael Langham, and Gower Champion; portrait of Peter Ustinov. Text by Geri Trotta.

Harper's Bazaar "New Flurry of Italian Films." (July 1963), pp. 67, 118. Portrait of the Sardinian actor Nani Loy. Text by Geri Trotta.

Esquire "Works in Progress: Norman Mailer vs. William Styron, James Jones, James Baldwin, Saul Bellow, Joseph Heller, John Updike, William Burroughs, J. D. Salinger, Philip Roth." (July 1963), pp. 63–69, 105. Portrait of Norman Mailer. Text by Norman Mailer.

Harper's Bazaar "William Golding." (August 1963), pp. 122–123. Portrait of the British novelist. Text by Geri Trotta.

New York Times Book Review "The Kennedys Didn't Reply." (November 17, 1963), p. 6. Review by John Kenneth Galbraith of Norman Mailer's *The Presidential Papers*. Portrait of Norman Mailer.

Harper's Bazaar "Auguries of Innocence." (December 1963), pp. 76–79. Four photographs of children. Text excerpts from William Blake, Lewis Carroll, et al.

1964

Glamour "What's New: The Witch Predicts." (January 1964), pp. 66–69. Portraits of soothsayers Sandra and Dr. George Dareos. Uncredited text by Diane Arbus, edited by Marguerite Lamkin.

Harper's Bazaar "Madame Grès: A Unique Talent." (February 1964), pp. 154–155. Two portraits of the French fashion designer.

Esquire "The Long Happy Life of Bennett Cerf." (March 1964), pp. 112–118, 150. Portrait of the president of Random House. Text by Thomas B. Morgan.

Harper's Bazaar "Fashion Independents: The Young Heiresses." (April 1964), pp. 162–167. Five portraits of trend-setters Reed Buchanan, Mia Villiers-Farrow, Patricia Merle Silver, Maria Christine Drew, Cynthia Boves Taylor.

Harper's Bazaar "Affinities." (April 1964), pp. 142–145. Portraits of Lillian and Dorothy Gish; Erik Bruhn and Rudolf Nureyev; W. H. Auden and Marianne Moore; Pearl Bailey and Louis Bellson. Text by Geri Trotta.

Esquire * "Lee Oswald's Letters to His Mother (with Footnotes by Mrs. Oswald)." (May 1964), pp. 67–75, 162. Portrait of Marguerite Oswald.

Esquire * "Blaze Starr in Nighttown." (July 1964), pp. 58–62, 110. Two portraits of the burlesque queen. Text by Thomas B. Morgan.

Harper's Bazaar "The Couple." (September 1964), pp. 256–257, 307–308, 312. Photograph of anonymous couple on park bench. Text by Marcel Aymé.

Esquire * "Nevertheless, God Probably Loves Mrs. Murray . . ." (October 1964), pp. 110–112, 168–171. Portrait of atheist Madalyn Murray. Text by Bynum Shaw.

Glamour | "What's New: The Witch Predicts." (October 1964), pp. 130–131. Portraits of soothsayers Leslie Elliot and Doris Fulton. Uncredited text by Diane Arbus, edited by Marguerite Lamkin.

Saturday Evening Post | "This Ho-Ho-Ho Business." (December 12, 1964), pp. 20–21. Three portraits of students at Santa Claus school. Text by Alan Levy.

1965

Show | "Mae West: Emotion in Motion." (January 1965), pp. 42–45. Three portraits, one in color. Text by Diane Arbus.

Harper's Bazaar | "Fashion Independents: On Marriage." (May 1965), pp. 156–161, 184. Portraits of married trend-setters Paul Lester and Ingeborg Wiener; Armando and Georgiana Orsini; Frederick and Isabel Eberstadt; John Gruen and Jane Wilson; Herbert and Eliette Von Karajan; Gilbert and Kitty Miller; Mr. and Mrs. Howard Oxenberg; Otto Preminger and Hope Bryce. Text by Geri Trotta.

Harper's Bazaar | "Fashion Independent: Mrs. T. Charlton Henry." (July 1965), pp. 90–93. Four portraits of the fashion luminary. Text by Geri Trotta.

Esquire * | "Familial Colloquies." (July 1965), pp. 54–57. Portraits of Jane Jacobs and son; Ogden Reid and son; Jayne Mansfield Climber-Ottaviano and daughter; Richard Lippold and daughter. Uncredited captions by Diane Arbus.

1966

Herald Tribune Magazine (New York) | "James Brown Is Out of Sight." (March 20, 1966), pp. 14–24. Two portraits of the soul singer, published to coincide with his debut at Madison Square Garden. Text by Doon Arbus.

Esquire * | "The Girl of the Year, 1938." (July 1966), pp. 72–75, 116. Portrait of former debutante Brenda Diana Duff Frazier. Text by Bernard Weinraub.

Harper's Bazaar | "Not to Be Missed: The American Art Scene." (July 1966), pp. 80–85. Portraits of Frank Stella, James Rosenquist, Charles Hinman, Lee Bontecou, Tom Wesselman, Larry Bell, Lucas Samaras, Roy Lichtenstein, Kenneth Noland, Marvin Israel, Agnes Martin, Claes Oldenberg, Richard Lindner. Text by Geri Trotta.

Harper's Bazaar | "Ad Reinhardt—Or the Artist as Artist." (November 1966), pp. 176–177. Portrait of Reinhardt. Text by Annette Michelson.

1967

Esquire | "Just Plain H. L. Hunt." (January 1967), pp. 64–69, 140–154. Portrait of the Texas oil magnate. Text by Tom Buckley.

The New York Times Magazine Part II | "Children in the Sun." (March 12, 1967). Children's Fashions supplement—cover plus eleven color and black-and-white photographs. Text by Patricia Peterson.

Harper's Bazaar | "Thomas Hoving Talks about the Metropolitan Museum." (April 1967), pp. 178–179, 108, 112. Portrait of the museum director. Text by Geri Trotta.

Esquire * | "The Transsexual Operation." (April 1967), pp. 111–115, 205–208. Portrait of a man who became a woman in 1958. Text by Tom Buckley. Uncredited extended caption by Diane Arbus.

Esquire * | "Mirror, Mirror, on the Ceiling, How'm I Doin'?" (July 1967), pp. 72–74, 113–114. Color portrait of Mae West; variant of series published in *Show* (January 1965). Text by Helen Lawrenson.

1968

Sunday Times Magazine (London) | "Pauline Peters on People: Dr. Glassbury's Widow." (January 7, 1968), pp. 30–31. Portrait of Betty Blanc Glassbury (published in *Diane Arbus*, Aperture, 1972: *Widow in Her Bedroom, New York City*, 1963). Text by Pauline Peters.

Esquire * | "God Is Back, He Says So Himself." (February 1968), pp. 104–105. Portrait of folk singer Mel Lyman. Text by L. M. Kit Carson.

Harper's Bazaar | "The New Life." (February 1968), pp. 160–161. Portrait of Anderson Hayes Cooper, infant son of Gloria Vanderbilt and Wyatt Cooper. Poems by Sandra Hochman.

Sunday Times Magazine (London) | "Pauline Peters on People: How to Train a Derby Winner." (March 21, 1968), pp. 44–48. Three photographs of suburban New Jersey diaper derby. (One was published in *Diane Arbus*, Aperture, 1972: *Mother Holding Her Child, New Jersey*, 1967). Text by Pauline Peters.

Sunday Times Magazine (London) | "Please Don't Feed Me." (April 14, 1968), pp. 34–37. Two portraits of campers at Camp Lakecrest for overweight girls in New York State. Text by Hunter Davies.

New York | "La Dolce Viva." (April 29, 1968), pp. 36–41. Two portraits of the actress Viva. Text by Barbara L. Goldsmith.

Esquire * | "Let Us Now Praise Dr. Gatch." (June 1968), pp. 108–111, 152–156. Three photographs of the crusading doctor with some of his patients in Beaufort County, South Carolina. Text by Bynum Shaw.

Sunday Times Magazine (London) | "Tiptoe to Happiness with Mr. Tiny Tim." (July 14, 1968), pp. 11–15. Five portraits of the pop singer. Text by Francis Wyndham.

Sunday Times Magazine (London)	"Two American Families." (November 10, 1968), pp. 56–57. Portrait of a Brooklyn, New York, family; portrait of a Westchester, Connecticut, family (published in *Diane Arbus*, Aperture, 1972: *Brooklyn Family on Sunday Outing*, 1966, and *Family on Lawn One Sunday*, *Westchester*, 1968). Text by Diane Arbus.
Harper's Bazaar	"On a Photograph of Mrs. Martin Luther King at the Funeral." (December 1968), pp. 106–107. Portrait of the widow at her Atlanta home. Poem by Paul Engle.

1969

Sunday Times Magazine (London)	"How Fat Alice Lost 12 Stone (Yes 12 Stone—the Weight of an Average Man!) and Found Happiness, God and the Chance of a Husband." (January 19, 1969), pp. 8–15. Portrait of Alice Madeiros. Members of Weight Watchers International. Text by Doon Arbus.
Harper's Bazaar	"Not to Be Missed." (February 1969), pp. 162–163. Portrait of the singers Evelyn Lear and husband Thomas Stewart. Text by Geri Trotta.
The New York Times Magazine Part II	"Ready for Action." (March 16, 1969). Children's Fashions supplement, photographed on St. Croix, Virgin Islands—cover plus twenty-eight color and black-and-white photographs. Text by Patricia Peterson.
Harper's Bazaar	"Three Poems." (March 1969), pp. 238–239; and "Editor's Guest Book," p. 155. Two portraits of the Argentine writer Jorge Luis Borges, one with his wife. Poems by Borges.
Holiday	"Leonard in the Lyons Den." (March 1969), pp. 44–47, 94. Portrait of columnist Leonard Lyons. Twenty-one portraits of Lyons with celebrities. Text by Alfred Bester.
Sports Illustrated	"The Greatest Showman on Earth, and He's the First to Admit It." (April 21, 1969), pp. 36–49. Portrait of Judge Roy Mark Hofheinz. Text by Tex Maule.
Creative Camera	Untitled. (May 1969), pp. 174–175. Reprint of *New York* article "La Dolce Viva" with one additional photograph.
Esquire *	"Tokyo Rose Is Home." (May 1969), pp. 168–169. Text by Diane Arbus. Portrait of Toyko Rose.
Nova	"Get to Know Your Local Rocker." (September 1969), pp. 60–65. Five portraits of members of a British motorcycle gang. Text by Peter Martin.
Sunday Times Magazine (London)	"Make War Not Love!" (September 14, 1969), pp. 18–29. Nine portraits of feminist leaders Roxanne Dunbar, Rose Mary Byrd, Ti-Grace Atkinson, June West, Betty Friedan, Anne Koedt, Kate Millet, and

	members of The Red Stockings, a radical feminist group. Text by Irma Kurtz.
Sunday Times Magazine (London)	" 'But Ladies, I Am 76 Years Old.' 'The World's Most Perfectly Developed Man' Now Lives among the Aged in Florida. But Age, to Charles Atlas, Does Not Mean Being Reduced to a Seven-Stone Weakling Again." (October 19, 1969), pp. 26–31. Two portraits of Charles Atlas. Text by Philip Norman.
Nova	"People Who Think They Look Like Other People." (October 1969), pp. 66–71. Eight portraits of look-alikes. Text by Pauline Peters and Margaret Pringle.
Harper's Magazine	"Jacqueline Susann: The Writing Machine." (October 1969), pp. 65–71. Portrait of the author with husband Irving Mansfield. Text by Sara Davidson.

1970

Nova	"Lulu's Career Is Important." (January 1970), pp. 30–33. Nine photographs of the British rock singer. Text by Helen Lawrenson.
The New York Times Magazine Part II	"Looking to Summer." (March 15, 1970). Children's Fashions supplement, photographed in Barbados—cover plus twenty-two color and black-and-white photographs. Text by Patricia Peterson.
Essence	"How Radical Is Black Youth?" (November 1970), pp. 46–49. Three portraits of young activists, two uncredited. Text by Cheryl Aldridge.
Essence	"Conversation: Ida Lewis and Rev. Albert B. Cleage, Jr." (December 1970), pp. 22–27. One uncredited photograph of the altar of the Shrine of the Black Madonna and a portrait of its pastor. Interview by Ida Lewis.

1971

Sunday Times Magazine (London)	"The Affluent Ghetto." (January 3, 1971), pp. 8–15. Six photographs of planned communities in America. Text by Ann Leslie.
Essence	"Conversation: Ida Lewis and Aileen Hernandez." (February 1971), pp. 20–25, 74–75. Uncredited portrait of NOW president. Interview by Ida Lewis.
Artforum	"Five Photographs by Diane Arbus." (May 1971), pp. 64–69. Photographs from Arbus portfolio. Text by Diane Arbus.
Esquire *	"The Last of Life." (May 1971), pp. 118–119, 128. Yetta Grant and Charles Fahrer (published in *Diane Arbus*, Aperture, 1972: *The King and Queen of a Senior Citizens' Dance, N.Y.C.*, 1970). Text by Gina Berriault. Caption by Diane Arbus.

Esquire * "The Happy, Happy, Happy Nelsons." (June 1971), pp. 97–101, 157–168. Three portraits of the Ozzie and Harriet Nelson families. Text by Sara Davidson.

Time Life Books *Life Library of Photography: The Art of Photography*, New York: Time, Inc., 1971. "Responding to the Subject: Assignment: Love." Portrait of woman with pet macaque monkey.

WORKS CITED

For a comprehensive bibliography of articles on Diane Arbus's photography see Robert B. Stevens, "The Diane Arbus Bibliography," *Exposure*, 15:3 (September 1977), updated for *Picture Magazine* #16 (1980).

Arbus, Diane, *Diane Arbus*, Millerton, N.Y.: Aperture, 1972.

"The Editor's Guest Book." *Harper's Bazaar* (December 1963), p. 7. Photograph of Diane and Doon Arbus by Allan Arbus.

"The Editor's Guest Book." *Harper's Bazaar* (March 1969), p. 155.

Gingrich, Arnold, "Publisher's Page," *Esquire* (May 1967), pp. 6, 164.

Hayes, Harold, "Editor's Notes," *Esquire* (November 1971), pp. 8, 216.

Janis, Eugenia Parry, and MacNeil, Wendy, editors, *Photography within the Humanities*, Danbury, N.H.: Addison House, 1977.

Levy, Alan, "Working with Diane Arbus: 'A Many-Splendored Experience,' " *Artnews* (Summer 1973), pp. 80–81.

"Mr. and Mrs. Inc.," *Glamour* (April 1947), p. 170.

The Photographers' Gallery, *British Photography 1955–1965: The Master Craftsmen in Print*, London: The Photographers' Gallery, 1983.

"Playing Games with Magazines: 3. The Moving Finger Writes and Having Writ Moves On," *Print* (July/August 1970), pp. 43–51.

Robinson, Leonard Wallace, "A Discussion Conducted by Professor Leonard Wallace Robinson of the Columbia School of Journalism with *Esquire*'s Editor Harold Hayes and Writers Gay Talese and Tom Wolfe, Exponents All, of The New Journalism," *Writer's Digest* (January 1970), pp. 32–35, 19.

Szarkowski, John, "Photography and the Mass Media," *Dot Zero* (Spring 1967), reprinted in *Creative Camera* (February 1969), pp. 62–63.

Szarkowski, John, unpublished wall label for "New Documents" exhibition, The Museum of Modern Art, New York (February 28–May 7, 1967).

Unpublished Arbus letters to Peter Crookston, 1968–1971.

Unpublished notes and correspondence related to Arbus's projects for *Esquire*, Spencer Museum of Art, The University of Kansas, Lawrence.

Unpublished Arbus letters to Allan Arbus, 1969.

ACKNOWLEDGMENTS

This publication and exhibition project began with the donation by Esquire, Inc., to The University of Kansas of an archive of artwork that included, among thousands of items, thirty-one vintage prints of photographs that Diane Arbus made on assignment for *Esquire*. These photographs appear on pages 8–13, 26, 44, 46–47, 55, 66 bottom, 67, 76, 89, 100, 104–105, 149 top left, 160, 170. Special thanks are due to A. L. Binder, Bernard Kraus, and Phyllis Crawley of Esquire, Inc., and to Lee Young of Kansas University's William Allen White School of Journalism and Mass Communications, who made this donation possible. As the significance of this magazine work became clear, Anne Tucker, Robert B. Stephens, Peter C. Bunnell, and Catherine Lord provided useful information on Arbus's work and contributed significantly to the bibliography.

Great appreciation is due the Estate of Diane Arbus for making negatives of the magazine work available, to Amy Arbus for her photo research, and to Neil Selkirk and Bob Wagner for their excellent prints.

Many friends and associates of Diane Arbus have provided invaluable information, including Marvin Israel, Harold Hayes, Robert Benton, Samuel N. Antupit, Ruth Ansel, John Szarkowski, Thomas B. Morgan, Bynum Shaw, Clay Felker, Patricia Peterson, Deborah Turbeville, Geri Trotta, John Gruen, Nancy White, Michael Rand, and Jane Drew. Special thanks is owed to Peter Crookston for his perspective on working with Arbus and his generous sharing of their correspondence.

We are indebted to the following individuals and institutions for their permission to print published and unpublished photographs by Arbus: F. Lee Bailey, Mildred Dunnock, Germaine Greer, Christopher Isherwood, Gerard Malanga, Irving Mansfield, Eugene McCarthy, Kate Millet, and Susan Sontag; The Hearst Corporation for *Harper's Bazaar;* Times Newspapers Limited for the London *Sunday Times Magazine;* Huntington Hartford for *Show;* The Condé Nast Publications Inc. for *Glamour;* the New York Times; International Publishing Corporation for *Nova; Essence;* Whitney Communications Corporation for the New York *Herald Tribune;* Curtis Publishing for *Saturday Evening Post; Travel-Holiday; Sports Illustrated*, Time, Inc.; and *Harper's Magazine*.

The exhibition is supported by grants from the National Endowment for the Arts, The University of Kansas General Research Fund, and The Art History Travel Fund. Many thanks to Elizabeth Broun, Douglas Tilghman, Jay Gates, Deanell Tacha, Jan Howard, Elizabeth Wright, Jon Blumb, Miriam Neuringer, Mary Lynn Bass, Sam Harrell, and Mary Kay's resourceful staff at the Inter-Library Loan Department of The University of Kansas for their assistance and support.

Special thanks to Scott Rucker for his research and preparation of the prints for reproduction, Valerie Sonnenthal and Heather Mee for their editorial assistance, Mary Wachs for her editing of the essay, and Doon Arbus for her editorial contributions.

The support and patience of Jan Kozma throughout the development of this complex project are warmly appreciated.

"Diane Arbus: Magazine Work, 1960–1971" is an exhibition of seventy-five photographs originated by the Helen Foresman Spencer Museum of Art, The University of Kansas, Lawrence, and organized by Thomas W. Southall, curator of photography. The exhibition schedule includes:

Spencer Museum of Art, The University of Kansas, Lawrence, Kansas
January 22–March 4, 1984

Minneapolis Institute of Arts, Minneapolis, Minnesota
May 5–June 24, 1984

University of Kentucky Museum, Lexington, Kentucky
October 28–December 30, 1984

University Art Museum, California State University, Long Beach, California
January 29–February 24, 1985

Neuberger Museum, State University of New York at Purchase, Purchase, New York
April 15–June 9, 1985

Wellesley College Museum, Wellesley College, Wellesley, Massachusetts
September 6—October 27, 1985

The Philadelphia Museum of Art, Philadelphia, Pennsylvania
February–March 1986